A Concise History of Indian Art

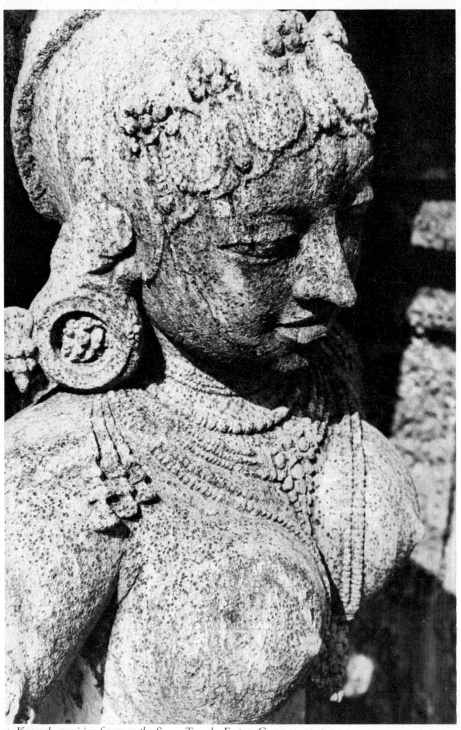

1 Konarak, musician figure on the Surya Temple. Eastern Ganga, c. 1240

A Concise History of
INDIAN ART

ROY C. CRAVEN

200 illustrations, 30 in colour

 Thames and Hudson · London

This book is dedicated to my students, who
helped give form and purpose to its pages

Printed in Great Britain by Jarrold and Sons Ltd, Norwich

Contents

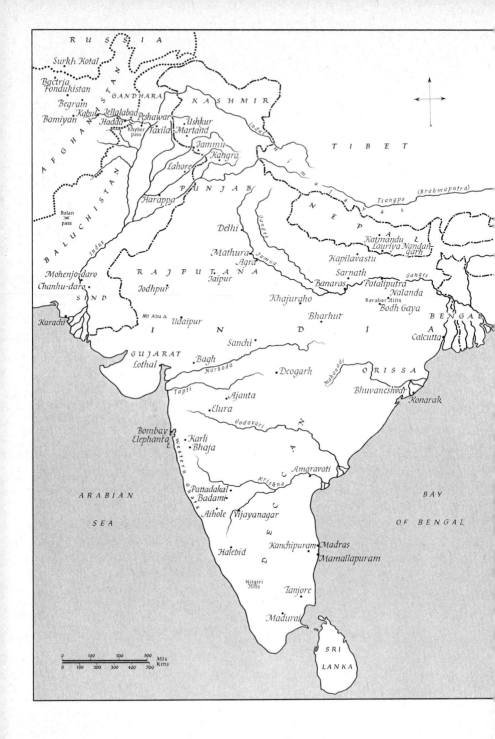

Introduction

The undertaking of this book was approached with considerable trepidation. From the first, I was more than aware of the hazards inherent in the attempt to frame the rich, complex history of India's art within the limited dimension of a single book. Because this is a general introductory survey, the scholar will find nothing unknown to him here, and in fact he will be aware of omissions. I have deferentially followed in the footsteps of numerous scholars in attempting to construct this basic image of Indian art, and if I have succeeded here it is due primarily to their labours.

Much of what is known of the history of Indian art is of comparatively recent scholarship, and even more work awaits future studies. The work which defined the field was Ananda K. Coomaraswamy's *History of Indian and Indonesian Art*, published in 1927. Though the book is now somewhat outdated, anyone involved with the art of India owes a fundamental debt to Coomaraswamy and must ultimately come to regard him as their scholarly patriarch. This I feel deeply but I am also further aware of my immense debt to legions of others who have opened various vistas for me. This is especially true of Dr W. G. Archer, whose scholarship has for many years illumined my paths of study and who, with typical enthusiasm and generosity, not only encouraged the undertaking of the present volume, but most helpfully read and commented upon its pages.

I am further indebted to numerous friends and colleagues who have encouraged me in this project by providing suggestions and illustrations, and I am deeply grateful to the University of Florida for allowing me the leave time which made it possible to produce this manuscript.

To my wife Lorna I express my love and appreciation for not only typing this demanding manuscript, but also for continuing to sustain me in all involvements of life.

Here at the beginning it is important that I caution the reader regarding the terms 'art' and 'artist' in relation to Indian culture. For convenience I shall use them; but most of the objects to be met are devotional in nature, created with religious and utilitarian rather than aesthetic motives; and they were fashioned by craftsmen who worked in a tradition which dictated strict canons of iconography and manufacture, and who could never have understood the meaning of the word 'artist' as it is used today.

Despite such a cultural matrix, or perhaps because of it, Indian craftsmen produced objects which can only be described as masterpieces. Such achievements are difficult to resist and I am confident that the reader will be inspired, moved and excited by the virtues of each unique creation with which he is about to be confronted.

R.C.C.
University of Florida

The transcription of Indian words for the general English reader has always presented difficulties. Here the attempt is made to simplify the matter as much as possible by making the pronunciation more or less phonetical. Diacritical marks are omitted; for example, sh is used for ś and s (Ashoka for Aśoka, and yakshi for yakṣi). The only exception has been in the case of Sri Lanka – pronounced Shri Lanka, but universally known in one spelling only.

Harappan culture: beginnings on the Indus

The evidence of India's historical beginnings, so many thousands of years ago, has only been provided by archaeology in recent times. Hints of a glorious past have always been at hand in the ancient myths and epics of India, and the Vedic texts (*c.* 1500–900 BC) intriguingly describe how remote nomadic invaders conquered mighty citadels. Under the banner of their God, Indra, lord of the heavens and 'Hurler of the Thunderbolt', fierce Aryan warriors stormed the ancient 'cities' of the hated 'broad-nosed' *Dasas*, the dark-skinned worshippers of the phallus, and subdued them. In the great *Rigveda*, the first of the four sacred books of the Aryans, the praises of Indra are sung for rending the Dasas' fortresses 'as age consumes a garment'. But who were the Dasas (a term later to mean slave) and where were their 'cities'? Had the earth swallowed up such citadels and left no trace, or was the substance of their ramparts only that of poetic metaphor?

At the mouth of the mighty Indus river in Pakistan sprawls the modern city of Karachi. If a person stands on the sandy beach to the north and turns from the blue waters of the Arabian Sea to look inland, he will be overwhelmed by a vast scrub desert that stretches beyond the horizon to the east. For almost a thousand miles up the broad but sparsely watered plains of the Indus valley the vast wasteland spreads, until it ultimately revives in the greenery of the Punjab, 'the Land of the Five Rivers', at the foothills of the Himalayas. Here in 1856, during the construction of a railway, at a spot six miles from the modern bank of the river Ravi the workmen came upon a crumbling hill of fire-baked brick. This they quickly robbed for the railway's ballast. In the process of digging out the brick, they found small square steatite (soapstone) seals intricately carved with images of animals and a curious glyphic script (see pp. 14–15). Amazingly, in an area where few blades of grass and only dwarfed trees were growing, early craftsmen had fashioned images not only of bulls but of elephants, tigers, rhinoceros, and water-buffalo.

5–7

Sir Alexander Cunningham, the father of Indian archaeology, later inspected the site and the seals and realized their antiquity, but he could only confirm the enigma of their presence. He did at least realize that the maimed hill of brick, now named Harappa after a near-by village, was the ruin of an ancient city.

Little remains today at Harappa to interest the average visitor, but certain basic features were identified: a high citadel, some fifty feet above a lower city proper, a great waterproofed tank or bath, and a granary. It was also established that six levels of occupation occurred at the site, and that the whole complex was contained within a three-mile circumference.

These first facts were the result of a systematic excavation of Harappa in 1921. A year later, however, a more important discovery was made almost four hundred miles farther south on the Indus in the district of Sind. It was the site which became known as Mohenjo-daro (place or hill of the dead). Here, on a rise of land, some 210 miles from the sea, an archaeologist investigating an ancient Buddhist mound (*stupa*) of the second century AD realized that an older and more important site lay beneath it. Unlike Harappa, Mohenjo-daro was unmolested, and soon Sir John Marshall and his staff began an excavation which they knew would rewrite history.

Today this Indus valley civilization, or Harappan culture, can be defined as an early urban civilization existing in full flower at the end of the third millennium BC. It was primarily situated within the Indus river basin but it also appeared along the Arabian coast, spreading north and south from the Indus delta. Sites have been identified inland as far as the Himalayan foothills and in Rajasthan, not far from Delhi, while later sites have been discovered and investigated in Saurashtra, along the coast of Kutch, and the Gulf of Cambay.

The civilization's two major cities appear to have been Mohenjo-daro and Harappa. It has been estimated that at its greatest extent Mohenjo-daro had about 35,000 inhabitants, and the same would be true of Harappa. Both are distinguished by advanced urban planning. Most of Mohenjo-daro was built of kiln-fired brick, and the buildings were massed into 'super-blocks' of 600 by 1200 feet. The major streets are 33 feet wide and run north–south intersecting subordinate ones, running east–west, at right angles. Neighbourhoods within the super-

3

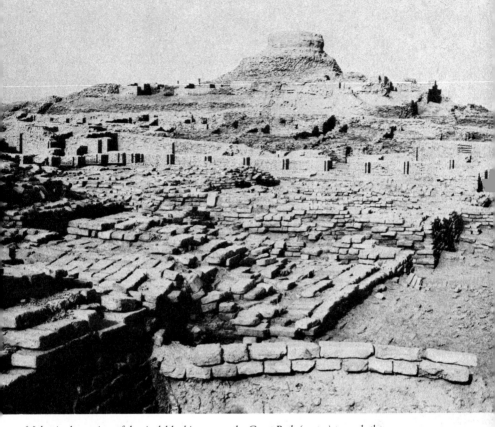

3 *Mohenjo-daro, view of the citadel looking across the Great Bath (centre) towards the ruined stupa; c. 2300 BC and later*

blocks are reached by lanes, 5 to 10 feet wide, which run at right angles to the streets. These lanes are frequently interrupted by small dog-leg corners, and many times contain capped stone sewer lines with inspection traps. Also present are the remains of shops, and of structures so substantial as to suggest temples or religious buildings.

The most dramatic characteristic of the two cities, and to a degree of other Harappan sites, is a commanding citadel. At Mohenjo-daro it is a massive, mud-filled brick embankment which rises 43 feet above the lower city. On its summit are the remains of several impressive structures of which the most prominent is the so-called Great Bath. The pool,

3

4

surrounded by a paved courtyard, is 39 feet long (north to south), 23 feet wide, and 8 feet deep. It was entered at each end by steps, and its bottom of sawed and fitted brick was sealed watertight by bitumen. Its purpose can only be guessed. Archaeologists generally agree that it must have been associated with some sort of bathing ritual, and this strongly recalls later Hindu practices and concepts of pollution. A similar construction in Indian villages today catches and retains monsoon rains, and is used for practical as well as ritual bathing.

On the citadel to the west of the Great Bath at Mohenjo-daro are the remains of twenty-seven brick foundations which have been identified as remains of a sophisticated granary complex. The citadel at Harappa also displays a Great Bath and a granary but of slightly different design.

At a lower level at Harappa, below the granary platforms and the citadel, were crowded, single-celled dwellings, which have suggested slave habitats elsewhere in the ancient world. The uniqueness of the citadel structures and their physical relationship to the lower city at Harappa and Mohenjo-daro dramatically hint at a social and religious structure with precedents for later Indian society. Assuredly the height of the citadel also had a practical purpose, in that it remained dry during seasonal floods. It is important to remember that Mohenjo-daro shows nine levels of occupation towering over 30 feet above the present flood plain. These nine levels represent a period of more than seven hundred years. Recent borings have also disclosed that an additional 39 feet of occupational levels exist below the present flood plain, and these illuminate a continuing struggle with flooding which occurred in antiquity. A number of these lower levels predate the earliest levels at Harappa.

Beyond the impressive, practically planned but dull physical remains of these cities, what do we know about Harappan culture and art, and what were the people's origins and ultimate fate? It appears, from seals and inscriptions found at Ur and other sites in Mesopotamia, and datable to c. 2400–2000 BC, that there was trade between the empires of Mesopotamia and the Harappan culture. A vital link in the trade was almost certainly the island of Bahrein; for there archaeologists have found evidence of extensive copper industries and, even more significantly, many round seals with Harappan motifs and glyphs. Only a few of these so-called 'Persian Gulf seals' have so far been found in India.

The site of Lothal in Saurashtra is also interesting in the context of trade, since it displays a unique and elaborate brick-lined dock, 710 feet long.

The dates of the Harappan civilization remain somewhat vague, but carbon-14 datings of *c.* 2300 to 1750 BC generally confirm Sir Mortimer Wheeler's round bracketing of *c.* 2500 to 1500 BC.

It can be generally stated that on the Iranian plateau during the fourth and third millennia BC diverse nomadic peoples tended to settle and form societies marked by a mixed technology of stone and bronze. Engaging in minimal agriculture and animal husbandry, they gradually evolved a basic culture which spread first south-west into the Fertile Crescent and later south-east across the Baluchistan hills into the Indus basin, and gave birth – first in Mesopotamia and later along the Indus – to new and comparatively sophisticated urban civilizations.

4 Mohenjo-daro, the Great Bath. Harappan culture, c. 2300–1750 BC

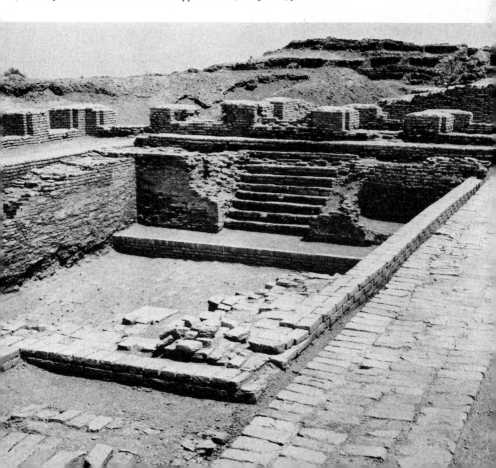

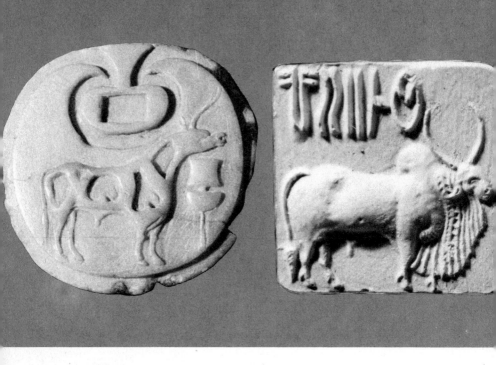

6, 7 The steatite seals remain the most impressive and enigmatic artefacts from the Harappan civilization. Thousands have now been recovered, and their physical character is fairly consistent. In size they range from $\frac{3}{4}$ inch to $1\frac{1}{2}$ inches square. In most cases they have a pierced boss at the back to accommodate a cord for handling or for use as personal adornment. When the carving was complete the objects were covered with an alkali covering and fired, producing a fine lustrous white finish. Although the pictographic symbols remain one of archaeology's great mysteries, the variety of the text on the seals seems to suggest personal identities rather than religious phrases, which undoubtedly would recur. Such repetitions are exceptions.

The diversity of the animals depicted on the seals is astounding, and the beauty of their execution is impressive. The frequent occurrence of bulls and also of grotesque multi-headed or composite animals suggests that they must be religious symbols. Some human forms are present, but these, which will be discussed shortly, are generally more primitive,

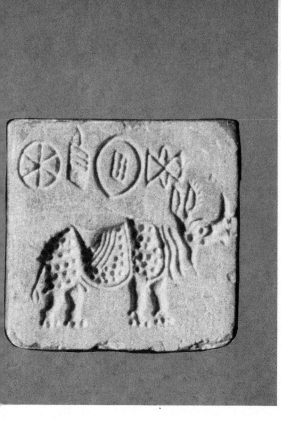

5 (far left) Pectoral carved with a 'unicorn' bull and 'manger', from Mohenjo-daro. Harappan culture, c. 2300–1750 BC. Steatite, W. about 3 in. (7.5 cm). National Museum of Pakistan, Karachi

6 (centre) Impression of a steatite seal from Mohenjo-daro showing a Brahmani bull. Harappan culture, c. 2300–1750 BC. W. 1⅜ in. (3.5 cm). British Museum, London

7 (left) Seal incised with a rhinoceros, from Mohenjo-daro. Harappan culture, c. 2300–1750 BC. Steatite, W. 1⅜ in. (3.5 cm). National Museum of Pakistan, Karachi

and less successfully realized than the animals. Also, some of the seals display plain linear symbols, such as multiple circles, crosses, dots, swastikas, and the leaves of the sacred pipal tree.

Among the creatures included in the engravers' repertory are the tiger, elephant, one-horned Indian rhinoceros, hare, crocodile, antelope, Brahmani bull, composite animal forms, and a curious single-horned ox which is the most frequently depicted subject. This humpless animal is sometimes referred to as a 'unicorn' bull, because its two horns seen in profile merge into one. It is frequently associated with an unidentified object which has been variously identified as an incense-brazier, an altar, and a manger.

The seals might be considered the first art objects in India. In them we already find, superbly contained within a format less than two inches high, features that were to be hallmarks of Indian art throughout history – a love of animals combined with a keen sense of observation and craftsmanship, creating a vital reality.

An outstanding icon in Indian art appears in Harappan culture
8 for the first time, on a famous seal from Mohenjo-daro. This seal
is highly important for many reasons, chief among them being that
it bears the first anthropomorphic representation of a deity in India, and
that it shows the concept of yoga to have been present in Harappan
culture. It appears to delineate (as Sir John Marshall observed in his
report of 1872–3 for the Archaeological Survey of India) a prototype
for the later Indian god Shiva.

The seal shows a central figure seated upon a low throne in a yogic
position. The arms, which are covered with bangles, are extended
outward over the knees in a way reminiscent of the pose seen in later
Chola bronzes of meditating Hindu gods. The figure is further dis-
tinguished by having a multiple visage (variously interpreted as three
faces or a mask), crowned by a large horned head-dress whose shape
suggests the trident symbol of Shiva. The head-dress definitely marks
the image as a sacred one, and the obsequious animals further emphasize
this aspect and hint at a fertility rite. The fertility symbolism is also
underlined by the prominent display of the deity's phallus. Along with
the elephant, tiger, rhinoceros, buffalo, and deer appear what may be
two exceedingly stylized human figures. One stands on the right edge
of the seal, just behind the tiger, and there appears to be another in the
upper left corner, though it may be part of the glyphic inscription
which occupies the top edge. Another interesting detail which relates
to the later iconography of Buddhism is the two deer under the throne.
A set of deer, flanking a central wheel on the Lord Buddha's throne,
became universally understood as the symbol for the first sermon in the
54 Deer Park of Sarnath (see p. 32). A throne supported by lions also became
59 common both to Buddha images and to those of the Jain saints
(*Tirthankaras*).

The vehicle or mount of Shiva in later Hinduism is a bull, and thus
he becomes confused with the Vedic god Rudra who is sometimes
referred to in Vedic verse as a bull. It is interesting to remember the
6 prevalence of bull seals in Harappan culture, in concert with this present
image and with the fact that great numbers of stone phalli (*lingams*),
another symbol of Shiva, have also been discovered in the Indus valley
ruins. It seems that Shiva, by whatever name he was known on the banks
of the Indus, was a dominant presence.

16

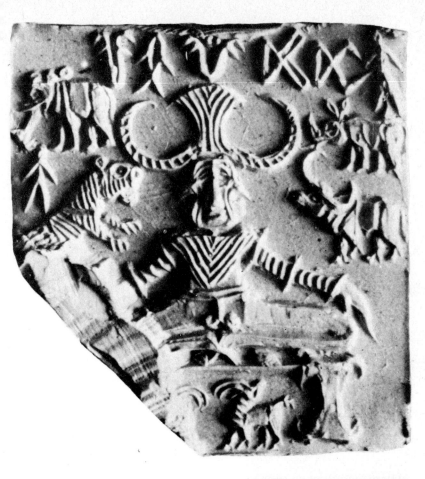

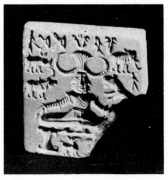

8 Impression and seal (right, actual size) from Mohenjo-daro showing a seated 'yogi' figure surrounded by animals. Harappan culture, c. 2300–1750 BC. Steatite seal, W. 1⅜ in. (3.5 cm). National Museum of Pakistan, Karachi

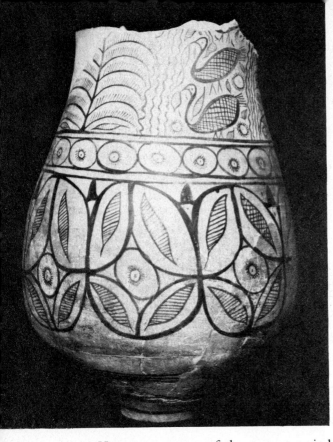

9 *Large earthenware jar painted with designs including birds, a stylized tree and leaves, from Lothal. Harappan culture, c. 2300–1750 BC*

9 Harappan pottery of the mature period was in keeping with the logical and ordered mentality that conceived the efficient urban planning and drainage systems of the Indus cities. It consists chiefly of wheel-turned items of a wide variety, which show the consistent characteristics and standards of an organized manufacturing system. Among the various shapes created are huge tall decorated storage jars, strainers, bowls with a pedestal (common to all ancient Asian cultures), pointed goblets which stood in the ground on their points (unique to Indus sites), some of which appear to carry what may be the potter's stamp, and many other utilitarian forms.

The ware consists of a pinkish-buff body, coated with red slip and painted with black lines. The designs range from simple horizontal stripes of varying thickness to elaborate patterns, such as checks or overlapping rows of circles. Descriptive elements occasionally include bulls, peacocks, pipal leaves, fish, and – rarely – crudely defined human

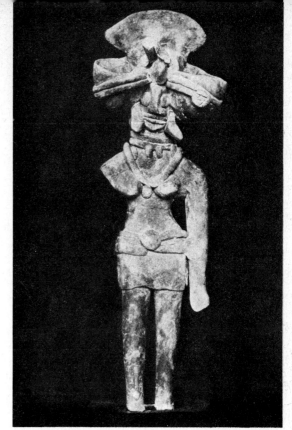

10 *Terracotta 'mother goddess' figurine from Mohenjo-daro. Harappan culture, c. 2300–1750 BC. National Museum of Pakistan, Karachi*

figures. Some of these motifs also appear on pottery from earlier pre-Harappan settlements in northern Baluchistan, and especially Mundigak in Afghanistan. It seems probable that, as G. F. Dales suggests, they moved down from sites in the Indus foothills, such as Amri, before actually reaching the proto-Harappan settlements in the Indus valley.

More engaging are the small terracotta toys, votive animals, and figurines. Here the ancient craftsmen relaxed and became more spontaneous, diverse, and even humorous, revealing, in the animals, a keen perception which recalls the vividness of the seals. The terracottas include great numbers of 'mother goddess' images, not too different 10 from those found in other early cultures. Displaying wide hips and ample breasts, bedecked with heavy jewellery, they are an early manifestation of that Indian idealized feminine beauty which will be met again and again. Their heads generally support huge flared head-dresses which, in some cases, provide cavities for votive lamps.

19

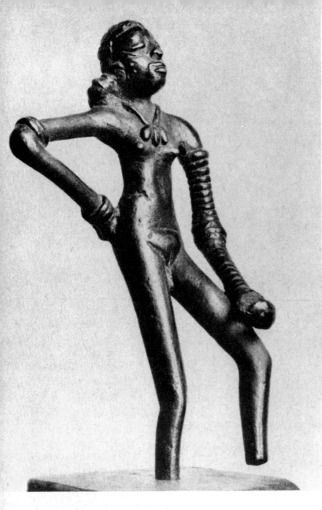

11 *Figurine of a young woman, perhaps a dancing girl, from Mohenjo-daro. Harappan culture, c. 2300–1750 BC. Copper, H. 5¼ in. (14 cm). National Museum, New Delhi*

11 Even more impressive is a unique small copper sculpture of a young woman, perhaps a dancing girl, from Mohenjo-daro. This jewel of realism is completely urban in pose and hauteur. Standing nude except for a brief necklace and an arm completely ringed with bangles, her relaxed body twists so that one hand rests on her right hip while the other holds a small bowl against her left leg. Her negroid features identify her as one of the Dasas described in the *Rigveda*. So far this figure is the single major metal sculpture from Harappan sites: the other known bronze and copper items are several miniature animal figures, corroded almost beyond recognition, and utilitarian objects such as axe-heads and fishing-hooks.

We find a more readily identifiable dancing figure in an incomplete 12 male torso in grey stone from Harappa. The body is twisted into a pose which has invited comparisons with the great Chola icons of Shiva 117 Nataraja. The figure's legs are broken; drilled sockets at the shoulders and neck must originally have been fitted with separately carved but now lost arms and head. The nipples of the breasts were also fashioned separately and still remain cemented into place. A large cavity in the groin indicates that the figure was originally of an ithyphallic nature.

12 Torso of a male dancing figure from Harappa. Probably Harappan culture,
c. 2300–1750 BC. Grey limestone, H. 4 in. (10 cm). National Museum, New Delhi

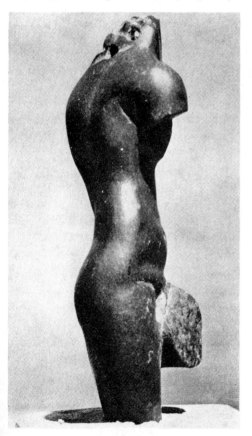
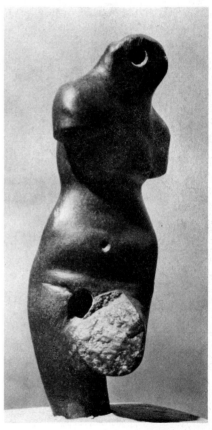

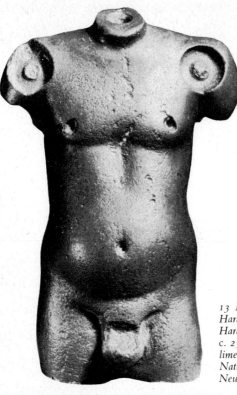

14 (opposite) Bust of a
priest-king or deity from
Mohenjo-daro. Late
Harappan culture,
c. 2000–1750 BC.
Steatite, H. 6⅞ in.
(17.5 cm). National
Museum of Pakistan,
Karachi

13 Male torso from
Harappa. Probably
Harappan culture,
c. 2300–1750 BC. Red
limestone, H. 3¼ in. (9 cm).
National Museum,
New Delhi

13 Despite the fact that some scholars have challenged the origin of a
small male torso of red limestone it is obviously the most interesting and
sophisticated Harappan image we have seen so far. Despite its small size
it has a monumentality which suggests life-size or even larger. Because
of this a few scholars have suggested that it is an importation from the
later Mediterranean world, which through some quirk of fate became
deposited in the debris of Harappa. Its presence there is scientifically
shaky since it was unearthed only a few feet below the surface, and was
only vaguely documented, but a claim of foreign origin seems extreme.
One must agree with Benjamin Rowland that the work is stylistically
and conceptionally clearly an Indian creation, since the figure's life
comes more from internal dynamics than from any anatomical accuracy.
Instead of Hellenistic realism, we see a later Indian concept of yogic
breath control (prana) used in sculpture to signify inner life and vitality.

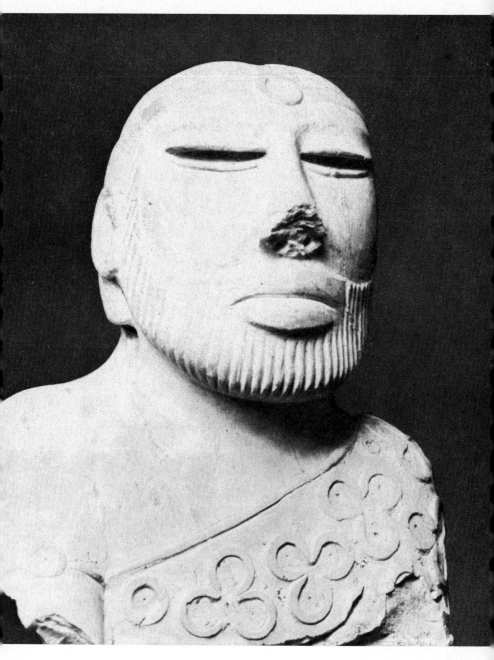

This image's prominent belly is also an Indian element, symbolizing physical and spiritual well-being. Similar nude male figures are common later as icons representing Jain Tirthankaras. The Jain figures consistently display a *shrivasta* jewel on their chests as a mark of physical and spiritual purity; but because of this figure's small scale and the fact that it is damaged, one cannot be sure if such a sign was ever present. A last fact which tends to support the contention that it was later deposited at Harappa concerns the strangely oversized drill-holes on the front of each shoulder. Some have suggested that these were executed to accommodate some sort of inlay decoration. They are aesthetically and technically out of character with the figure, and suggest a crude later attempt at reworking the piece for a new purpose.

14 Perhaps the most remarkable of all known Harappan creations is a small bust depicting a priest-king or deity, a late work carved in steatite, found at Mohenjo-daro. The face sports a carefully barbered beard, the upper lip is shaved and the hair is gathered in a bun behind the head. The wide headband has in its centre a flat circular ornament which is duplicated on the bangle worn high on the right arm. We know that the eyes were originally inlaid with shell, since one eye still retained its inset when found.

The priest-king's thick lips and wide nose distinguish him as one of the Dasas. His robe or toga-like garment, decorated with trefoil designs, falls diagonally across the upper chest and leaves the right shoulder bare. Originally the trefoil forms and the spaces around them must have been filled with coloured paste, to suggest the fabric more vividly. The trefoil symbol was known and used as a sacred sign early in Egypt, Crete, and Mesopotamia, representing various deities and celestial bodies. It has also been found on Harappan beads, pottery, and what may be a stone altar.

As yet no Harappan wooden artefacts or wall-paintings have been found. It is hard to believe that they did not exist, because both media are central to later Indian artistic expression. We can hope that archaeology will one day fill this gap.

The demise of the Harappan civilization must have followed a long period of decay, aided by various accidental acts of man and nature. Important environmental changes have recently been shown to have contributed to the decline. It was found that several Harappan sites on the Makran coast of Iran, far north-west of Karachi, which are now

8 to 35 miles inland, were once probably coastal stations related to seagoing trade, and hydrological studies have confirmed that during the later Harappan period a tectonic shift slowly took place along the coast of the Indus delta. A steady upthrust of the earth extended the shores and changed and blocked the river's flow. This created wide, long-lasting floods that varied with the seasons, and with a steady accumulation of silt Mohenjo-daro slowly became a city in a marshy lake. Each year the city-dwellers were forced to raise their structures higher and higher. Gradually their culture declined, and finally it was eclipsed by the new aggressive barbarians from the north. With their chariots, bronze weapons and Vedic religion, they brought a vigorous new culture which eventually moved beyond the Indus and the Punjab to spread across all of India.

Only to the south, at such Saurashtrian sites as Lothal, did the Harappan culture outlive the Indus valley cities. There, where it had arrived late, it continued to 'shade off' (in Wheeler's phrase) until it lost its identity by being suffused with elements of the later cultures of Central India.

Even so, one is haunted today by the yogi image on the seal and by the vision of sun-splashed waters in the baths on the citadels. Was the Harappan culture completely lost, or did some of its elements survive through time subtly to touch each epoch of Indian history? We will do well to carry this question with us through the chapters ahead.

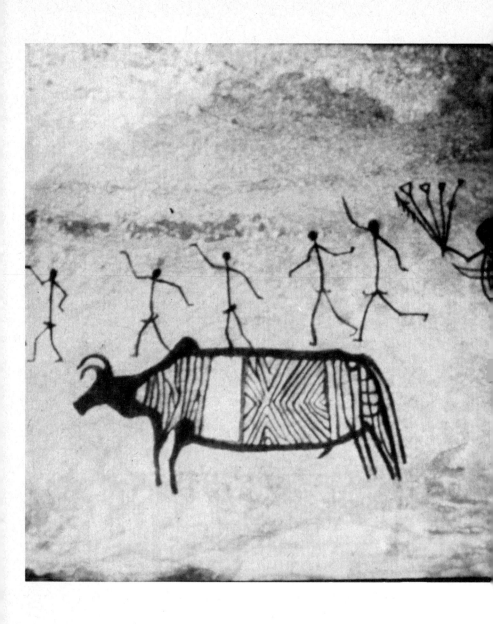

15 *Bhimbetka, Deccan, painting in a Mesolithic rock shelter showing a hunting dance, c. 5500 BC or later. H. about 20 in. (50·8 cm)*

Historical and religious origins

Knowledge of man's beginnings in India is still imperfect, and we cannot say how he originally came to occupy the greater part of the subcontinent. The small aboriginal peoples of the South, as a whole, belong to the proto-Australoid or Veddoid group and, except for their short height, resemble the Australian bushmen. Indeed, it is believed that India was once directly connected by a giant landbridge with the Indonesian islands and Australia. The rise in sea-level at the end of the last glacial age cut the overland contacts and left related bodies of ancient peoples widely scattered. Small remnants of these remote, mostly hill-dwelling people have maintained their archaic forest societies intact into the twentieth century, and today are among the so-called 'scheduled castes' of modern India.

The very first works of visual art created on the Indian subcontinent were primitive cave- or rock-paintings. Many hundreds are known, but the largest concentrations appear in Central India, on sandstone rock shelters within a hundred-mile radius of the city of Bhopal. None are as ancient as the cave-paintings of Europe: carbon-14 datings place the oldest at *c.* 5500 BC. In many cases the older images are overlaid with later paintings and graffiti, continuing down to modern times. 15

The paintings most often depict animals, either singly or along with stylized humans in hunting or magical scenes. Some tableaux seem to show such activities as hunting or perhaps bull-jumping, and figures with bows and arrows; other paintings, evidently later, show humans on horseback carrying swords and shields, which are obviously Iron Age objects. There are also rare examples of 'x-ray imagery', where a cow's unborn calf appears inside the animal or the internal organs of an antelope are charted, very much in the style of paintings made by the contemporary Australian bushmen.

The pigments used are all natural mineral colours and range in hue from dark reds and purples through terracotta creams, pinks, and oranges, to blues and greens and white ochres outlined in red. The paintings are executed in solid areas or lines of colour and attempts at tone and value are rare. According to Robert Brooks, some pigments were applied directly with the fingers, while others were apparently brushed on with a frayed palmetto stem or some other crude brush-like object. The pictures drawn in outline appear to be the most recent of these ancient works: they can be dated roughly to the fourth century AD.

Although Neolithic culture persisted for over three millennia, down to the beginning of the Christian era, it was overlaid by varying elements of Iron Age culture, starting about 1000 BC. The greatest pressure occurred about the third century BC when established Iron Age cultures of North India, in the Gangetic plain, began extending their influence into the South. Iron Age culture may also have arrived earlier in South India through maritime contacts with the Middle East.

The chief physical remains of Dravidian societies in South India, except for rock-paintings, are comparatively late in date, and consist of megalithic tombs – primitive burial cist or pit mounds covered and circled with stones. Found chiefly south of the Godavari river, the tombs have yet to be accurately dated, but they appear to have originated chiefly during the last two or three centuries BC. They contained simple iron items such as tools, weapons, ceremonial axes and tridents, and horse-trappings.

Also found in these burials were typical items of Iron Age black-and-red ware pottery. In some cases this pottery was scratched with what have been called 'owner's marks', but these graffiti are startlingly reminiscent of glyph designs found on Harappan seals. It must also be noted that the stone-circle, dolmen-type burials are obviously primitive relations of the Buddhist stupas, of which the earliest were being erected elsewhere at the same time. When a king or holy man was interred in such a mound it was enlarged. This natural process of elaboration eventually led to architectural structures that became places of reverence for both Buddhists and Jains.

Unfortunately, no sophisticated art remains to document one of the most important epochs of Indian history – between the period of Aryan conquest, c. 1500 BC, and the advent of the historical Buddha (566?–

37, 43

c. 486 B C). We know from literary sources, however, that all the arts were practised. They were, moreover, central to the education and life style of society's élite. Elaborate palaces of kings and town-houses of the wealthy are described as being embellished with wall-paintings and ornate wood-carvings. Major and minor arts were enhanced with accents of pigment, ivory, silver, gold, and precious stones, and miniature paintings were also known. But all was ephemeral and now appears lost forever. Slight suggestions of this lost art may be glimpsed in stone sculptures of the third and second centuries B C, and in the later cave-paintings at Ajanta, executed during the Gupta period in the fifth century A D.

Once the Aryans had settled in North India, an acculturation sequence began which saw a slow amalgamation of Vedic culture with that of the conquered, dark-skinned Dravidians. At first, as separate tribes, the Aryans herded cattle and waged wars both with the Dasas and among themselves. Eventually, however, they settled down, turned to cultivation, and began to intermarry with the native Indians. Before too many years had passed, small urban centres grew up and became the focus of kingdoms which consolidated tribal groups. The Aryans had spread south-east from the original areas first conquered in the Indus valley and the Punjab, and the chief arena for their development now became the Doab, or the plains adjacent to the Jumna and Ganges rivers.

The Aryans had brought to India the concept of religious worship centred upon sacrifice to deities who were the personification of the forces of nature. Their social structure, which grew out of their religious practices, consisted of a hierarchy which has come to be called the caste system. Actually our word comes from the Portuguese word *castas*, which was first used in the sixteenth century; the Aryans used the Sanskrit word *varna*, meaning colour.

There were (and are) four basic social classes. The priests, or *brahmans*, were the most exalted since they performed the Vedic sacrifice and, with their knowledge of the Vedic texts and rites, functioned as inter-mediaries between the gods and man. Second in importance were the *kshatriyas*, who constituted the warrior class and were the kings and administrators. Then came the *vaishyas*, or merchants and tradesmen. Last were the labourers, or serfs, the *shudras*. Outside this structure were the people who belonged to no caste, the 'outcastes', the impure, the

untouchables. This was the group to which the conquered dark-skinned Dasas belonged. The word was no longer just a term in the *Rigveda* describing the despised 'broad-nosed' defenders of the Indus cities, but now had the definite connotation of slave.

The first and chief book of the Vedas is the *Rigveda*, which was compiled some time between 1500 and 1000 BC. It is the oldest religious text in the world and contains 1028 hymns to various deities. Hymns
28
were especially directed towards Indra, the god of the heavens, the warrior-king who rode a white elephant and threw the thunderbolt. Varuna, next in importance to Indra, was the feared and mysterious deity who not only created the cosmic order, *rita*, but maintained it from heaven. The cosmic order governed the rhythms of nature and man, and could be disrupted by man's sinful acts of lying and drunkenness. Varuna's presence (or that of his spies) was therefore always felt ('Wherever there are two, a third also is there'). Other Vedic deities were Agni, the god of fire, who on the Vedic altar consumed the sacrifice for the gods and was associated with the sun and lightning;
28, 64
Surya, the Sun God proper, whose chariot was daily pulled by stallions across the heavens; and Yama, the god of death.

Of particular interest is *soma*, which was both a substance vital to the Vedic ritual and the personification of this drink as a god. At a sacrifice a plant (probably a mushroom, according to R. G. Wasson) was pressed between rocks and mixed with milk or curd. The person who consumed it then had vivid and pleasant hallucinations. With soma as part of the ritual, the brahmans had a potent device for convincing the worshippers that Indra came down and caroused with them within the sacred grass-strewn compound of the sacrifice.

The three later Vedas, *Sama*, *Yajur*, and *Atharva*, which date from some time between 900 and 600 BC, contain instructions for performing sacrifices, magic formulae, and spells. After the tenth century BC, as the Vedas became more obscure, the *Brahmanas* and the later mystical *Upanishads* were appended as commentaries. The Sanskrit of the *Rigveda* is one of the earliest known languages derived from the ancient Indo-European, parent of so many of today's languages.

The great epic poems of India, the *Ramayana* and the *Mahabharata*, were conceived in classical Sanskrit and were formulated about 400 BC. The *Ramayana* is the older of the two, but the *Mahabharata* is the longest

poem in the world, containing 90,000 verses or *slokas* formalized into a gigantic omnibus of sub-stories, myths, and legends (the *Bhagavad Gita*, for example). It is a veritable Hindu manual for social, ethical, and religious traditions.

These vast epics, and the four 'books' of the Vedas, were originally transmitted by a phenomenal human chain of memory, and only written down centuries after their actual compilation. This oral tradition still exists in India today. It is not unusual even now for scholars to discover and record a previously unknown ancient Sanskrit text that is being correctly chanted by an illiterate holy man.

As briefly indicated above, the Aryan tradition through the centuries was shaped by contact with the indigenous cultures of the subcontinent. By the beginning of the Christian era, it had changed so completely from its original Vedic character that we can begin to recognize in it clear qualities of the later Brahmanism. In fact, some time after the first century AD a doctrine based upon the *Upanishads* had codified into what is called *Vedanta*. *Vedanta* actually means 'the end of the Vedas', and its texts, the *Brahma Sutras*, containing the seeds of modern intellectual Hinduism, are still revered and studied in India today.

At this time we also see other important new elements beginning to emerge. Already present were the concepts of *bhakti*, or devotional love of the deity (later an important aspect of the Krishna cult); *jnana*, or knowledge of spiritual texts; and *yoga*, which was a system of gaining knowledge through asceticism and physical control of the body's senses. This last development was most significant because it revealed that the Vedic tradition of ritual sacrifice, necessary to maintain the universe, had been displaced by the concept of self-denial and penance which the Lord Shiva performs, meditating forever, in the far Himalaya. Shiva, the Hindu god of fertility and regeneration, associated in these early times with the Vedic god Rudra (see p. 16), was traditionally aided in his cosmic task by his human devotees, who also followed him in an ascetic path to mysticism. We might here recall the seated yogi figure 8 on the seal from Mohenjo-daro to note how within two millennia the indigenous cultures, present and active in early Harappan times, have significantly penetrated the Vedic traditions.

The mystical practice of yoga was eventually accepted as an orthodox element of Brahmanism's social structure and was made an important

component of the four prescribed states of life recognized by a devoted Hindu. These are the celibate student, the married householder, the ascetic forest hermit, and, finally, the old homeless pilgrim. Asceticism was also an important element in the earlier schisms away from Vedic Brahmanism such as Jainism and Buddhism.

Buddhism, one of the world's great religions, originated with a historical personage, Siddhartha, born about 556 BC into a warrior caste (kshatriya) family in the Nepalese foothills. He was raised as a prince in the city of Kapilavastu, but at twenty-nine he renounced the world to seek spiritual truth. His family's clan name was Shakya and when he became the Buddha (the Enlightened or Awakened One) he was called Shakyamuni, the sage of the Shakyas.

After six years of attempting to gain salvation through self-denial, Siddhartha resolved to sit immersed in contemplation under the Bodhi
53 tree at Bodh Gaya near Banaras until he achieved enlightenment. At the end of forty-nine days of meditation, salvation came, and he rose and
54 went to the Deer Park near Sarnath, where he preached his first sermon to his former companions in austerities.

For the next fifty years the Buddha travelled over a good part of the Gangetic basin, teaching and converting regardless of caste, peasants and princes alike. He organized the original Buddhist order of monks and shared with thousands the wisdom of his 'Four Noble Truths' and the 'Noble Eightfold Path' or 'Middle Path' to liberation, or *nirvana* (literally 'extinction', blowing out the flame).

The Four Noble Truths are: 1. life is suffering; 2. the reason for suffering is desire; 3. suffering must be caused to cease by overcoming desire; and 4. suffering will cease if one finds the path to deliverance, which is the Eightfold Path. The elements of the Eightfold Path are: 1. right knowledge or understanding; 2. right purpose or resolve; 3. right speech; 4. right conduct or action; 5. right occupation or a livelihood conducive to salvation, preferably the monastic life; 6. right effort; 7. right awareness or self-mastery; and 8. right meditation.

It is doubtful that the historical Buddha looked upon his philosophical teachings as a formal religion. He did organize a society of monks, but his last message to them as he lay dying (c. 486 BC) was to 'work out your own salvation with diligence'. Undoubtedly among the main

factors which originally led to the popularity of Buddhism as a religion were its lack of priests and its disregard of caste.

One other important religious movement in India at this time was Jainism, whose concepts seem to have originated in India before the arrival of the Aryans. The religion was dedicated to asceticism and the sacredness of all life, its chief concept being *ahimsa* or non-violence. The apparent founder of Jainism was an individual called Mahavira, or Great Spirit (*c.* 599–527 B C). He was a contemporary of Buddha, and was even mentioned several times in the Buddhist canons. Mahavira was either the first or, as the Jains claim, the last of twenty-four great Jain saints called Tirthankaras, 'the ones who lead to the other shore'. By their ascetic example the Tirthankaras show all souls how to achieve release from the cycle of endless rebirth by the complete purification of their minds and bodies. The Jains are strict vegetarians and consider death by starvation meritorious. The Tirthankaras are also called *jinas* (victors or heroes), and their followers therefore are called Jains, or the sons of victors.

The Jains conceive the universe as an exceedingly complex living organism made of imperishable particles, some too small to be seen, all of which have souls. This fact accounts for the Jain aversion to violence. Today in India one sees Jain monks and nuns wearing gauze masks over their mouths to safeguard the unseen living organisms in the air. They also carry small brooms to sweep minute creatures from their paths as they walk.

The Jains were originally organized into two main sects, the Shvetambaras, or 'white-garmented ones', and the Digambaras, or 'space-garmented ones', who considered clothing to be a manifestation of involvement with the world and so went about garbed only in air. (Alexander the Great encountered Digambaras when he arrived in North India in 326 B C, and called them gymnosophists, or 'naked philosophers'.) As we will shortly see, the Jains, like the Buddhists, were eventually responsible for some of India's major works of art.

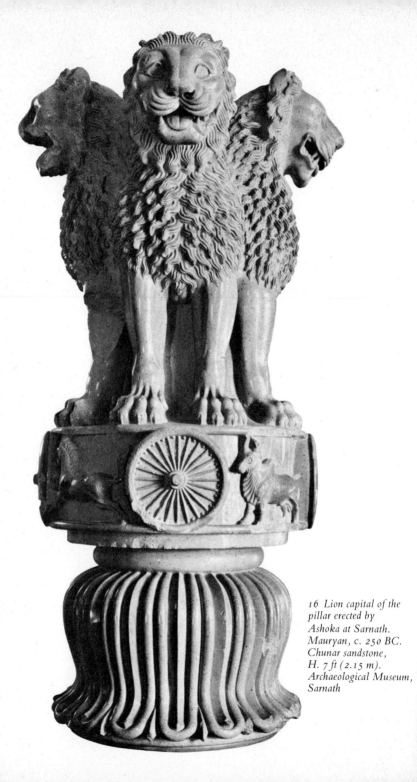

*16 Lion capital of the
pillar erected by
Ashoka at Sarnath.
Mauryan, c. 250 BC.
Chunar sandstone,
H. 7 ft (2.15 m).
Archaeological Museum,
Sarnath*

The Mauryan period: the first imperial art

In 326 BC the army of the young Macedonian adventurer who had conquered the Mediterranean world and the great Persian empire of Darius III crossed the Indus river and moved on to the plains of India. Alexander the Great's desire to conquer all the lands of the Persian empire, of which he had now become emperor, had brought him to its richest satrapy – to the region of Gandhara and the friendly city of Taxila, whose king had solicited his aid in attacking a rival ruler. Soon, on the banks of the Hydaspes (the river Jhelum), Alexander and his phalanxes were to fight one of their last and most brilliant battles against the heroic Raja Poros's 50,000 troops and 200 elephants. But even in victory, the homesick and exhausted Macedonians soon persuaded Alexander to leave India and turn west, back towards Ionia.

Although the brief and dramatic phenomenon of a Greek invasion of North India had few lasting qualities it did create a political vacuum from which rose the first great historical Indian empire, that of the Mauryas.

After Alexander's death his conquered lands in the East were held by isolated Greek colonies under the tenuous command of Seleucus Nicator, one of his generals. This arrangement did not last long because another young adventurer, an Indian named Chandragupta Maurya, came forward to take advantage of the disrupted situation.

Chandragupta Maurya's origins are obscure, but as a youth during the time of the Greek invasion he seems to have been active in North India as a marauding guerrilla on horseback. In fact, it is apocryphally claimed that he and Alexander actually met for an uncomfortable moment at one of the latter's camps in the Punjab. In any case, in such unsettled conditions Chandragupta Maurya was able to gain strength and successfully depose the last king of the Nanda dynasty at Pataliputra

35

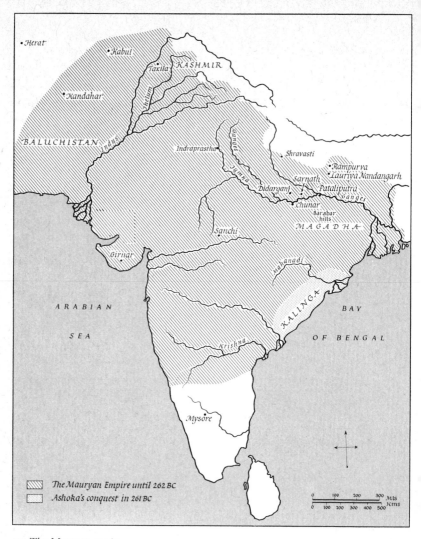

17 *The Mauryan empire*

(near the modern city of Patna) and establish his domain over Magadha
in north-eastern India. He then quickly moved north-west into the
Punjab where he overthrew the remnants of Greek power, and by
305 BC he had added western India and the Indus valley to his holdings.
At this point Seleucus Nicator decided to challenge Chandragupta; but
he was defeated and forced to relinquish the Greek satrapies of Kabul,

Herat, Kandahar and Baluchistan, and was further humbled into forming a matrimonial alliance with the Maurya clan.

As the first true emperor of India, Chandragupta Maurya successfully reigned from his capital at Pataliputra for twenty-four years (*c.* 322–298 BC) over an empire which covered all of North India, from the Ganges to the Indus and into the mountains of the Hindu Kush. Because he maintained diplomatic relations with Seleucus Nicator, we have the first clear picture of events in Indian history, recorded by the Greek diplomat Megasthenes. The Mauryan capital of Pataliputra is described as a city stretching nine miles along the banks of the Ganges, with mighty wooden walls pierced by 64 gates and surmounted by 570 towers. Megasthenes also relates, significantly, that the palace of the Mauryan emperor exceeded in grandeur those of Persia at Susa and Ecbatana. Little is to be seen today on the site of Pataliputra, at the confluence of the Ganges and Son rivers, but excavations did recover from the river sand remains of gigantic wooden walls or palisades.

Chandragupta's son Bindusara extended the empire into the Deccan as far south as the area of Mysore, and then he was succeeded by the most famous and greatest Mauryan emperor of all, Ashoka.

Little is known of the early part of Ashoka's long reign of forty years (*c.* 273–232 BC), except that the eighth year was a pivotal one. This was the year of his successful, but bloody, attack on the region of Kalinga, where, according to one of his edicts (translated by Nikam and McKeon), 'one hundred and fifty thousand persons were carried away captive, one hundred thousand were slain, and many times that number died'. The emperor, we can assume, had up to that time enjoyed all the royal pleasures of his kingdom, which of course included hunting and warfare, but after his great victory he was overcome with deep regret and looked upon violence with abhorrence. An edict carved upon a rock at the boundary of the ancient Kalinga country, south of Orissa on the Bay of Bengal, documents not only Ashoka's conversion, but also his missionary zeal for the non-violence of Buddhism.

Immediately after the Kaliṅgas had been conquered, King Priyadarśī [Aśoka] became intensely devoted to the study of Dharma [Buddhism], to the love of Dharma, and to the inculcation of Dharma.

The Beloved of the Gods, conqueror of the Kalingas, is moved to remorse now. For he has felt profound sorrow and regret because of

the conquest of a people previously unconquered involves slaughter, death and deportation . . . King Priyadarśī now thinks that even a person who wrongs him must be forgiven . . . King Priyadarśī considers moral conquest [that is, conquest by Dharma, *Dharmavijaya*] the most important conquest. He has achieved this moral conquest repeatedly both here and among the peoples living beyond the borders of his kingdom . . . Even in countries which King Priyadarśī's envoys have not reached, people have heard about Dharma and about His Majesty's ordinances and instructions in Dharma. . . . This edict on Dharma has been inscribed so that my sons and great-grandsons who may come after should not think new conquests worth achieving. Let them consider moral conquest the only true conquest.

Actually Ashoka's kingdom lasted hardly more than fifty years beyond his death, but thanks to his dedication to Buddhism the sect became a major world religion and the dominant one of Asia.

Ashoka's missionaries travelled out from India in all directions. Among them were his son and a daughter, who carried to Sri Lanka the word of Dharma and, reputedly, a branch of the sacred Bodhi tree under which the Buddha was enlightened. In fact, a great deal of what we know of Ashoka today was preserved in the Pali Buddhist texts of Sri Lanka.

During the Mauryan period many stupas containing holy relics were raised by Ashoka to mark the sites sacred to the imperial Buddhist faith. Before this time, eight stupas had reputedly been used to enshrine the last possessions and remains of the Buddha. Then Ashoka, according to legend, further divided the relics and erected 84,000 stupas to commemorate various events of the saint's life. Subsequently stupas were erected to memorialize such things as the Buddha's enlightenment, miracles, death, or even a footprint, and to house the sacred texts, the 'word body' of the Buddha. Some stupas were solely objects of worship, such as the solid stone ones in *chaitya* halls (p. 52); later they were also used for the remains of holy monks.

It is, however, the numerous edicts cut into rocks, caves, and stone pillars across his empire, expounding the virtues of Dharma, that provide us with a penetrating insight into Ashoka's personality. The polished stone columns, erected at places associated with events in the

31

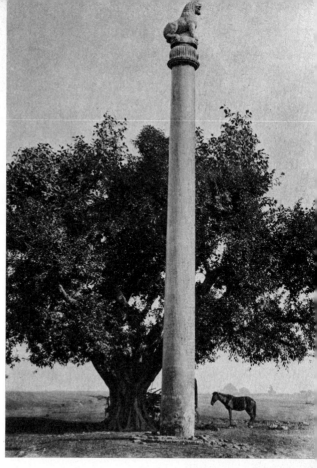

18 *Lauriya Nandangarh, edict
pillar erected by Ashoka.
Mauryan, c. 242/241 BC*

Buddha's life or marking pilgrim routes to holy places, are of special
interest for their capitals which provide us with the best remaining
examples of Mauryan imperial art. Nothing so substantial has survived
from an earlier period, no doubt because major works of art had been
created chiefly of wood, but in the Mauryan period stone sculpture
dramatically emerges to become the medium *par excellence* of Indian
artists. The practice of erecting monumental columns may be indigenous
to India: recently strong evidence has been presented by John Irwin to
suggest that the Ashokan columns may be the culmination of an ancient
pre-Buddhist religious tradition in India of a cult of the cosmic pillar,
or *Axis Mundi*.

The best preserved of all the Ashokan edict columns, dating from
c. 242/241 BC, still stands at Lauriya Nandangarh in Bihar State near the

16, 18

18

Nepalese border. Its form is typical: topped by a seated lion, the solid shaft of polished sandstone rises some thirty-two feet in the air and projects a mood of grandeur which must have characterized many other columns now lost, fallen, or shattered. The engineering skill required to position a monument that might weigh up to fifty tons ranks with the aesthetic achievement of the columns' capitals.

16 The finest and most famous of all the capitals is the one at Sarnath. The formality of its design makes its height of seven feet appear deceptively small in a photograph; however, the precision of execution and the unique surface gloss, known as the 'Mauryan polish', can easily be seen. The distinctive material used here, as in all the known Ashokan capitals, is a singularly handsome tan sandstone called Chunar after the quarry of its origin, upriver near Banaras.

The capital is composed of three diverse elements. A fluted bell supports a circular abacus, on which four royal animals and four wheels are carved in relief, and the dominant upper unit displays a quartet of alert lions, back to back, carved in the round. As excellent as this totality is, it is incomplete, for the work originally terminated with a large stone wheel supported on the shoulders of the four lions.

To understand the symbolism of the Sarnath capital, which has been adopted as the emblem for the modern Republic of India, we must consider a number of facts. The capital was found at Sarnath, the holy site where the Buddha first preached the doctrine of Dharma and thus put the Wheel of the Law into motion. In the earliest works of Buddhist art the image of Buddha himself is never depicted, but the events of his life are represented by various signs. The solar disc or wheel was an ancient Middle Eastern symbol for the Supreme Deity and/or knowledge, but in Buddhist nomenclature the wheel (*chakra*) came to be used and read
32 universally as the Wheel of the Law (Dharma Chakra), symbolic of Dharma.

In the Sarnath capital a dominant wheel was supported by four lions and echoed by the four subordinate wheels on the abacus. Lions, which roamed the jungles of India until recent years, were considered in those days to be the kings of the animal world. Thus, the Buddha was a lion
69 among spiritual teachers, and his sermon prevailed to all the four corners of the world just as the lion's roar established his authority in the forest. The four animals on the abacus – an elephant, a horse, a bull, and a lion –

40

illustrate the extent and persuasive command of the Buddha's sermon. In India since the Vedic period each of these beasts has symbolized one of the four quarters of the world. The elephant is the east, the horse is the south, the bull is the west, and the lion is the north. Each animal here alternates with a solar wheel to signify the true Law projected out to all four corners of the world, and thus combined they provide the base for the ultimate cosmic roar of Dharma which rises above.

This magnificently executed work is not only an exceedingly effective symbol for the Buddha's cosmic preaching of the Law: it is also an illustration of what must have been Ashoka's attitude towards his imperial status as an enlightened world-ruler. Here again we are dealing with an ancient Middle Eastern concept whose origins reach back to Babylon. The universal ruler, or *Chakravartin* in Indian terminology, is 'the holder of the wheel' or solar symbol of divine knowledge and authority. The Chakravartin is depicted in Indian art as possessing the Seven Treasures or Jewels, the light-giving Wheel, a loving queen, a steward, and a prime minister. A relief from the stupa at Jaggayyapeta 44 shows a Chakravartin, attended by the royal white elephant and horse, and extending his hand into the clouds to receive the rain of wealth (depicted as ancient square punch-marked coins) which falls in blessing on his kingdom. With this symbolism in mind, it is hard not to see the Sarnath capital as having an additional meaning – to represent Ashoka as an earthly Chakravartin, propagating the true Dharma and serving the holy Chakravartin, the Buddha.

Turning to the sculptural detail and technique of the capital, we find strong evidence of Persian or, more exactly, Achaemenid influence. The elongated petals which form the fluting on the bell, the bell itself, the realism of the animals portrayed on the abacus, the stylized and strained muscles and deep-carved claws of the four tense lions – all these features are duplicated on Achaemenid sculptures from the great capital city of Persepolis. It is important to remember that the Mauryan empire came into being as the result of Alexander's invasion of North India and following his destruction of Persepolis: the Persian sculptors who had worked for Darius were thus in need of new patronage. The Sarnath capital is vivid evidence that either Persian or Persian-trained Greek sculptors were at work in Ashoka's Chunar atelier. The very fact that a school of art, fully mature and creating lasting monuments in stone,

suddenly appeared and changed forever the quality and direction of sculpture in India proves that it was an alien importation. The non-Indian form of the Sarnath capital, and the precise and elegant carving technique and uniquely polished finish which are obviously not the product of a wood-carving tradition, all confirm the arrival of a new, sophisticated art.

We must not forget Megasthenes' report that Pataliputra exceeded in grandeur the Persian cities of Susa and Ecbatana. These few souvenirs in stone are enough to give substance to his remarks. Another capital which speaks directly of Pataliputra's grandeur was discovered at the city's site during the first casual excavation in 1886. It too prominently features palmette motifs centred on the flat open faces of its stepped impost block. Four cylindrical volutes project from the block's sides, and the two highest support the top abacus which features a running row of rosettes. These volutes, which recall those of Ionic capitals, join with the palmettes to document an Indian interpretation of Hellenic and Iranian motifs, which again confirms an Achaemenid influence and taste operative in Mauryan art.

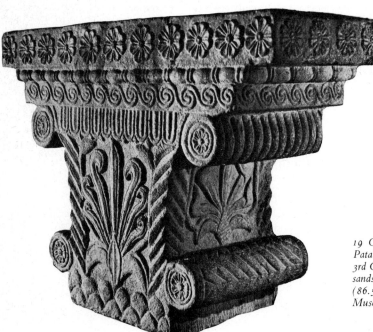

19 Capital from Pataliputra. Mauryan, 3rd C. BC. Buff sandstone, H. 34⅛ in. (86.5 cm). Patna Museum

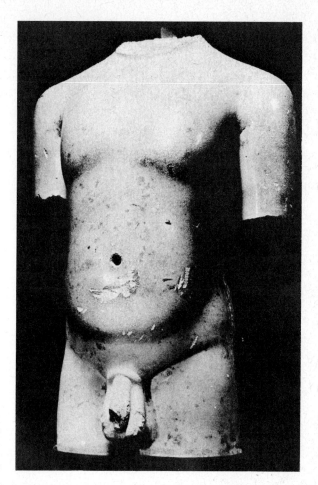

20 *Torso of a Tirthankara from Lohanipur. Mauryan, 3rd C. BC. Buff sandstone, H. 26⅜ in. (67 cm). Patna Museum*

Although no other capitals have yet been retrieved from the unstable river sands, the stumps of many polished stone columns were discovered, giving credence to the account of a Mauryan thousand-columned hall at Pataliputra.

Only a very few Mauryan figure sculptures have so far come to light, and these again are generally identifiable by their 'Mauryan polish' surfaces. Two headless male torsos, one with the imperial polished finish, have been found at Lohanipur, a site near modern Patna. They are of extreme interest because they are the earliest known sculptures of Jain Tirthankaras.

20

43

Perhaps the two most impressive examples of free-standing Mauryan sculptures are the figures of a *yakshi*, or female earth-spirit, from Didarganj near Patna, and a *yaksha* (male earth-spirit) from Patna. There is a continuing debate concerning the dating of these two figures, since some scholars see them as post-Mauryan, especially the yakshi, whose physical attributes, jewellery, and dress resemble those of the yakshi figures on the gates of the Great Stupa at Sanchi. The time-span involved is not more than a hundred years, however, so it is still possible to look at the works within the Mauryan context. In fact they display major characteristics of the Mauryan style.

21, 22

38

First and immediately notable is the monumentality of each image. Like the animals on the capitals, they seem to be emerging into reality from a melting volume of stone. The carving is voluptuously realistic and each turn or fold of the indicated flesh has a slightly inflated sensuousness which paradoxically invests the heavy stone with lightness. This quality is heightened by the smooth, glossy surfaces which are contrasted with the meticulously carved details of the jewels and fabrics which clothe the figures.

Since the Mauryan gloss quickly disappeared from Indian art, its presence here tilts the scales in favour of a Mauryan origin for these two figures. The sculptors of the succeeding Shunga dynasty appear not to have given such a gloss to their carvings, and it was only much later, in certain post-Gupta and Medieval sculptures, that a polished stone surface again became conspicuous in Indian art.

These two massive images bring us face to face with the universal divinities of fertility, for they are personifications of the primordial forces of the soil. For aeons back into dim history, even before the advent of the Harappan culture in the third millennium BC, the aboriginal peoples of India worshipped the spirits of trees, waters, serpents, and earth. Some of these spirits took on human forms. As Zimmer writes in *The Art of Indian Asia*,

> yakṣas, no less than nāgas [serpents], must have been very popular in the pre-Āryan tradition, to judge from the frequency of their occurrence on early Buddhist monuments and later Indian art. Dwelling in the hills and mountains, they are guardians of the precious metals, stones, and jewels in the womb of the earth, and so are bestowers of

21 Yakshi from Didarganj. Probably late Mauryan, c. 200 BC. Chunar sandstone, H. 5 ft 4 in. (1.63 m). Patna Museum

riches and prosperity. Two yakṣas commonly are represented standing at either side of doors, carved on door-posts, as the guardians of the welfare of the home, and, according to Buddhist literary sources, a common feature in the inner yard of the ancient Hindu household was the standing figure of a gigantic yakṣa as the tutelary god of the house.

22 Even though the male figure is more damaged than the female and has lost its head and parts of both arms, we can see that each image once held a fly-whisk made of a yak's tail. The fly-whisk is, like the umbrella, a sign of honour; its presence suggests that these earth-spirits were worshipped, or perhaps stood as a guard of honour to a shrine or to a carved symbol of the Buddha. We may be seeing an attempt to placate the humbler citizens of Mauryan times by associating representations of their divinities with the State-endorsed Buddhist faith, even though Ashoka had curtailed the festivals and ceremonies of popular religion. We will shortly see at Bharhut and Sanchi actual examples of tree spirits taking on dominant roles by attending portals of Buddhist sanctuaries.

23 Our last Mauryan/Shungan figure of a yaksha well illustrates how a style of sculpture other than that of the imperial atelier was flourishing closer to the people. It is a giant image (over 8 feet high) of cream sandstone, found at Parkham, near Mathura.

This image is more damaged and weathered than either of the two previous ones, but it is not difficult to see that it is conceived and executed in a more vital and primitive style. Its almost savage frontality marks it as an icon for humble reverence and suggests a long wood-carving tradition. Adapted to a newly evolving technique of stone-carving, the yaksha is like a huge gingerbread man, cut from a flattened mass with little back or side articulation. The major sculptural manipulation occurs on the front, where a huge belly dominates. The prominent belly immediately suggests that the figure might represent Kubera, king of yakshas and deity of wealth and the north, but certain identification is impossible. Such a sculpture may indicate that once the dominant personality of Ashoka was missing, Dharma could no longer maintain its dominance over the religions of the soil.

The earliest surviving examples of Indian architecture date from the period of Ashoka, and their longevity also comes from the fact that

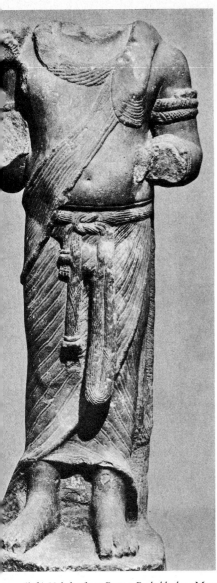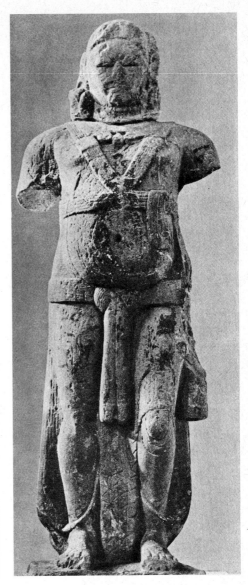

22 (left) Yaksha from Patna. Probably late Mauryan, c. 200 BC. Chunar sandstone,
H. 5 ft 5 in. (1.65 m). National Museum, New Delhi

23 (right) Yaksha from Parkham. Mauryan or Shunga, 2nd C. BC. Sandstone,
H. 8 ft 7½ in. (2.62 m). Archaeological Museum, Mathura

they are cut from solid rock. Here again we see a Persian mentality at work on Mauryan imperial attitudes, since royal rock-cut tombs were well known in Persia centuries before they were created in India.

As a gesture of religious piety and tolerance, Ashoka had a series of chambers, duplicating wood and thatch construction, carved into several boulder masses in Bihar for the Ajivika ascetics. There are a number of examples in the area, but those in the Barabar Hills about nineteen miles north of Bodh Gaya are the finest. Traditionally during the monsoon season monks of various sects ceased their wandering and withdrew to retreats. There, generally under the sponsorship of a local king, they meditated and prepared themselves for their spiritual duties back in the world of men when the rains ended. The Ashokan chambers carved into the living rock emulated the humble and temporary shelters of the transients, but as they were fashioned from stone, they obviously provided a permanent and continuing retreat for the monks of this non-Buddhist sect.

The two most noteworthy wood-imitating chambers are the Lomas Rishi and Sudama caves. Both of them have barrel-vaulted interiors, about 12 feet high and 32 feet long, but Sudama also contains a stone replica of a circular hut with a 12-foot domed and 'thatched' roof. Its internal walls are also vertically grooved to give the impression of upright wood members, and all surfaces are polished to a glassy smoothness.

24 Lomas Rishi is, however, even more impressive because its entrance, on the face of the boulder, is carved as a faithful imitation of a wooden building with a free-standing barrel roof supported on posts and beams. Among its various 'wooden' details are three smooth curved bands which arch above the $7\frac{1}{2}$-foot high doorway and span the space between the two major vertical members 'supporting' the structure. The space between the two upper bands is filled by a lattice screen which emulates a bamboo prototype that would have admitted light and air into a real building. The lower space has been magnificently carved with a procession of elephants showing reverence to three stupas. Except for a few cracks, all remains as crisp and clear as the day the sculptor stepped down from his scaffolding.

These third-century BC rock-cut chambers mark the beginning of a great tradition which would span more than a thousand years and, as we shall see, would serve all of India's religious communities.

24 Lomas Rishi cave, Barabar Hills. Mauryan, 3rd C. BC

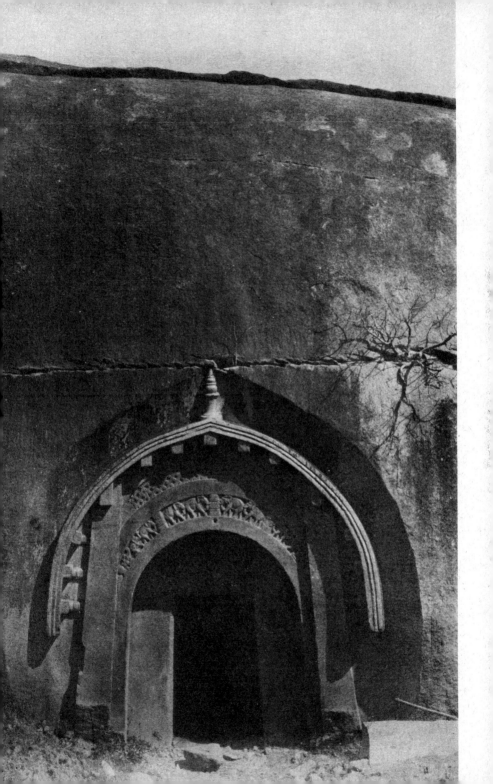

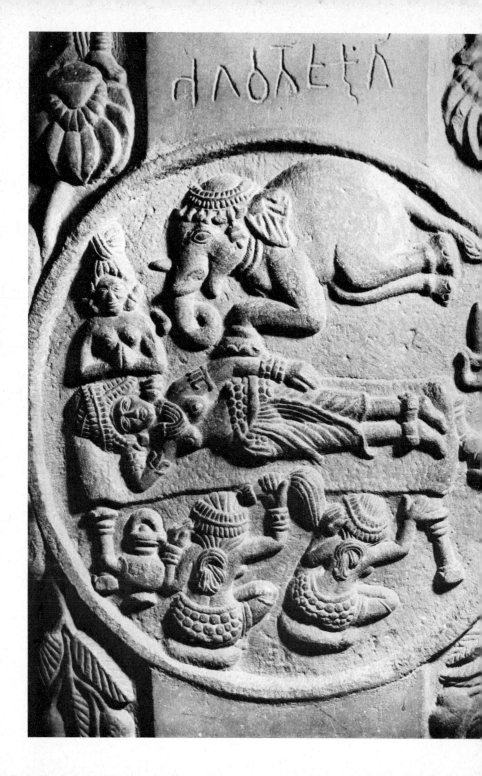

The Shunga dynasty: chaityas, viharas and stupas

When the Emperor Ashoka died in 232 BC, the Mauryan empire was divided between two of his grandsons. Administrative strength soon eroded, as many areas of the empire broke away to become independent. In 185 BC the last Mauryan emperor was killed by one of his brahman generals who then became the ruler and gave his name of Shunga to the new dynasty. During the 112-year rule of the Shungas the dominance of Buddhism as the imperial religion slipped, and its followers were even reputedly oppressed. During these times, moreover, many followers of Dharma were converted to Brahmanism. Such events, however, did not mean that Buddhism was completely eclipsed. The finest monuments of the Shunga period are, in fact, Buddhist creations.

Undoubtedly one of the most impressive monuments remaining from the late Shunga period is the rock-cut Buddhist worship hall (*chaitya*) at Bhaja, which dates from about the middle of the second century BC. More than twelve hundred such rock-cut chambers, large and small, were to be carved by Buddhists, Jains, and Brahmans in the centuries to come, and these monuments constitute a unique episode in Indian art.

26, 27

The greatest number of these sanctuaries, both early and late in date, are to be found in western India. The plan of the twenty-nine *viharas* (monasteries) and *chaityas* at Ajanta, famous for its wall-paintings which will be discussed later, gives a dramatic idea of how elaborate such rock-cut complexes can be. There, in what today is Maharashtra, the monuments are concentrated on the escarpments rising from the streams that lace the Western Ghats. Aware of the need for wealthy patrons, the holy orders also carved their retreats near ancient trade routes which passed from the inland centre of Ujjain through the Ghats to the western seaports.

81

25 Queen Maya's dream, railing medallion from the Bharhut stupa. Shunga, 2nd C. BC. Red sandstone, D. about 21½ in. (54 cm). Indian Museum, Calcutta

At this period the stupa emerged as the central focus of Buddhist worship. It is in its simplest form a hemispherical burial-mound, and as a final receptacle for man's earthly remains it was easily identifiable as the symbol for release or nirvana. Thus it represented the Buddha's *Parinirvana*, his passage from the world of pain and illusion to the world of bliss and true reality. The stupa symbolized the goal of every devout 31 Buddhist, and as such it became an integral element of the chaitya hall.

The term *chaitya* means 'place of worship'. (A chaitya can in fact, as Coomaraswamy noted, be a building, a stupa, an altar, or even a tree.) Not unlike the Roman basilica, which was emerging concurrently in 26, 31 the West, the chaitya hall is a long apsed chamber divided longitudinally by two rows of columns which create a broad central nave flanked by two narrow aisles. In the apse the two aisles meet and curve around the stupa, which, when seen from the entrance door, is centred dramatically at the nave's end. The nave is covered with a curved 'vault'.

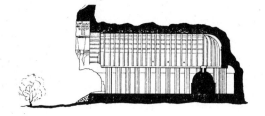

27 (opposite) Bhaja, façade of the chaitya hall and adjoining vihara. Shunga, mid-2nd C. BC

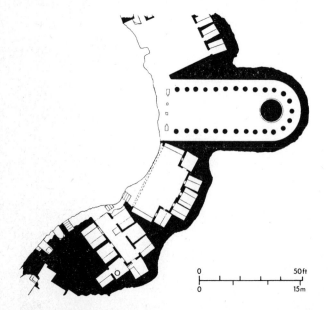

26 (left) Bhaja, section of the chaitya hall and plans of the chaitya hall and viharas. Shunga, mid-2nd C. BC

0 50 ft

0 15 m

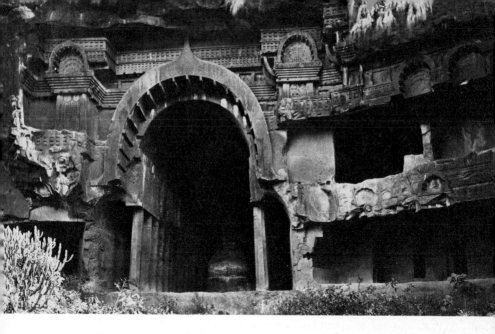

Generally the main feature of a chaitya hall's façade is a huge horseshoe-shaped window, surmounted by a peak, which pierces the stone wall above the doorway and provides the chief source of daylight for the hall. This architectural feature evolved from the stylized view of the end of a barrel-vault, first seen at the Lomas Rishi cave. Many centuries later the distinctive shape of the chaitya window or chaitya arch was still visible, as a sculptural motif on the towers of Medieval Hindu temples. 29, 86 24 134, 135

Bhaja appears to be one of the earliest attempts to create a large chamber from living rock, and it lacks a sophisticated stone façade. Mortise holes cut into the stone surrounding the entrance indicate that an elaborate wooden screen was added to the chamber after its completion. We can gain some impression of its appearance from the pattern of chaitya arches and uprights on either side of the vast entrance. Wood was not used only for the façade. The roof ribs were augmented by wooden members inset into the high vault, and wood formed the umbrella of the stupa as well as the small square railing on the stupa's crown. The scale of the chamber is remarkable: it is 55 feet long and 26 feet wide, and the vault rises to a height of 29 feet. 27

Because of the absence of a screen, the dominant chaitya arch is immediately revealed, along with the nave which is divided from its aisles by massive octagonal pillars that tilt inward, imitating the thrust

needed to support vaulting in a built structure. On either side of the opening we can still observe details of smaller chaitya-arch motifs, latticing and 'timbered' walls, all carved in imitation of a free-standing wooden building.

The chaitya chambers are not really buildings at all, but spectacular examples of giant sculpture. Nor are they caves, as they are sometimes called, even though the Indian mentality which created them undoubtedly associated them with a traditional religious practice of using caves and grottoes for ascetic retreats.

One must constantly recall that these chambers were excavated solely by human labour, which carved the cliff's face away foot by foot. After the master craftsman had laid out the dimensions and design of the planned space on the rock wall, the sculptors first carved into the upper façade by cutting a rough opening which eventually would become the finished ceiling. This permitted them to work back and down through hundreds of square yards of solid stone, ultimately to the chamber's floor. Heavy iron picks first removed the unwanted rock and shaped the rough forms of the 'architectural' details, and then the workmen executed the subtle finishing with chisels, some of them as small as a quarter of an inch wide.

26, 82 The viharas or monasteries which were carved out in association with the chaitya halls were generally designed as open square halls, approached by a doorway through a vestibule or porch and encircled by small cells for the monks carved deeper into the rock. Here the brotherhood lived, meditated, and slept in close proximity to their holy chaitya, where the ritual included the circumambulation of the stupa.

26 At Bhaja the monks' cells are located to the east of the chaitya hall, and here, on a porch some distance from the worship hall, are found several low reliefs unexpectedly depicting non-Buddhist subjects. Flanking a 28 cell's plain doorway are carved two Vedic deities in shallow relief which are reminiscent of the small mould-formed terracottas of the period. On the viewer's right, the god Indra is shown mounted on his cloud elephant, Airavata, who flourishes in his trunk a tree which has been uprooted from the landscape depicted below. There an enthroned king can be seen, with people worshipping a sacred tree covered with garlands, and also there another holy tree is apparently hung with human bodies. An attendant clings to the elephant's back, holding the Lord of the Heavens'

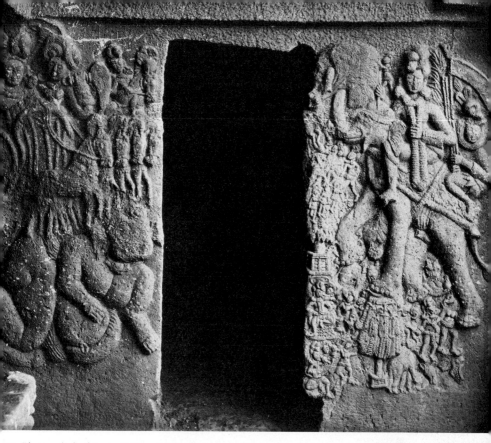

28 Bhaja, reliefs of Surya (left) and Indra flanking the doorway to a cell. Shunga, mid-2nd C. BC

banner and weapons. The relief on the left features Surya, the Sun God, accompanied by an attendant bearing an umbrella and a fly-whisk, subduing the monstrous forces of darkness. His chariot is pulled across the skies by four horses which rudely subdue the 'inflated' demons of night who roll and fall beneath the attack. The tableau must have been even more impressive in its original painted state. These reliefs featuring the older deities in heroic roles again underline early Buddhism's tolerance and its ability at integration – perhaps designed to avoid alienating the common people.

A short distance from Bhaja, and about a hundred miles south-east of Bombay, the greatest example of the rock-cut chaitya hall is found at Karli. Even though this is a later work of the Andhra dynasty, apparently

31

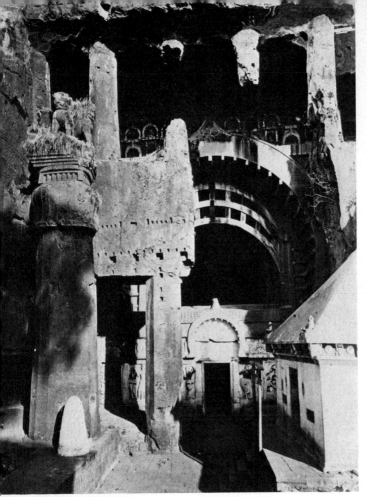

excavated from the late first to the early second century AD, it will be
advantageous to discuss it here with Bhaja.

29 Today as one approaches the monument, it appears informally
disposed because a modern Hindu shrine occupies space on the right
side of its outer porch. Originally, however, it had a formal plan
dramatically fronted by two huge stone columns. Only one, that on the
left, remains today; about 38 feet high, it is a massive faceted shaft
topped by a bell-shaped abacus and a capital with a grouped lion motif.
Originally it supported a metal wheel and rose in height to over 50 feet.
Even with its heavy design, the capital is reminiscent of the earlier
Ashokan lion capital from Sarnath.

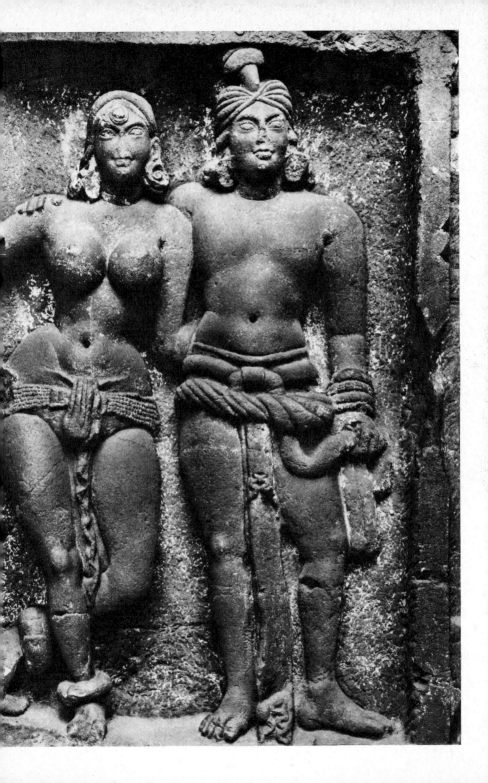

Almost immediately behind this column stand the equally massive but plain remains of a stone screen carved with supporting columns and surmounted by a pillared clerestory. The screen's main component was a central façade about 15 feet high, and judging by the presence of numerous mortise holes it must have originally supported a wooden gallery which was suspended like a decorative band across the whole front of the vestibule.

Inside the vestibule a second stone screen wall is dominated by the huge horseshoe-shaped chaitya window carved above three entrance doors which are separated by various relief carvings. Some of these reliefs are contemporary with the hall, but a number of them are seventh-century additions. The side walls are elaborately carved with small chaitya arches rising in four tiers above three half-life-sized elephants, which face forward and support the towering architectural fantasies. The elephants were originally fitted with ivory tusks and metal orna-ments. The central doorway is the largest of the three doors, and was approached by a slightly inclined ramp fashioned from the living rock floor. This entrance was obviously reserved for the chief monks and persons of rank. In contrast, the two smaller side doors were approached only through shallow foot-baths which ritually washed the feet of the devotees entering the sanctuary.

Carved on either side of the vestibule's central entrance are several conspicuous reliefs, previously thought to show donor figures. They were conceived not as anatomical studies of the human body, but rather as essays in stylizing the symbolic essence of human life at its most vital apogee. These idealized bodies are full-figured and firmly fleshed, and they graphically display the Indian quality of inner breath (*prana*) which grants them complete harmony with the robust fertility of all nature and the earth. Here again we are in the presence of the ancient yaksha and yakshi (see pp. 45–6), which now, however, have developed into what is known in Indian art as *mithuna*. The term refers to an auspicious erotic couple, to be found from this time onward on both Buddhist and Hindu structures. It was such figures that shocked Victorian art critics and led them to denigrate Indian art.

The hall at Karli is 124 feet long, 46½ feet wide, and 45 feet high. The nave is flanked by thirty-seven closely set octagonal columns which run around the plain stupa at the far end in the apse. Thirty of these columns

30

31

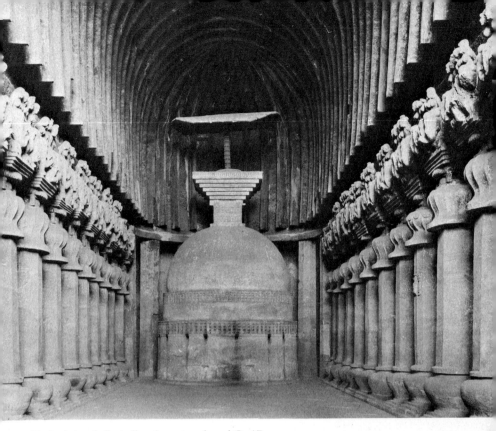

31 Karli, chaitya hall. Andhra, late 1st–early 2nd C. AD

have capitals and vase-shaped bases which stand on square three-tiered plinths. The seven remaining columns which surround the stupa are completely plain, except for their octagonal shafts. In contrast to the shafts at Bhaja, there is no slant; the columns stand completely vertical in recognition of their decorative, not pseudo-structural, function. The capitals are composed of a faceted bell-shaped abacus topped by kneeling elephants surmounted by deeply carved regal couples which, like the column bases, are also supported by tiered plinths. The rich sculptural qualities of these capitals and the close spacing of the columns combine to create the effect of a continuous high relief running down each side of the nave. The sides of the capitals towards the aisle are also carved with royal figures, but here their mounts are horses.

The light coming from the chaitya window has been carefully orchestrated to focus softly on the climax of the chamber, the stupa.

59

Also, since the columns are closely spaced, the light glows gently on them, but hardly beyond, creating the illusion that these shafts confine a sacred glowing space within the dark unlimited heart of the mountain.

Our attention can now return to a Shunga monument which, even in a ruined state, is more elaborate than any other thus far encountered. In 1873, about a hundred miles south-west of Allahabad, not far from the Son river in the north-eastern corner of Madhya Pradesh, Sir Alexander Cunningham (who had investigated Harappa) discovered in an open field the ruins of a Buddhist stupa known as Bharhut. The stupa itself had unfortunately been completely despoiled by the local people, who were quarrying its brick for village constructions. Stupas had by Shunga times evolved into major religious structures; the stupa at Bharhut was in addition enclosed within a circular stone fence dominated by four gateways. These embellishments, of dark red sandstone, were luxuriously carved with reliefs. Fortunately the weight of these stones prevented the villagers from successfully removing many of them, but scores were broken in the attempt.

We can understand basically how Bharhut looked by referring to the Great Stupa at Sanchi. The elaborate enclosures serving to define the sacred precinct of the stupa obviously evolved, as did the rock-cut chaitya halls, from wooden predecessors. This kinship is evident not only from the slotted construction of the railing and the gate's post-and-lintel assembly, but also from the profusion of carving on all the surfaces (see below, p. 62).

The reliefs at Bharhut depict, in the fashions and settings of Shunga times, the numerous birth stories of the Buddha's previous existence (*Jatakas*) and the significant events of his life as Shakyamuni. The Buddha's figure never appears, however: he is always represented by one of a series of symbols that allude to major events in his life (see p. 32). The symbolic vocabulary includes such signs as the wheel, representing the first sermon of the Law; the Bodhi tree, representing the Enlightenment; and the stupa, representing the Buddha's Great Release or Parinirvana. A riderless horse recalls the departure of the young Buddha-to-be from his father's royal house; a set of footprints displays the auspicious symbols of a spiritual Chakravartin (see p. 41); a royal umbrella over a vacant space proclaims his holy presence. Each of these symbols established a focus for a pictorial event.

32 *King Vidudabha visiting the Buddha, from the Bharhut stupa. Shunga, 2nd C. BC. Red sandstone, H. 18⅞ in. (48 cm). Courtesy of the Smithsonian Institution, Freer Gallery of Art, Washington, D.C.*

An outstanding relief features the Buddha 'turning the Wheel of the Law'. In a vaulted building with columns, upper railings and chaitya arches, four devotees pay homage to the preaching Buddha who is here represented as a giant wheel. The episode has been identified as the visit by King Vidudabha to the Buddha in a story related to the history of the Shakya clan. The Buddha's throne is strewn with flowers, and his presence is further established by the umbrella festooned with flower garlands. The large central wheel is also embellished with a garland of

such size and location, on the wheel's hub, that we of a more mechanically oriented age are almost immediately inclined to see the Chakra not as a symbol of the Buddha, but as a central fly-wheel in a dynamic power-house. Later, when images of the Buddha in human form became permissible under Mahayana Buddhism, this aspect of 'turning the Wheel of the Law' would be represented by a seated ascetic holding his hands in the position or *mudra* known as Dharma Chakra mudra.

Of great visual delight here is the genre setting among activities common to the daily lives of second-century Indians, but of unique, if not exotic, interest to viewers two thousand years later. On the left the rear of a horse has all but disappeared through a chaitya-arched gateway, while beyond the wall a mahout struggles to refrain his elephant from breaking a branch from a blossoming mango tree. To the right of the shrine we are confronted with an onrushing chariot bearing two turbaned figures. The occupant to the driver's right appears to be the king, Vidudabha. An honorific umbrella is held above his head, and he raises one hand in greeting, while with the other he steadies himself on the shoulder of the driver. The two bullocks wear oversized pompoms and with raised hooves seem to be approaching at a fast trot.

All units in this vertical composition slide upward on the picture plane and enhance the quality of action. Background details also seem more crisply defined than those in the foreground, and figures appear to grow larger as they move deeper into the setting. The composition is thus flattened out, taking on the quality of a modern photograph made with a telephoto lens, whose nature is to enlarge objects proportionately to their greater distance from the camera.

Such a shallow-relief technique had its origins in wood-carving, and the sculptures at Bharhut are so close to the edge of that tradition that we can imagine and lament the quantities of wooden art works lost to us from the previous centuries. Also, one must remember that these sculptures were undoubtedly painted when new, and so were the earlier wooden works.

The episodes depicted were all well known to the Buddhist devotees, but the reliefs at Bharhut are carved with identifying inscriptions. In fact, most of the worshippers must have been illiterate and such captions would have been meaningless to them. The relief of the Buddha's sermon originally had such an inscription on the roof of the shrine, but

most of the characters have now been lost through the stone's flaking.

Important elements in the decoration of the Bharhut railing are the large round medallions on both the vertical posts and the heavy horizontal slats. It has been suggested that they are derived from the heads of brass pins or nails which held the joints in earlier wooden railings. Their designs are rich and varied and range from purely geometric and floral designs to settings for 'portrait' heads, animals, and complex narratives.

An excellent example of the narrative scenes is the renowned relief depicting the dream of Queen Maya, or the conception of Buddha. The Buddhist legend relates that when it came time for the *Tathagata* ('He – the Buddha – who comes in truth') to descend to the world of man for the last time, he took the form of a white elephant and entered the womb of a virtuous royal queen. The miracle depicted here, in direct and economic means, shows Queen Maya lying on a bed in the palace, attended by her ladies-in-waiting. As the lamp flickers at the foot of her bed, a large but gentle white elephant hovers momentarily

33 Railing from the Bharhut stupa; at the right, the yakshi Chulakota Devata standing on an elephant. Shunga, 2nd C. BC. Red sandstone, H. about 7 ft (2.15 m). Indian Museum, Calcutta

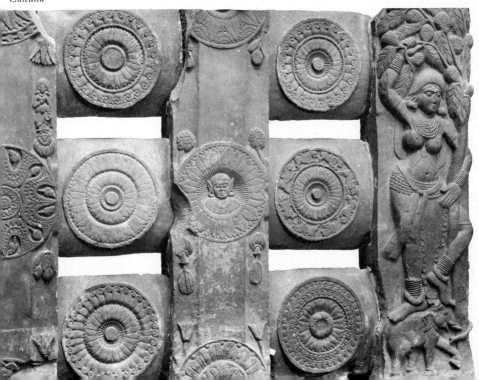

above her in her dream, before descending into her side. The medallion is only 19 inches high, but the sculptor easily accommodated all the necessary details within the circular shape, and even had room to spare. Each figure has a distinctive coiffure and pose, and the queen's jewellery is shown in exact detail, as are the lamp and water-urn next to her bed. Her sleeping figure is the obvious centre of interest, and the sculptor has used the thrust of the arm under her head and the other curving along her body as a compositional device. These curves not only echo the curved back of the elephant above, but also draw the two figures below into a related tension with the upper unit. A compositional problem is simply and neatly solved.

Elaborate monuments like the Bharhut stupa were often commissioned by a single royal patron to acquire religious merit, but here we know from inscriptions on many of the sculptures that they were paid for by various patrons. This would account for the general lack of continuity between related episodes: units in a story sequence are often not next to one another. (The practice of gaining merit by making gifts is seen in the West as well, for instance when a parishioner dedicates a window or a pew in a church. In India the tradition survives in the humble contributions of inscribed flagstones set in the floors of modern Hindu temples.)

The horizontal coping-stones on the railing are elaborately carved with individual Jataka scenes intertwined with a voluted vine pattern. This motif is in perfect harmony with Bharhut's rich surfaces, and contributes to the over-all mood of pulsating life which relates the shrine to other vital qualities of the earth. To complete this harmony, the yakshas and yakshis are out in force, especially stationed at the gateways, blessing the stupa with their protection and fertility and blessing those who pass through the gates into the holy enclosure.

34 To the left of the north gate, the railing post is fittingly carved with a figure of the yaksha Kubera, who we may recall is the deity of the north. He is immediately attended by the bejewelled yakshi Chandra, who sensuously clings to a flowering tree. Her regal bearing is complemented by her elaborate head-dress, her braided hair, her ankle and arm bracelets, her multiple necklaces, her girdle, and the auspicious marks tattooed on her cheeks. She is in fact portrayed as a queen of the Shunga period, but she is primarily a queen of fertility. Her languorous pose, with an arm grasping the blossoming branch above and her leg em-

bracing the tree-trunk below, identifies her with the *shalabhanjika* – a 137 beautiful woman who can, by the mere touch of her foot, cause a tree to bloom. The iconographic form of this ancient fertility concept undoubtedly originated with the early yakshi figures. Chandra stands on an early form of a *makara*, a mythical beast associated with waters and fertility, which is part fish or crocodile and is usually shown with an elephant's head.

Many varied examples of the shalabhanjika and *naga* (an anthropo-33, 34 morphic serpent figure) appear on the railing posts at Bharhut, and invariably they are supported by various symbolic animals. Hindu deities all eventually became associated with animal vehicles (*vahanas*) which both symbolize and support them; but it is at Bharhut that the earliest examples of this imaginative form occur.

Bharhut is one of India's earliest and most significant monuments. It is important as a 'library' of Buddhist mythology, but it is also of prime value because it preserves early iconographic motifs which matured in the centuries to follow, in both Buddhist and Brahmanical art.

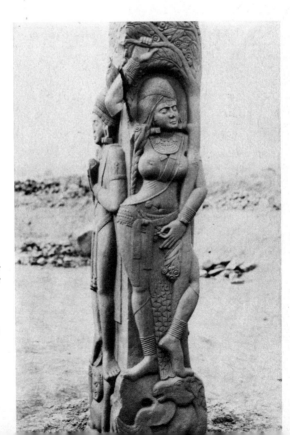

34 *North gate-post of the Bharhut stupa, showing the yakshi Chandra and (to the left) the yaksha Kubera. Shunga, 2nd C. BC. Red sandstone, H. about 7 ft (2.15 m). Indian Museum, Calcutta*

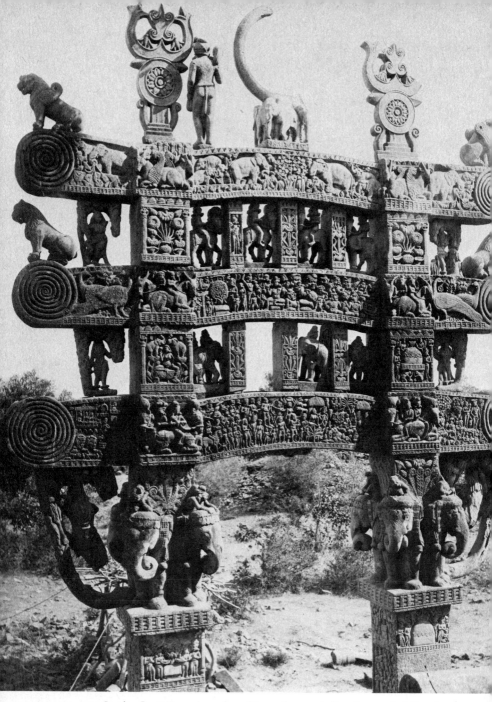

35 Sanchi, Great Stupa, inner face of the north gate. Andhra, late 1st C. BC–early
1st C. AD. Sandstone, total H. of gate 34 ft (10.35 m)

The Andhra period: the 'world mountains'

For most of their rule of more than a hundred years, the Shungas were involved in warfare. During that time north-west India was invaded by the Bactrian Greeks, who penetrated even the Doab. Also, the Kalingas, still smarting from their defeat by Ashoka, momentarily gained power and broke out to raid the Greeks in the north and the Pandyan kingdom far to the south. At the same time in Central Asia remote events were occurring which would drastically affect the course of Indian history in the early centuries of the Christian era.

The remnants of Alexander's Greeks who had clung to power in Bactria, between the Oxus river and the Hindu Kush mountains, had survived Parthian pressures in the west, but in the first century BC began to be subdued by nomadic tribes from the Steppes. First to come were the Scythians, or, as the Indians called them, the Shakas; they were soon followed by a group from southern Mongolia called the Yueh-Chi. These last barbaric nomads were a portion of several hordes of people who had pressed in on the western frontier of Imperial China during the third century BC, and were at last checked by the construction of the Great Wall. Under pressure from the Han dynasty, they were decisively driven away, and by the first century BC they had arrived far west in Parthia. There they displaced the Shakas and the Greeks, and soon, about the time of Christ, they invaded Gandhara (see p. 82).

Meanwhile, to the south an obscure tribal people, mentioned as subjects of Ashoka's empire, rose to power in the Deccan and assumed there the Mauryan mantle of power. These were the Satavahanas from West Central India. Later, in the *Puranas* of the Gupta period, they are called the Andhras. Eventually they also ruled the eastern Deccan, and the memory of this rule contributed their name to the area, Andhra Pradesh. By the second century AD they had reached the zenith of their power and dominated the central Deccan from coast to coast and controlled most of India's rich trade routes and seaports.

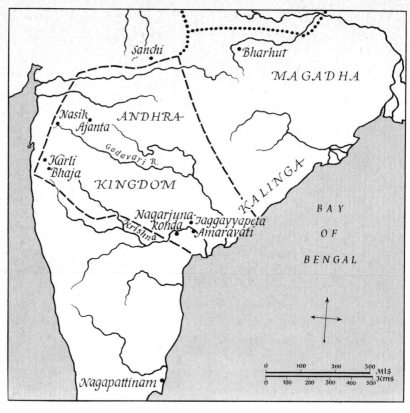

36 *The area of Andhra dominance*

In the centuries preceding the Christian era, as we have seen, the stupa had become, for the growing Buddhist faith, a focus for religious reverence. Among the 84,000 stupas reputedly erected in the Mauryan period by the great Ashoka was one located in Central India about forty miles from Bhopal. Here at Sanchi, on the site of an early monastery, Ashoka constructed a stupa which measured about 60 feet in diameter and was some 25 feet high. In the middle of the second century BC his stupa was doubled in size and its older wooden railings (*vedikas*) were replaced with new, massive, plain ones of stone, 9 feet high.

At this time an ambulatory passage was raised up round the stupa's base or drum to a height of 16 feet above the ground, and a double stairway up to the passage was added on the south side. The whole

37

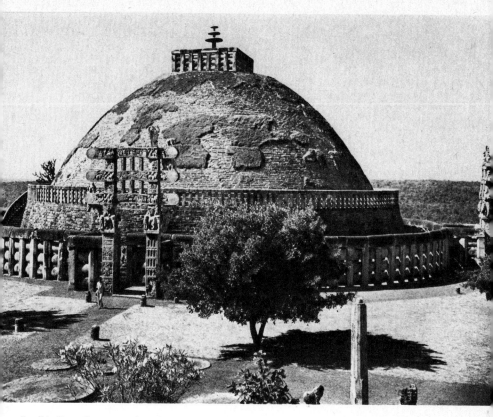

37 Sanchi, Great Stupa, seen from the east. Shunga and early Andhra, 3rd C. BC–early 1st C. AD

spherical body of the dome (*anda*) was covered with roughly finished stone blocks, and a three-tiered umbrella (*chattra*) was placed on its flattened top. The three elements of the umbrella represented the Three Jewels of Buddhism: the Buddha, the Law, and the community of monks. The umbrella stood within a square railed enclosure (*harmika*) derived from the ancient tradition of enclosing a sacred tree with a fence.

Near the end of the first century BC the Andhras arrived at Sanchi to begin their significant stone renovations, which resulted in the stupa becoming the greatest Buddhist monument in India.

The major features of the new work are the four gloriously carved stone gates (*toranas*), 34 feet high, which were begun in the later years of the first century BC and completed during the lifetime of Christ. The

35, 37

69

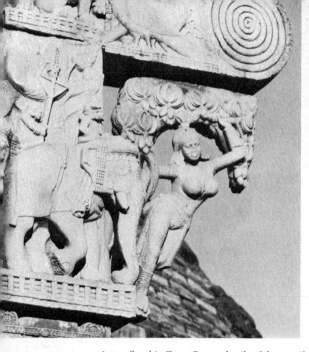

38, 39 *Sanchi, Great Stupa, details of the east (left) and south gates. Andhra, late 1st C. BC–early 1st C. AD*

sculptors were, at least in one instance – recorded by an inscription on the southern gate – ivory craftsmen from the near-by town of Beshnagar. That might account for the fact that the carving on the toranas is much more sophisticated than the construction methods, which still treat stone like wood.

Here at Sanchi, as at Bharhut, the Buddha's presence is still represented by symbols – empty thrones, footprints, umbrellas, and the like. The earth spirits are also here, and in fact the stone brackets carved in the shape of yakshis are the most beautiful creations at Sanchi. Perhaps not even a hundred years separate the Bharhut yakshi from her sister at Sanchi, but in the interim the shalabhanjika had breathed deeply and stepped from her block of stone. No longer is the figure a formalized symbol for the human body, whose angled arms and legs imitate motion; here the yakshi moves free in space and stands in the classical three-body-bends pose (*tribhanga*) which will characterize Indian sculpture from this moment on.

On the square columns and cross-members of the gates are depicted various events from the life of Shakyamuni and from the Jatakas. These are complemented by various sculptures in the round of other yakshis, fly-whisk-bearers, wheels, *trishulas* (trident shapes symbolizing the Three Jewels of Buddhism), elephants, peacocks, solar discs, and other subjects. This complex stone gallery is inhabited by the creatures of the seen and unseen worlds, who in some cases are carved with double faces to allow the devotee to see them as he approached the gate and again as he circumambulated the stupa.

The ritual of circumambulation was performed by entering the precinct through the east gate and walking clockwise. This direction related the devotee's movements with the passage of the sun (east, south, and west) and put him in harmony with the cosmos. In fact, his involvement with the stupa was a bodily engagement within a gigantic three-dimensional *mandala*, or sacred diagram of the cosmos, which slowly and systematically transported him from the mundane world into the spiritual one.

40 Two addorsed shalabhanjika images from Stupa I at Sanchi. Andhra, c. AD 10–25. Sandstone, H. 25 in. (63.5 cm). Nasli and Alice Heeramaneck Collection, Los Angeles County Museum of Art

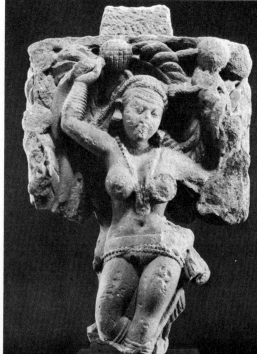

Here at Sanchi the ancient burial-mound had been completely trans-figured into a 'world mountain', oriented by its four gates to the four quarters of the universe. The tiered umbrella, housed within its holy compound, rose as the sacred tree to Heaven, and in so doing it joined by its shaft the celestial powers with the fertile soils of the earth. Within the deep centre of the solid hemispherical mass, called the egg, and directly beneath the umbrella, resided the reliquary containing the relic which was referred to as the seed. As the devotee approached the sacred compound and passed through the east gate, he was caught up in a psychological state which grew in intensity as he moved closer to the holy relic, until he momentarily became transfixed by the experience of being moved by the sight or presence of a sacred person or object (*darshana*). Excavations into the body of several stupas have revealed that the internal construction sometimes took the form of auspicious or magical designs, such as a wheel or a swastika, all hidden from view but exercising the power of their holy essence on the stupa's nature as a mandala.

The stupa, central to Buddhist ritual, was exported with the faith beyond India to evolve into different forms in new lands – the pointed pagoda of Burma, the stacked *chorten* of Tibet, the tiered tower pagoda of China, and the mammoth 'world mountain' of Borobudur in Central Java, the greatest of all Buddhist stupas.

Several small but notable footnotes to Andhran sculpture, particularly related to the yakshi bracket figures at Sanchi and the couples at Karli, are two small ivory-carvings discovered outside India. The first and most dramatically found is an ivory mirror-handle carved with a figure of a yakshi or a courtesan, which was recovered from the volcanic ash of Pompeii. Obviously it had arrived in Italy before AD 79, when Vesuvius erupted. Its stylistic details mark it as a product of the very late first century BC or the very early first century AD. Some of the statuette's jewellery recalls items seen at Bharhut, but the natural stance and elaborate hair arrangement on the figure's back relate it more closely to the yakshis at Sanchi. These qualities, added to the Roman setting, strongly point to an Andhran origin – made even more probable by the fact that the Andhras at this period controlled the trade routes which flowed from India through Alexandria in Egypt and ultimately to Rome.

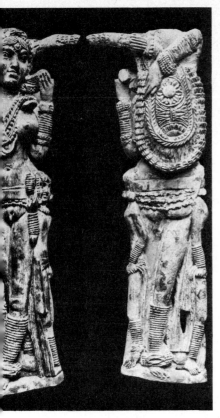
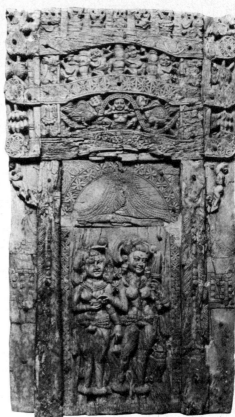

41 (left) Front and back views of a mirror-handle found at Pompeii. Andhra, late 1st C. BC–early 1st C. AD. Ivory, H. 9½ in. (24 cm). Museo Nazionale, Naples

42 (right) Plaque from Begram. Andhra, 1st C. AD. Ivory, H. 16½ in. (41 cm). Kabul Museum

A second fine ivory-carving which must be an Andhran product of a slightly later period, probably the first century AD, is a plaque which originally formed a decorative panel on a throne. Along with many other ivory fragments and luxury items, it was discovered in 1937 by a French expedition led by the Hackins in a cache at Begram in Afghanistan. Begram lay on a major trade route to Central Asia which joined the Chinese Silk Road with Indian trade centres and seaports in the Deccan. The plaque shows two bejewelled women standing under a torana of the type we have noted at Bharhut and at Sanchi. We should recall the inscription on the south gate at Sanchi recording that it was created by the ivory-carvers of a near-by town.

42

35

73

South in the Deccan, in an area between the Krishna and the Godavari rivers, the Andhras were also responsible, from the second century BC through the third century AD, for a series of significant Buddhist complexes. Today crumbled brick remains are all one can see at the sites of at least eleven once highly embellished stupas, which included the renowned monuments of Jaggayyapeta, Nagarjunakonda, and Amaravati. Fortunately, many reliefs and a number of sculptures in the round have survived as testimony of the greatest flowering of Andhran sculpture, in what is generally known as the Amaravati School.

Although long abandoned, the stupas at Amaravati, encased by slabs of a distinctive white-green marble, had survived into the early nineteenth century. Then they were all but destroyed by a greedy landowner who saw their ample supply of carved marble as a source for plaster and began reducing it in lime-kilns. A desperate last-minute rescue took place, and most of the surviving sculptures are now in the Madras Museum and in the British Museum in London.

The Great Stupa at Amaravati was the most splendid and the largest of the Andhran stupas in the Deccan. It was begun as a brick-cored shrine at about the time of Christ, but received its final carved facings and railings from about AD 150 to 200. Its representation on numerous
43 reliefs gives an impression of its elaborate qualities. The drum below the dome was 162 feet in diameter, and was encircled at a distance of 15 feet by an outer railing, making a total diameter of 192 feet. As we can see from the panel reproduced, this railing was richly carved both inside and out. Reliefs also covered a projecting base around the drum, the top of which provided a second, higher, level for circumambulation. This upper processional path, embellished with an additional sculpture gallery, stood about 20 feet above the ground and was interrupted at each of the four railing entrances by an offset panel unit surmounted by five lofty columns. The columns in effect take the place of toranas, which were absent.

The earliest Andhran sculptures, which date from the first century BC, are very close to those seen in North India at Bharhut. A good example of their somewhat stiff and angular style is the relief from Jaggayyapeta
44 depicting a Chakravartin (see p. 41).

The mature art of the Amaravati region is one of India's major and distinct styles, considered by many critics to be the finest school of

74

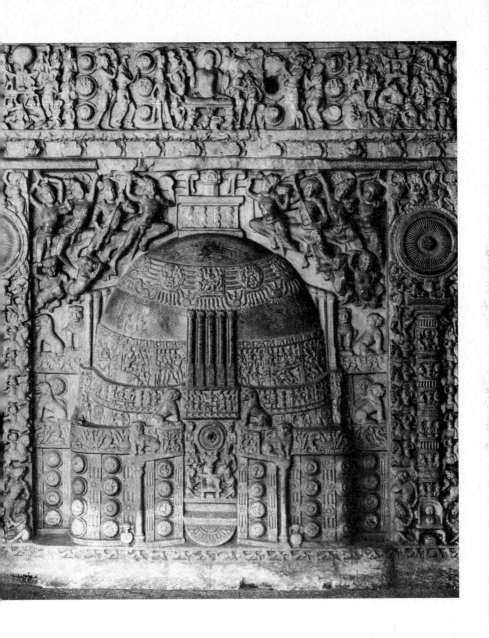

43 The Great Stupa at Amaravati, represented on a slab from its casing. Andhra,
c. AD 150–200. Marble, H. 6 ft 2 in. (1.88 m). Government Museum, Madras

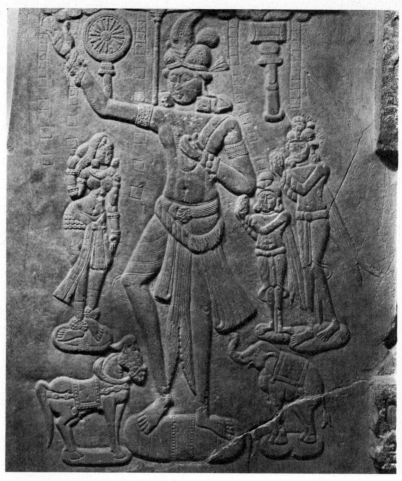

44 *Chakravartin, from the Jaggayyapeta stupa. Andhra, 1st C. BC. Marble, H. 4 ft 3 in. (1.30 m). Government Museum, Madras*

Indian sculpture. Even a non-partisan viewer can easily appreciate the reliefs, peopled by a host of graceful, elongated figures who imbue the sculpted scenes with a sense of life and action that is unique in Indian art. Not only is each figure animated by an internal vitality, but the quality of the surfaces further enhances the action by having a fluid quality reminiscent of water-worn pebbles.

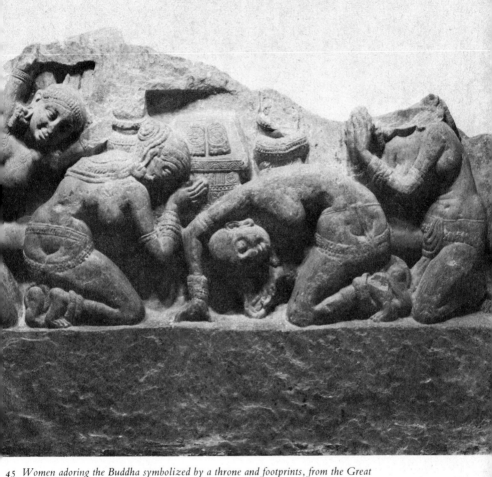

45 *Women adoring the Buddha symbolized by a throne and footprints, from the Great Stupa at Amaravati. Andhra, c. AD 140. Marble, H.16 in. (40.6 cm). Government Museum, Madras*

As in other early Buddhist sculpture, the Buddha's presence is at first only symbolized. A relief of about AD 140 from the Great Stupa shows female devotees paying homage to an empty throne marked with the Lord's footprints. Very shortly afterwards, however, about AD 180–200 – perhaps due to influences from Mathura in the North (pp. 102, 106–9) – the figure of the Buddha suddenly appears at Amaravati.

45

46

46 A roundel from one of the Great Stupa's railings, dating from the beginning of the third century A D, shows the Buddha in human form subduing a maddened elephant which had been sent by his jealous cousin, Devadatta, to attack him. The narrative includes both the enraged elephant's charge, tossing bystanders aside with its trunk, and the scene where it kneels humbly, pacified before the sacred presence of the Buddha. The work is a superb example of the mature Amaravati School: the representation of action is remarkable, as is the organization of space which amply accommodates the story and the wealth of architectural and human detail. The figure of the Buddha indicates cultural and *48* theological influence from the Kushans, who were now the dominant dynasty in Northern India.

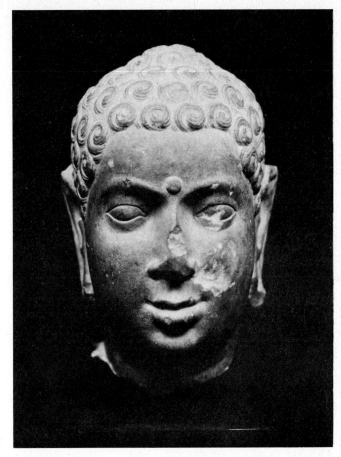

47 Head of the Buddha
from Amaravati.
Andhra, 3rd C. AD.
Marble. Musée Guimet,
Paris

A marble head of the third century AD shows the Amaravati style 47
applied to sculpture in the round. It is a sophisticated production by a
master sculptor; and the slight damage in no way detracts from the sure
and subtle modulation of the flowing sculptural volume and the illusion
of life, both hallmarks of late Andhran art.

With the decline of Andhra power in the Deccan, Brahmanism
would again dominate the South, and the voice of Dharma would only
continue to be heard in a few centres, such as Nagapattinam farther
down the eastern coast. But now our attention must return to the North,
where the Kushans have moved centre stage, and Buddhist religion
and art are undergoing far-reaching changes.

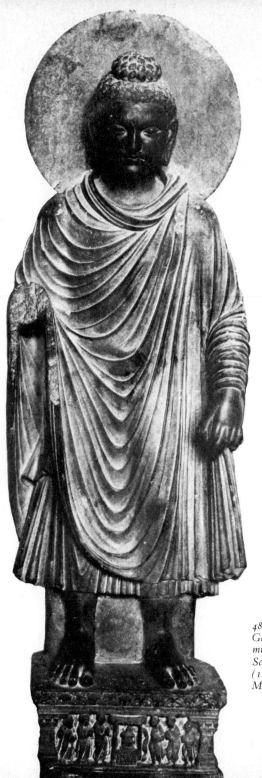

48 *Buddha from
Gandhara. Kushan,
mid-2nd C. AD or later.
Schist, H. 4 ft 7½ in.
(1.40 m). Central
Museum, Lahore*

The Kushan period: Gandhara and Mathura

At the beginning of the Christian era Northern India provided the panoramic backdrop for a series of evolutions in history and art which would modify not only the future culture of India but also that of Greater Asia. Indeed, from an Asian point of view this might be considered the time and place of the 'millennium'. The Buddhist church in Gandhara was beginning a mutation which would ultimately move its simpler monastic form of *Hinayana* ('Little Vehicle') towards a broader and more humanistic faith called the *Mahayana* ('Larger Vehicle'). Within this new Buddhist climate the focus would shift away from the closed community of monks towards an open religious atmosphere with greater participation by the lay community. Devotees in turn would look more and more towards an evolving cosmology of merciful saints (*Bodhisattvas*), who on the threshold of nirvana would hold out their compassionate hands to bridge the gulf between the illusionary world (*maya*) and the eternal bliss of true reality. Central to the new cosmology was the Buddha, who originally was only a revered human being commanding the devotee to work out his own salvation with diligence, but who ultimately became a saviour and a god. The Buddhist church therefore needed an icon, and soon an image of a new deity would be created (see pp. 84–6).

55, 62 67, 68

At this very time Roman trade with Asia was almost at its peak, and the great Silk Road, spanning a quarter of the globe, brought the luxuries of Cathay to the villas of Rome. The bustling trade routes streamed westward from the environs of modern Peking across Western China, through Persia and the Levant to the shores of the Mediterranean. Other connecting routes dropped from the high plateaus of Central Asia down through the towering snow-covered passes of the Himalayas and out on to the hot plains of India to find Roman sail waiting in west

coast ports. As the Parthians became increasingly hostile towards Rome, trade through the Levant was cut off, and the mountain passes of India became the highways for the diverted camel caravans *en route* to the sea.

This elaborate conduit carried commercial currents two ways. Asian silks and spices reached the Western world, and objects of gold, glass, and other prized Roman creations were eagerly imported by the élite of the Orient. Adventurers and artisans also moved along these highways and a desire for profit and new opportunity saw them at work in far exotic lands. If the Andhras were to flourish from this profitable trade in the Deccan, the Yueh-Chi, soon to be known as the Kushans, were to prosper even more in Northern India.

Following their subjugation of Central Asia, the Yueh-Chi settled first in the region of the Oxus river. Then in the second century B C they moved into Bactria and there learned to use a form of the Greek alphabet. In the next century the five Yueh-Chi tribes were unified into one Kushan nation by their leader Kujula Kadphises, and during the early years of the first century A D he led them south across the mountains into Gandhara, where he established his court at Kabul. His son Vima Kadphises, who succeeded him about the middle of the century, was the first Indian ruler to strike coins of gold in imitation of the Roman *denarii* exchanged along the caravan routes, and this very use of gold in coins attests to the prestige and power achieved by the Kushans. Under Vima coins also began to show Indian influence, but it was during the rule of his successor, the great Kanishka, that the most dramatic developments occurred.

The Kushan dynasty reached the summit of its grandeur under King Kanishka. His realm extended from Gandhara and Kashmir south as far as Sanchi and east to Banaras. Peshawar, not far from the Khyber Pass, was Kanishka's capital, and Mathura appears to have been a second capital to the south. The date of Kanishka's accession is unfortunately still in dispute, with speculations ranging generally from A D 78 to 144. The date A D 78 is attractive because it appears to fit the Kushans' dynastic chronology and also marks the beginning year of the important Shaka era. It also coincides with the fourth Buddhist council. This event, which followed the demise of the Buddha by five hundred years, was looked upon as a critical turning-point because the Buddha himself had prophesied that Dharma would endure for only five centuries.

63

50, 65

82

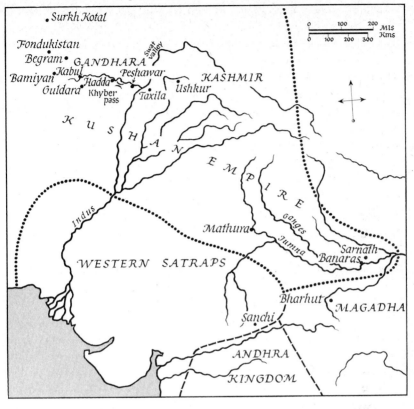

49 *The Kushan empire*

On mounting the Kushan throne, Kanishka found himself the ruler of
a flourishing nation strategically located to control the gates to the rich
network of trade crossing Asia. He not only succeeded in maintaining
control over vital sections of this profitable trade system, but even sent
an envoy to the Emperor Trajan in Rome. Kanishka's coins also vividly
display his desire to live harmoniously with the various peoples and
religions within his domain and beyond it. The elaborate pantheon
struck on the face of his coins illustrates particularly the various religions
practised beyond Gandhara in related regions of foreign trade. The
deities of Persia dominate; the gods of Rome, Alexandria, and the
Hellenized Orient include Herakles, Helios, Serapis, and Victory;
Shiva and Skanda-Kumara represent Brahmanical India.

50

83

The most remarkable image to appear on a gold coin of Kanishka is, however, a standing figure of the Buddha. The image of the Buddha as a god, which here emerges for the first time, is already sophisticated and well developed. Its iconographic features were soon to be found on larger and more complete stone images.

The figure on the coin is dressed in the *sanghati*, or monastic robe. Clearly seen are several of the Buddha's distinctive features, which are among the thirty-two marks of Buddhahood: a halo behind the head; a cranial protuberance (*ushnisha*), representative of super-spiritual knowledge, shown here as a chignon at the top of the skull; and elongated earlobes, extended by the weight of jewels when the Buddha was still Prince Siddhartha. In addition, the body is surrounded by a halo. The monastic robe is worn high in a collar-like roll around the neck. The left hand grasps the hem of the robe, while the right hand appears to be performing *abhaya* mudra, the gesture of benediction. On the right side, between the aureole and the coin's beaded edge, is Kanishka's distinctive monogram. An inscription in Greek characters conclusively identifies the central figure as the Buddha.

A full-length portrait of Kanishka pouring an offering on a fire altar appears on the coin's obverse side. This representation of the king contrasts dramatically with the Buddha image on the reverse: it is more stylized and primitive, but it affirms power and authority. Bearded, wearing a crown and holding a spear, the king stands with his feet splayed outward, in long baggy trousers and heavy soft boots. His long tunic flares to the knees and is gathered at the waist by a belt. This nomadic garb, rather similar to that of the modern gaucho, suggests a foreign origin, such as Parthia. The fire altar is of Persian origin, as are the small flames of regal identity on the king's shoulders. Fire worship was to remain central to the imperial Kushans even after Kanishka became a 'second Ashoka' in his patronage of Buddhism.

The minuscule image on the coin might be compared with a later

stone figure at Lahore. The stone is a blue-grey schist flecked with mica, which is as distinctive a fabric of Gandharan sculpture as Chunar sandstone was of Mauryan creations. The figure is again clothed in a long, flowing, toga-like robe. He stands barefooted on a base carved with six small devotees worshipping a stupa. The generally static style and the illustrative base suggest a date later than the mid-second century AD,

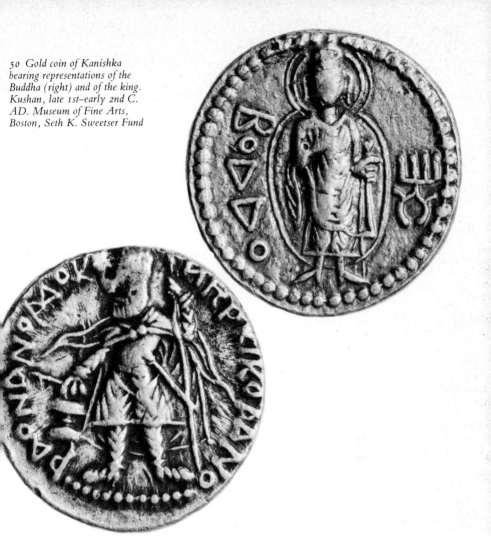

50 Gold coin of Kanishka bearing representations of the Buddha (right) and of the king. Kushan, late 1st–early 2nd C. AD. Museum of Fine Arts, Boston, Seth K. Sweetser Fund

but the chronology of Gandharan sculpture, like the dates of Kanishka, is still uncertain. The figure's left hand holds the hem of his robe, lower than on the coin. The right hand, which was carved separately and attached into a slot on the arm, is missing, but undoubtedly performed the gesture of abhaya mudra. An additional feature seen here is the dot or whorl of hair between the Buddha's eyebrows, representing a third eye of spiritual vision (*urna*).

The realism of the drapery and the body-enveloping robe is un-Indian in concept and execution, though the figure's stance and the flow

of the drapery are already more formalized than in earlier examples. Remembering Gandhara's position on the trade routes brings the realization that Gandharan sculpture, like the imperial Mauryan stone-work, was an art which originated with alien craftsmen. This statue is an Indian product, possibly created by an itinerant provincial Roman sculptor, but it owes its origin to the repertory of a Graeco-Roman style.

When Hellenized stone-carvers from the West were commissioned by the Kushans to produce an icon for a changing Buddhist religion, they naturally drew directly upon their past experiences in providing standing portraits of nobility, fashioned after images of the emperor in Rome. It is known that Roman workshops, especially in Alexandria, maintained reserves of headless stone sculptures which were fitted with portrait heads only when the subjects were known. The Gandharan solution was merely one of practical adaptation and elaboration. First the Persian solar disc, as a halo of deification, was applied, then the unique identifying signs of the Buddha were added and last the hands were positioned into the various symbolic mudras. (A similar process led to the creation of the Christ icon in the West.)

Simultaneously with the appearance of the Buddha icon in Gandhara, Buddha 'portraits' based upon yaksha models began to be created in the southern workshops at Mathura. This fact has led to a scholarly debate which attempted to establish primacy for one or the other of these two centres. Since each of these two Kushan schools soon began influencing the other the exact moment of historical origin quickly became obscured, and the question remains unsettled.

The impact of the provincial Hellenized Roman art style and imagery in Gandhara was exceedingly strong, and sculptures from the area – for instance stone stair-risers displaying sea or river deities, carved in Gandhara during the last part of the first century AD – would not look too much out of place in Rome, or at least in one of the Roman provincial cities on the eastern limits of the empire.

Perhaps one of the loveliest Gandharan sculptures reflecting a Western 51 subject is a figure of Athena or Roma at Lahore. Probably dating from the late second century, it is carved in fine-grained blue-grey schist and shows a young woman wearing a helmet and carrying a spear, now broken. The figure has also been identified as a city or river goddess, and as a foreign female bodyguard for an Indian king.

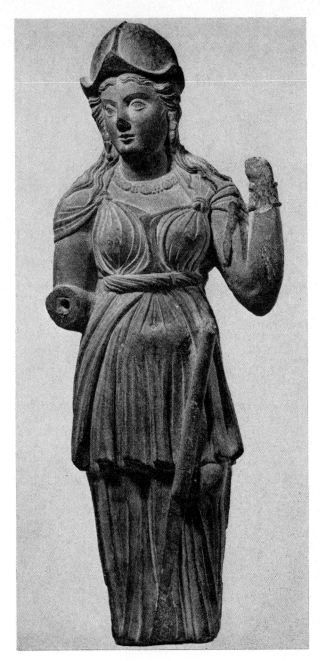

51 Athena or Roma,
from Gandhara.
Kushan, late 2nd C.
AD. Schist, H. $32\frac{3}{4}$ in.
(83 cm). Central
Museum, Lahore

52–54　　A remarkably well-preserved schist relief in Washington depicts the four major events of the Buddha's life. Its excellent condition and craftsmanship and detailed iconography combine to make it a major example of Gandharan sculpture. Of particular interest, beyond the central events portrayed, is the immediate clarity of the individuals and their costumes, which brings the second century AD in Gandhara dramatically alive before the viewer's eyes. The four events, from left to right, are 1. the Buddha's birth in the Lumbini grove; 2. the assault of Mara's host on the Buddha under the Bodhi tree; 3. the first sermon in the Deer Park at Sarnath; and 4. the death of the Buddha.

52　　Central to the birth scene is the figure of Queen Maya, who grasps a tree branch as a miniature haloed Buddha emerges from her side. Her familiar pose can be recognized as that of the yakshi figures on the gates at Sanchi and Bharhut, and it well illustrates how the primitive earth spirits continued to be woven into the fabric of evolving art forms. Equally interesting are the two figures to Queen Maya's right, who represent a Brahmanical presence at the holy miracle. The crowned figure receiving the sacred babe on a cloth is the god Indra, the worshipful holy man with matted hair Brahma. Their attendance and Queen Maya's

33, 34　　shalabhanjika pose (see p. 64) seem to endow the reformed Buddhist church and its new god with the sanctions of ancient tradition.

Two ladies attend the queen on the extreme right. One carries a round box and a fan made of peacock feathers, and a second holds a mirror. All three women are dressed as ladies of rank, and their costumes are especially intriguing in that they appear to reflect a cosmopolitan taste related to the trade routes. Similar attire was worn far to the west by contemporary noblewomen in Palmyra, and the distinctive rolled headpiece is duplicated on Palmyran grave stele portraits carved in the second to third centuries AD.

53　　The next scene of the relief depicts the onslaught of Mara's demons who are attempting to drive the Buddha from beneath the Bodhi tree and from the ultimate enlightenment. Among the demonic hosts the sculptor has clearly recorded a variety of types and individuals from his own day undoubtedly as he saw them on the streets of Peshawar or Taxila. The soldiers with their broad swords and armour, the goitred porter carrying a drum, the camel, a horse – all writhe in an attempt to distract the Buddha from his cosmic mission. Below the Buddha's throne

52, 53 Sections of a frieze from Gandhara showing the birth of the Buddha (above) and the assault of Mara's host. Kushan, 2nd C. AD. Courtesy of the Smithsonian Institution, Freer Gallery of Art, Washington, D.C.

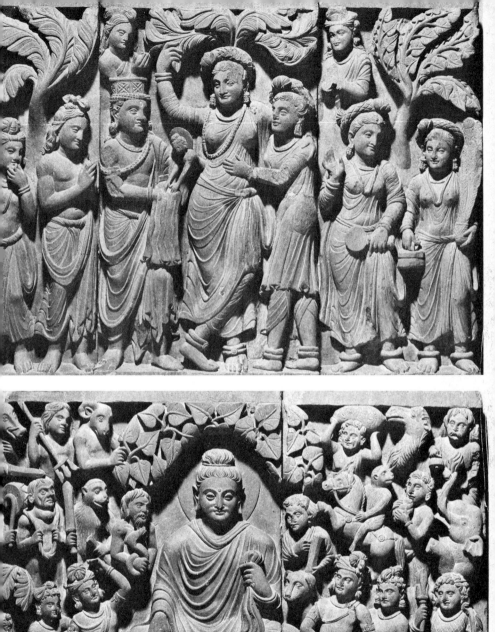

two warriors in armour fall stunned, symbolic of Mara's defeat, which is about to be accomplished when the Lord calls on the earth to witness his right to occupy the Bodhi seat of knowledge. The Buddha's right hand is in the act of reaching down and touching the earth to dismiss the tumultuous throng and restore solitude to his meditations. This hand position of touching the earth (*bhumi sparsha* mudra) is common in Buddhist art from this time forward.

54 The third tableau of the relief shows the Buddha blessing a group of monks and devotees. One can be confident that the scene is a representation of the first sermon because the Buddha's throne depicts the Wheel of the Law flanked by two deer. Of considerable interest in the scene is the moustached and bearded figure at the Buddha's right shoulder, who is identified as Vajrapani, or 'bearer of the thunderbolt'. He is a Bodhisattva (see below) and is the constant attendant of the Buddha in Gandharan art, where he is invariably shown carrying a large bone-shaped thunderbolt.

The last scene of the relief is incomplete, but the central motif of the Buddha's demise is intact. The Lord, as if sleeping, lies dying among lamenting monks and devotees. The diminutive figure stoically seated before the couch is generally interpreted as the Buddha's last convert, the monk Subhadra.

Thus the sculptors of Gandhara supplied the newly emerging faith with a Buddha icon. They also contributed significantly to the development of the Bodhisattva image, another feature of Mahayana Buddhism (see pp. 81, 172). The appearance of these saintly beings seems to have been related, as Rosenfield points out, to the yaksha cults which had been particularly strong in the Gandharan area before the advent of Buddhism. A Bodhisattva is a 'Buddha-to-be', a being capable of enlightenment, who in compassion for mankind delays his entry into the state of Buddhahood in order to minister to others striving for that goal. Before

67 meditating under the Bodhi tree and attaining enlightenment, Siddhartha himself was a Bodhisattva.

55 Such a holy being is seen in the handsome standing figure in St Petersburg, Florida. Unlike the Buddha, who has rejected the world, the Bodhisattva is here embellished with symbols of worldly involvement: long and dressed hair, moustache, elaborate jewellery, sandals on his feet, and rich non-monastic clothing.

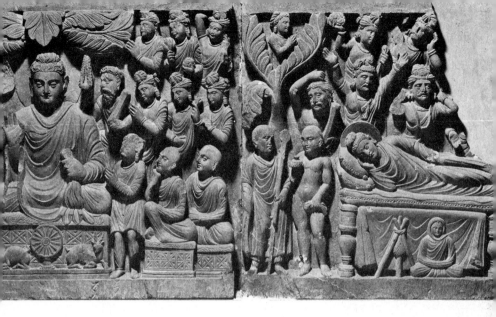

54 Detail of a frieze from Gandhara showing the first sermon in the Deer Park and the death of the Buddha (see ills. 52, 53)

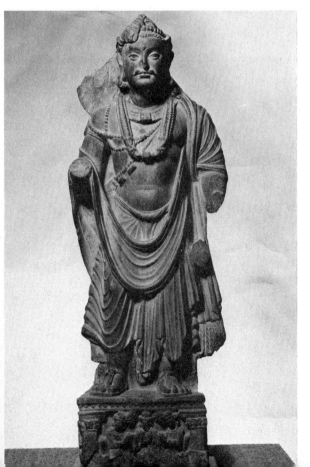

55 Bodhisattva from Gandhara. Kushan, c. AD 150–200. Schist, H. 22 in. (56 cm). Museum of Fine Arts, St Petersburg, Fla.

52 Just as the elegant ladies at the birth of the Buddha were dressed as Kushan nobility, this figure portrays a Kushan prince in all his finery. His damaged halo marks him, however, as a spiritual prince and not a temporal one. The right hand, which was separately carved, is missing: it must have performed the abhaya mudra of benediction. The left hand and the object it held have also been broken off. The nature of these fractures suggests that the figure originally held a globular vial containing

68 the elixir of immortality which is the symbol of the Bodhisattva Maitreya, or the 'Buddha of the Future'. The realistic treatment of the body, the draped cloth, and the illustrative base suggest the figure should be dated in the second half of the second century A D. Obviously such Bodhisattva figures affirm the strength of the merchant lay community, who were more attracted by worldly goods and display than by the austere and humble occupations of monastic life.

The great abundance of Gandharan sculpture is solid testimony of the proliferation of religious buildings under the Kushans. This industry might be explained by a number of factors, but foremost among them are the wealth of the Kushans and Kanishka's royal patronage of the changing Buddhist faith. As Gandhara grew, its importance as a religious region was enhanced by being associated, apocryphally, with events and miracles of the Buddha's previous lives. Monks from the Doab, the actual homeland of Buddha, were attracted north to the cooler centres in Gandhara where they lived comparatively sedentary lives and required more substantial and permanent monasteries. The monasteries and their stupas provided endless galleries for rows of sculptured reliefs and standing figures of Buddhas and Bodhisattvas. The sculptures were invariably stuccoed and painted, and would originally have appeared much more vivid than they do today.

56 A large Gandharan stupa and monastery survive as ruins at Guldara in Afghanistan. The remains of pilasters on the stupa's ground floor and the collar of arches around its drum still convey, even in ruin, a mood of complex opulence. When new, fully decorated with tiers of painted sculptures, such a monument must indeed have been as magnificent as the early Chinese pilgrims reported. We can gain a better idea of its

57 original appearance by comparing it with a small stone sculpture from the Swat valley which suggests how a stupa complete with its sculptural decoration would have looked. The miniature also helps us to understand

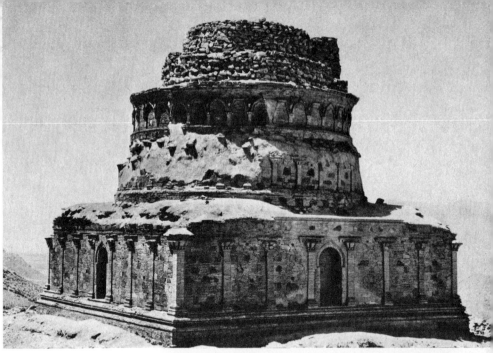

56 Guldara, ruins of a
Gandharan stupa

57 Votive stupa from Loriyan
Tangai, Swat valley, Gandhara.
Kushan. Schist, H. 4 ft 9 in.
(1.45 m). Indian Museum,
Calcutta

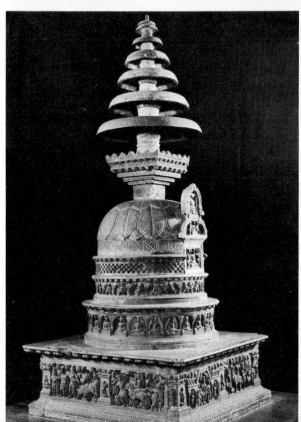

58 'Reliquary of Kanishka' from
Shah-ji-ki-Dheri, Gandhara. Late
Kushan. Bronze, H. 7¾ in. (19.5 cm).
Peshawar Museum

the tremendous production of the Gandharan ateliers and to realize the
great human effort that would have been required to produce all the
sculpture needed for a comparable full-sized stupa.

Of equal interest is the evolution of the stupa form in Gandhara, and
its departure from the type of the lower, hemispherical, domed structure
37 represented by the Great Stupa at Sanchi. The dome grew taller, and
the square railing at its summit was enlarged and elaborated. The most
dramatic change, however, is to be seen in the flowering of the tiered
umbrella unit, which grew until it towered over the entire structure.

The greatest of all Gandharan stupas was that erected by Kanishka at
Shah-ji-ki-Dheri, just outside the gates of modern Peshawar. Rising
from a plinth whose diameter was nearly 300 feet, it reached a height of
over 700 feet and was crowned with a tower of thirteen gilded umbrellas.
Nothing remains today except a few foundation stones, but from the
58 original excavation in 1908 a famous bronze reliquary was recovered.

94

This remarkable cylindrical box, known as the Reliquary of Kanishka, is about 5 inches in diameter and 4 inches high; the three figures on the lid bring the total height to almost 8 inches. An amalgamation of various art styles, the reliquary illustrates the cosmopolitan nature of Kushan culture. It is punched with a dotted Kharoshthi inscription, but this obscures rather than clarifies the identity of its donor and its period. It was first thought to be a reliquary of the great Kanishka himself, installed at the time of the stupa's dedication; but it was found not in the heart of the stupa but to one side, indicating that it was perhaps inserted during one of the numerous restorations carried out in later Kushan times. Since the Great Stupa was associated with a monastery and surrounded by hundreds of other smaller stupas, a later origin seems plausible.

The three figures on the lid of the reliquary represent the seated Buddha flanked by standing figures of Indra and Brahma. The side of the lid, which fits over the box, is decorated with flying geese, which in Buddhism are symbolic of the wandering monks who carry the word of Dharma to distant shores. During the Kushan period geese were also dynastic emblems. (The goose as a symbol is discussed in detail by J. P. Vogel.)

The relief on the face of the lower part of the casket depicts an almost Hellenistic scene with *putti* supporting a serpentine garland on which are seated Buddhas, anthropomorphic sun and moon figures, and a standing Kushan king. The king's costume of heavy boots and long tunic contrasts markedly with the other figures; it is the royal dress already encountered on Kanishka's coins. He is flanked by figures of the sun and moon, which definitely indicate Iranian influence. The seated Buddhas wear a high-necked sanghati with a distinctive 'apron' flap over the crossed legs, a style duplicated on the three-dimensional Buddha on the lid. The apron flap, the rounded facial features, and the arrangements of the hair and ushnishas are closely related to early Gandharan stone reliefs which appear to be contemporary with Kanishka. So are the two standing deities. A small metal disc rimmed with pointed lotus petals was found near the casket and has been interpreted as either a halo or an umbrella. The disc does indeed resemble a nimbus found on several stone Bodhisattvas from Gandhara. Despite its yet unresolved date and its unremarkable craftsmanship, the reliquary remains iconographically one of the most intriguing objects to emerge from Gandhara.

50

59 Reliquary from Bimaran, Gandhara. Kushan. Gold inset with rubies, H. 2¾ in. (7 cm). British Museum, London

59 In striking contrast is an elegant gold repoussé reliquary from Bimaran in Afghanistan. Here a series of figures are contained within an arcade, a Western motif directly adapted from Roman sarcophagi of the first and second centuries A D. Spread-winged eagles fill the triangular spaces between the arches, which have the shape of chaitya windows. Inset rubies alternate with small rosette shapes at the top and bottom. The reliquary provides strong documentation for the origin of the rows of

56, 57 arches on the stupa drums and monastery walls of Gandhara, which provided settings for sculpture. Seen in a museum, far from its place of origin, it might immediately be taken to be a precious object from the European Middle Ages.

These few select objects from Gandhara can only begin to hint at the scope and vitality of the Buddhist church during Kushan times. This high point of activity was a powerful stimulus for propagating the faith beyond Gandhara, and just as Indian monks journeyed to alien shores, foreign devotees were attracted to the 'golden holy land'. The Chinese monks came in great numbers, and to several of them we owe a great debt for their chronicles documenting the early Buddhist periods of Indian history.

By the middle of the third century East–West trade had been seriously interrupted. The Sassanians had overthrown the Parthians in Persia, and then had conquered Peshawar and Taxila, weakening Kushan power. Religious activities were, however, not noticeably disturbed, and Buddhism continued to flourish in Gandhara and beyond. The real disaster came at the end of the fifth century, when the so-called White Huns or Hephthalites from northern Central Asia descended through the mountain passes and ravaged Gandhara. Even then a second school of 'Gandharan' art lingered on in Afghanistan and Kashmir, to produce some of the most provocatively beautiful works associated with the style.

The extreme north-west area of Gandhara extended through the mountain passes and into the valleys of what is now Afghanistan. In this peripheral zone Gandharan-style religion and art continued at least into the eighth century. It was here, also, on the caravan route joining Taxila with Bactria, that one of Buddhism's greatest monastic centres flourished – in the narrow jade-green valley of Bamiyan, hemmed in by towering rock cliffs below the high snows of the Hindu Kush. The monks honeycombed the valley's walls with sacred grottoes, lavishly decorated with stucco sculpture and paintings which show a mixture of 60 provincial styles from both India and Iran.

The grottoes of Bamiyan are remarkable for a number of reasons. The paintings include motifs adapted from Sassanian fabric designs, and what may be the earliest depiction of *Vajrayana* (the esoteric and magical 'Thunderbolt Vehicle' or 'Diamond Vehicle') or Tantric Buddhist concepts (see pp. 171–2).

The most spectacular creations carved from the cliffs at Bamiyan are three colossal standing figures of the Buddha. The largest of these rises majestically to 175 feet in its stone niche at the western end of the valley. 61

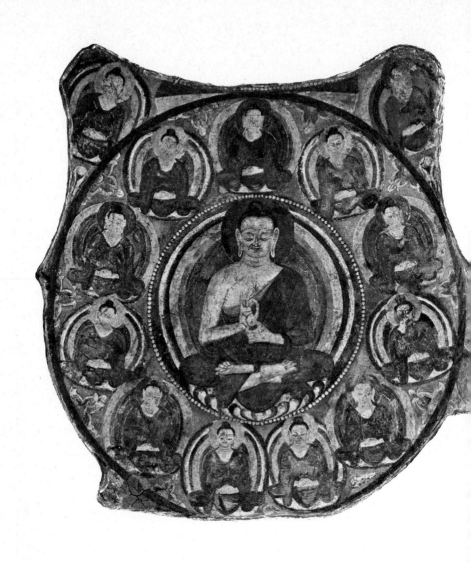

60 *Mandala painting from the dome of a cave-shrine at Bamiyan, Afghanistan, showing the Buddha surrounded by Bodhisattvas. Kushano-Sassanid, 5th–6th C. Paint on clay, D. 36¼ in. (92 cm). Kabul Museum*

61 *(opposite) Bamiyan, Afghanistan, colossal rock-cut Buddha. Kushan, early 5th C. H. 175 ft (53 m)*

Rough-hewn from the rock and finished with lime plaster, the image reflects the Gupta style of the early fifth century. Its details include string-like folds in the sanghati, based upon ropes pegged into the stone and covered with plaster and paint. Above the figure's head, in a trefoil niche, are fragments of painting related to those created in India by Gupta Buddhists at Ajanta.

The second largest image, 120 feet high, closely resembles the Gandharan Buddha figures of the early second century, though it may actually date from a later period. The soffit of its niche also retains a significant fragment of painting depicting the chariot of the Hindu Sun God, Surya, which may indicate not only the solar aspect of the Buddha carved here but also his supreme cosmic nature. In fact, the framing of the colossal central figure between painted celestial beings above and rows of meditating Buddhas below creates a mandala which elevates the Buddha above the status of a mere mortal teacher and strongly suggests, as Rowland notes, the concept of the universal Buddha, characteristic of the esoteric sects of Buddhism.

After the eighth century the grottoes were empty and the valley quiet. Later, with the advent of Islam in Central Asia, these huge icons, offensive to Muslim eyes, became targets, first for Mongol arrows and later for Mughal cannon. Even so, their colossal ruins have survived as mute testimony to the energy and creativity of the early Buddhist church in Afghanistan.

Probably because North India and Afghanistan had maintained trade contacts with Alexandria, where gypsum was widely used in sculpture as a substitute for costly marble, plaster had been used in all periods of Gandharan art, both independently and in association with stone sculpture. Many of the surviving examples of plaster sculpture were found in Afghanistan. The Afghan heads are especially notable for their fluid spontaneity and sensitive interpretation of reality. The prolific use of stucco for architectural ornament in Afghanistan may however have been due to strong Sassanian influence, from the mid-third century to the advent of the White Huns at the end of the fifth century.

Hadda in Afghanistan, at the western end of the Khyber Pass, was the site of the ancient sanctuary which held the relic of the Buddha's skull, and was noted for its beautiful stucco sculptures. Farther west, at Fondukistan, there was a monastery complex elaborately decorated

62 *Bodhisattva from Fondukistan (detail). Late Gandhara style, probably 7th C. Painted terracotta, H. of seated figure 28¾ in. (72 cm). Musée Guimet, Paris*

with brightly painted niches containing assemblies of terracotta figures 62 whose poses and graceful hand gestures constitute a 'mannerist' style of exaggerated elegance. Similar works were created in the sixth or seventh centuries far to the east in the mountains of Kashmir, at Ushkur (described by Charles Fabri), and the style moved to China along the trade routes to reach an artistic climax at the great oasis of Tun-Huang.

In Afghanistan late in the first century Kanishka had a remarkable shrine erected at Surkh Kotal. It is of immense interest because it has a parallel in another Kushan shrine 2,000 miles to the south, on the plains at Mathura.

At Surkh Kotal a complete hill has been transformed into a giant fire altar. Five terraces display a number of shrines, which include the fire altar, a fire temple, a temple of Ahura Mazda in Parthian style, and, particularly interesting, dynastic cult images of the Kushan rulers in the guise of or in association with Mithraic deities. Such a dynastic sanctuary, joined with the fire worship, shows a strong Parthian influence which undoubtedly grew out of the early Kushan experience when they, as the Yueh-Chi, confronted Persian civilization in Bactria in the first century BC. A parallel example of a regal shrine is the Commagene memorial of Antiochus I, far to the west in Anatolia, at Nimrud Dagh, where in the first century BC Antiochus had colossal images of himself and his gods carved and assembled on the top of a mountain.

Surkh Kotal, according to several variously interpreted Greek inscriptions found on the site, appears to have been founded during the reign of Kanishka, and repaired and extended at the time of Huvishka in the late second century. It cannot be determined exactly when the royal portrait statues, now badly mutilated, were first installed. Their fragments, carved from a yellowish limestone, show that they were conceived with a strong frontality and are related to the splay-footed pose of the statue of Kanishka at Mathura and the portrait figures on Kushan coins. In any case this distinctive dynastic style is autonomous, more strongly linked to Parthian portrait sculpture than to Gandharan or Mathuran iconography.

Mathura, 85 miles south of Delhi on the Jumna river, was a religious centre before the arrival of the Kushans. The Jains appeared early, and their activity continued alongside that of the Buddhists in the Kushan and Gupta periods. Later Mathura was also to be intimately associated with the Lord Krishna of the Hindus. Some scholars believe that the Mathuran workshops, schooled in the production of Jain art, created a Buddha icon at least as early as did Gandhara (see pp. 84–6). Certainly in Kushan times contact between the two centres resulted in the exchange and adaptation of iconographic subtleties.

The ruined site of Mat, a Kushan dynastic shrine near Mathura, is a southern parallel to Surkh Kotal. Here at Mat – or Tokri Tila as it is called by the local villagers, who have through the centuries robbed it of building materials – stood a sanctuary consisting of stone figures of Kushan rulers and deities on a brick-paved plinth. The plinth, originally

100 by 59 feet, held a circular sanctum towards its north-west end which echoes the design of Mauryan rock-cut shrines in the Barabar Hills. Nothing remains today but a sunlit wasteland of tangled underbrush and the sounds of crickets, but the mutilated sculptures retrieved there provide the Mathura Museum with some of its prize possessions. Like others originating at Mathura, they are carved from Sikri sandstone, which is red mottled with cream spots, and is unique to the area.

Mat's two most intriguing pieces are fragmentary portraits of an enthroned King Vima Kadphises and a standing King Kanishka. The 63, 65 huge Vima Kadphises (even now 6 feet 10 inches high) is headless, shattered across the knees, and completely fractured through the waist. Vividly intact, however, is the regal presence, which is emphasized by an impatient left arm angled to the waist and a right arm posed to the upper chest. The high, heavy boots and long tunic unmistakably mark the figure as Kushan. Such details as the alert lions flanking the throne and the elevated foot-rest contribute to the image's royal authority.

63 Enthroned figure of King Vima Kadphises from the dynastic shrine of Mat (Tokri Tila), Mathura. Kushan, late 1st–early 2nd C. AD. Red Sikri sandstone, H. 6 ft 10 in. (2.08 m). Archaeological Museum, Mathura

The distinctive red sandstone has been carved with a direct simplicity that imbues the figure with a primitive vigour which is the constant characteristic of Mathuran sculpture. One feels, however, that the artist has created, or perhaps copied, an unfamiliar icon: this is most obvious in the treatment of the heavy clothing, seemingly alien to a sculptor raised under the warm Indian sun.

65 These stylistic characteristics are also present in the towering and also headless figure of Kanishka. The King's arms are lost but the broken hands remain positioned on the waist, aggressively holding a sword and massive club. The long coat falls stiffly from the waist and spreads almost to the ankles. There thickly padded boots emerge, splayed outward, on a plinth upon which rests Kanishka's heavy club, ending in a makara (p. 65). The rippling folds across the front of the inner tunic are a completely stylized motif which reveals that the sculptor misunderstood the problem; or perhaps the solution was not included in his carving repertoire. Across the lower area, composed of the tunic and coat flaps, is carved a Kharoshthi inscription reading 'the great King, the King of Kings, the Son of God, Kanishka'.

Many other regal Kushan figures are known to have originated in and around Mathura. A second Kushan dynastic shrine, Gokarneshvara, on the northern limits of the city, has yielded sculptures that include a beautiful torso of a Kushan prince. Another site, Kankali Tila, which has been identified as the location of a great Jain stupa during Kushan times, was the source of a number of inscriptions as well as of an important 64 image of a squatting figure in buff sandstone. The sculpture shows a moustached figure dressed in Scythian costume which includes a long tunic and a rolled head-dress. He grasps a short sword attached to his belt and holds a small baton-like object (lotus bud?) against his right shoulder. A heavy necklace and high boots complete his costume, and he has a *tika* dot on his forehead. The figure was formerly considered to be a portrait of a Kushan prince, but Rosenfield has now identified it as an extremely early votive icon of a Brahmanic deity with Vedic origins, the Sun God Surya. There is indeed a small fire altar, carved in shallow relief on the plinth of the sculpture, and the flanking figures of horses are associated with the god's celestial chariot. The figure originally had a halo, which is now damaged. Considering the importance of fire and of the Mithraic ritual at Surkh Kotal, the depiction of a solar deity in

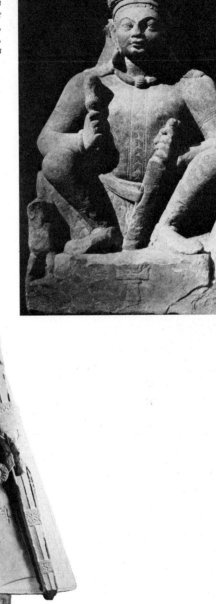

64 (right) Squatting figure of Surya from Kankali Tila, Mathura. Kushan, late 1st–early 2nd C. AD. Buff Sikri sandstone, H. 24 in. (61 cm). Archaeological Museum, Mathura

65 Standing figure of King Kanishka from the dynastic shrine of Mat (Tokri Tila), Mathura. Kushan, late 1st–early 2nd C. AD. Sikri sandstone, H. 5 ft 7¼ in. (1.70 m). Archaeological Museum, Mathura

the guise of a Kushan prince can hardly be doubted. Indeed, it seems that a duality was deliberately intended. The message is clear: a solar deity is a Kushan prince, and a Kushan prince is the same as a deity. It is interesting to note that the later Hindu *Puranas* describe Surya as being dressed like a 'northerner' and explain his strange un-Indian boots by a myth which blames their presence on the malpractice of Vishvakarma, the Hindu artificer of the gods, who did not finish making the god's legs.

66 Buddhist sculpture of the Kushan period from Mathura includes many standing yakshi figures, such as we have already encountered on railings and gates of early Shunga and Andhra monuments. At first glance these second-century yakshis appear to match those at Bharhut. On closer observation, however, they seem more vivacious and Amazonian in nature, and their smooth, inflated voluptuousness gives them buoyancy and life. They seem about to spring from the backs of their supporting dwarfs and away from the vertical stone railing posts which back them. They, too, have the monumental frontality which is characteristic of Mathuran sculpture.

Nagas (anthropomorphic serpent figures) and yakshas abound at Mathura, and they too assert their ancient ancestry and their direct descent from Shunga originals. Now, however, the yaksha figure was to be transformed to serve Buddhism as the Bodhisattva icon, and the great number of them found at Mathura suggests a local cult.

68 A particularly clear example of the transformation of a fertility spirit into a compassionate Buddhist saviour is a mid-second-century statue which is perhaps the earliest known representation of the Bodhisattva Maitreya. The figure is still basically a yaksha, but a number of specific details have been added that cast it in the role of a Bodhisattva. Immediately noticeable is the typical large nimbus with its sun rays, stylized into a continuing scallop motif around the edge. The right hand is held in the abhaya mudra of benediction, while the left holds the water-flask symbolic of the Buddha of the Future. A disc symbolic of Dharma appears on the palm of the right hand. The halo and stylized curls show how Gandharan features were transferred south to Central India. Completely frontal, the tense body and the expressive face again combine to convey a sense of suspended action which is recognized as one of the virtues of Mathuran sculpture.

66 Railing pillars with standing yakshis from Kankali Tila, Mathura. Kushan, 2nd C. AD. Sikri sandstone, H. 4 ft 2¾ in. (1.29 m). Indian Museum, Calcutta

Another related example of a Mathuran Bodhisattva from Sarnath is *67* inscribed as having been dedicated by one Friar Bala in the third year of King Kanishka's reign. The stance is the same as in the image of Maitreya; here, however, a lion stands between the feet and indicates that the figure is Shakyamuni, 'the lion of the Shakya clan', who preached his first sermon ('the lion's roar') at Sarnath. Fragments of a ten-foot stone umbrella, which originally surmounted the saint, have also been

found, and they bear various ancient Indian symbols which, together with the royal and solar symbolism, proclaim the Bodhisattva as a Universal Lord. This mutilated image is interesting not only for its size (8 feet 1½ inches high) and iconography, but also for the fact that it was found at Sarnath. It is known that images from Mathuran workshops were exported throughout the Doab, but at holy Sarnath a special artistic tie with Mathura was established during the Kushan period, and was to continue on into Gupta times. Mathuran icons were imported to Sarnath; and the Mathuran styles were copied in the local cream-coloured Chunar sandstone.

69 With a seated figure of the Buddha of the mid-second century we come to what must be considered the masterpiece of Kushan sculpture at Mathura. Carved from the local red sandstone, the figure is seated on a lion throne and carries an inscription which erroneously identifies it as a Bodhisattva. It was found in the Katra mound at Mathura and is an excellent early example of an entirely Indian Buddha. Unlike

48 the majority of static Roman-influenced Buddhas of Gandhara, wrapped in their toga-like sanghatis, this Buddha of a warmer clime is dressed as a true Indian, in a transparent muslin garment that covers only one

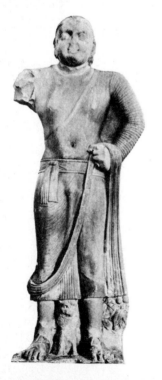

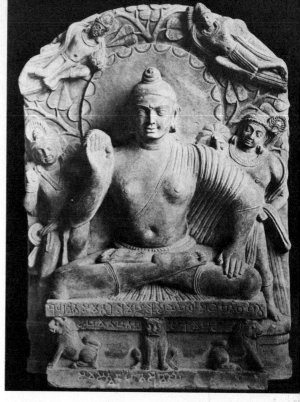

67 (opposite, left) Figure of the Bodhisattva Shakyamuni from Mathura, presented to the shrine at Sarnath by Friar Bala. Kushan, AD 131 or 147. Sikri sandstone, H. 8 ft 1½ in. (2.47 m). Archaeological Museum, Sarnath

68 (opposite, right) The Bodhisattva Maitreya, from Mathura. Kushan, 2nd–3rd C. AD. Sikri sandstone. Archaeological Museum, Mathura

69 The Buddha seated on a lion throne, from the Katra mound, Mathura. Kushan, c. AD 130. Sikri sandstone, H. 27¼ in. (69 cm). Archaeological Museum, Mathura

shoulder and gathers in small ringed folds along the upper left arm. This rendering of gathered, transparent textiles, which was also apparent on the two Bodhisattva figures, is a distinctive Mathuran feature.

Seated as a yogi, on a lion throne under the Bodhi tree, the Buddha is backed by a large scalloped halo and attended by heavenly beings and fly-whisk-bearers. His aggressively performed abhaya mudra and the alert angled arm, resting on his left knee, lend an air of activity to a creation which has no parallel in Gandharan art. Wheels symbolic of Dharma are displayed on the right palm and on the two exposed feet. Of particular interest is the primitive form of the ushnisha, or cranial protuberance, which has not yet been modified by Gandharan influence and protrudes as a single massed whorl of hair.

The third century was to be a time of great upheavals in Central India, which would result in the fall of the Andhras in the Deccan and a drastic weakening of the Kushans. The Kushan art style at Mathura, however, survived, and its qualities ultimately led to the supreme development of the Buddha icon in the Gupta period.

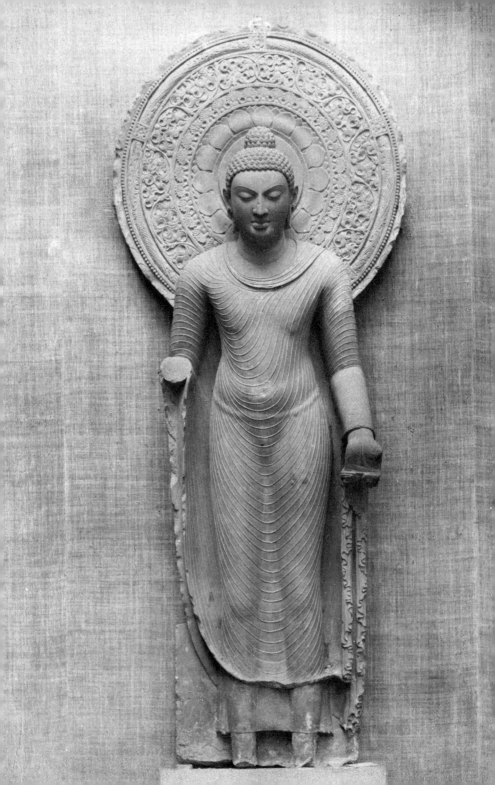

The Gupta and Post-Gupta periods

About AD 320 a powerful new empire, the Gupta, emerged in Bihar. Arising from obscure and possibly non-royal origins, the Guptas eventually dominated all of North Central India and gave their name to the 'Classic' period of Indian art. Consciously emulating the ancient Mauryan empire, they established their capital at Pataliputra, where they grew in power and importance until they, along with the remnants of Kushan culture, were finally crushed by the invasion of the White Huns in the last years of the fifth century. The Gupta period, while it lasted, was one of cultured opulence resulting in an outpouring of science, visual art, music, and literature. The zenith was reached during the reign of Chandra Gupta II (AD 375–415) and its jewel was the great Sanskrit writer Kalidasa. It was also during this period that some of India's earliest surviving examples of painting were created, on the walls of the Buddhist caves at Ajanta in the Deccan. 71

The justly renowned Gupta sculptural style appears to have grown out of the Kushan style, which survived at Mathura (see pp. 108–9). By the end of the fourth century or the beginning of the fifth a distinctive icon had been created, and it is well represented by a red sandstone figure of a standing Buddha with an immense, decorated halo, now in New Delhi. Many refinements are apparent here, but especially important are the monumental simplicity and the refined realism of the figure. The tension which activated earlier Mathuran sculptures has now given way to a mood of calm and inner tranquillity, a spiritual other worldliness which is the hallmark of the Gupta Buddhist style. The sanghati clings so close to the body that it all but disappears and is defined only by a series of string-like folds. The sole remnant of Kushan animation is perhaps the subtle cascade of folds dropping from the figure's left hand. The missing right hand undoubtedly performed the 70

III

70 *Standing Buddha from Mathura. Gupta, late 4th–early 5th C. Red sandstone, H. 7 ft 1⅜ in. (2.17 m). National Museum, New Delhi*

serene abhaya mudra of reassurance. The head and ushnisha are now completely covered with the snail-curl motif, and the heavy eyelids direct the subject's energies inward, away from the mundane world. In contrast to the stylized simplicity of the figure, a huge nimbus envelops the head with a complex riot of patterns. A circle of lotus petals forms the immediate backdrop for the head, and the petals are ringed by a row of palmette motifs recalling decorations found on the Mauryan *16* capitals of Ashoka. Beyond is a wide band of lotus buds and foliage along with a narrow twisted ring of jewels (?), carved next to the outer rim which is patterned with flattened scallops. This last simple motif, seen *68* on earlier Mathuran haloes, is here in the process of being expelled completely from the solar disc.

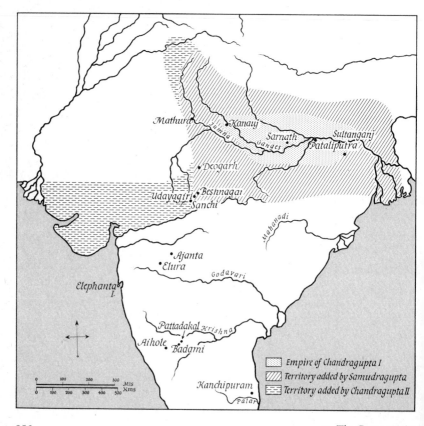

71 The Gupta empire

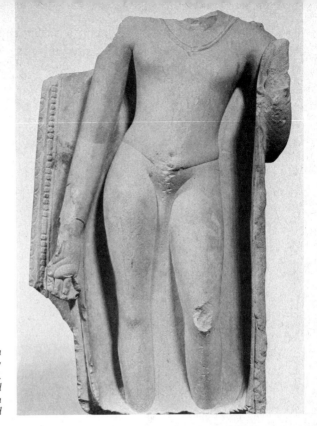

72 Torso of a standing Buddha from Sarnath. Gupta, probably 5th C. Chunar sandstone, H. 30 in. (76 cm). The Cleveland Museum of Art, Purchase from the J. H. Wade Fund

The Mathura-Gupta style was refined and perfected at Sarnath, where a great concentration of Buddhist sculptures has been unearthed. One unique group is known as the 'wet Buddhas', because 72 the figures look as if they had been immersed in water. The Mathuran string fold motif is omitted, and the sheer muslin sanghati appears to cling to the body and reveal its basic forms. The headless 'wet Buddha' now at Cleveland displays a webbing between the fingers which is another distinguishing characteristic of Gupta sculpture.

The sublime example of Gupta sculpture created at Sarnath is a fifth- 73 century figure of the seated Buddha preaching the Law, carved of Chunar sandstone. It typifies the essence of Gupta art, where a sophisticated balance was achieved between refined simplicity and the Indian love of decoration. This image affected all subsequent schools of Buddhist art within and beyond India, and also had a significant and lasting effect on Brahmanical art.

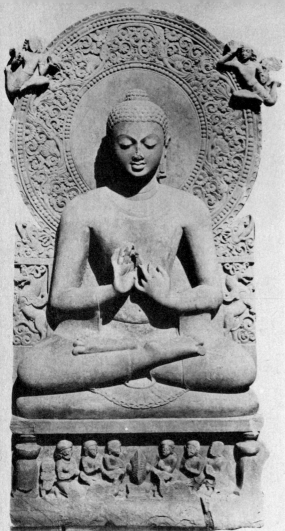

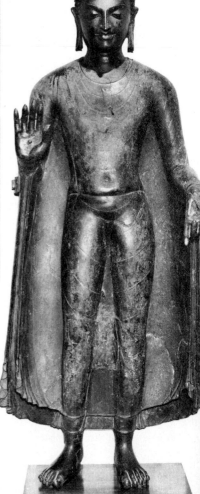

73 *The Buddha preaching the Law,*
from Sarnath. Gupta, 5th C. Chunar
sandstone, H. 5 ft 3 in. (1.60 m).
Archaeological Museum, Sarnath

74 *Standing Buddha from*
Sultanganj, Bihar. Gupta, c. 500.
Copper, H. 7 ft 6 in. (2.25 m).
City Museum and Art Gallery,
Birmingham

Backed by a huge decorated halo, the Buddha is seated as a yogi on a 73
throne and performs the Dharma Chakra mudra. His sanghati is only
subtly indicated by the hemlines at the neck, wrists, and ankles. Across
the central front edge of the cushion a mass of folds splays outward as a
lunette design, echoing the textures on the halo above. Two heavenly
beings fly in at the top of the halo, celebrating the miracle of the first
sermon at Sarnath, while on the throne's plinth six devotees pay homage
to a central wheel which is flanked by two deer, indicating that the
setting is the Deer Park. At the Buddha's sides two rampant leogryphs
define the back of the throne and symbolize, as they did on the lion
capital of Ashoka, the regal roar and authority of the Buddha's message. 16

Gupta art was produced in great quantities in a wide area across North
Central India. However, from the end of the fifth century on, at first
under the onslaught of the Huns, and later with the advent of Islam,
many of the products of Gupta art, both Buddhist and Hindu, were
destroyed. Today, happily, lost items of Gupta art continue to be un-
covered, and these recoveries expand our knowledge of the period's
rich diversity.

A remarkable piece of Gupta metal-casting, found at the end of the 74
last century at Sultanganj in Bihar, is a Buddha nearly 8 feet high, now
in Birmingham. Modelled closely on the Sarnath Buddhas, it is com-
pletely intact except for the lack of a nimbus. The sanghati folds are
concentrated at the extreme edges of the garment, except for a series of
widely spaced, stylized lines which are inscribed across the torso, arms,
and legs of the almost wet-looking figure. These elements, as well as
the slightly heavy features of the face, may indicate a date late in the
fifth or in the early sixth century.

Another metal figure of the Buddha, this time smaller and in bronze, 75
is in Kansas City. Its halo is dramatically large and drawn into rays that
terminate in small round balls. The figure was found in Uttar Pradesh,
but the fuller, more realistic folds of the sanghati suggest a connection
with bronzes from Gandhara.

A group of small ivory images of Buddhas and Bodhisattvas, believed
to have come from the Kashmir area, where they had survived in
mountain monasteries, are prime examples of late Gupta art from about
the eighth century. A sculpture now in Bombay depicts a Buddha
seated in a characteristic Kashmiri trefoil arch and surrounded by various

attending figures. The hands are held in the *dhyana* mudra of meditation and the sanghati covering the whole body gathers into a collar fold at the neck. This feature connects it with earlier Gandharan work and also anticipates later Nepalese icons.

Thus far we have concentrated on the religious and artistic developments of Buddhism; but at the same time Vedic Brahmanism had also been evolving its various icons. Now in the Gupta period Hindu art at last emerged into prominence, as Dharma began to wane in the country of its birth.

We have seen that during the Kushan period sculptures of Hindu subjects – notably of the Sun God Surya and of Vishnu, strongly associated in the Vedic tradition with the sun – were already being produced at Mathura and elsewhere (p. 104). During the Gupta period we find a major group of Brahmanical sculptures dealing with the various aspects of Vishnu.

The first and most dramatic examples of Gupta Hindu art date from AD 401–2 and are in the rock-cut shrine at Udayagiri, near Bhopal in Central India, dedicated in the reign of Chandra Gupta II. The relief to

64

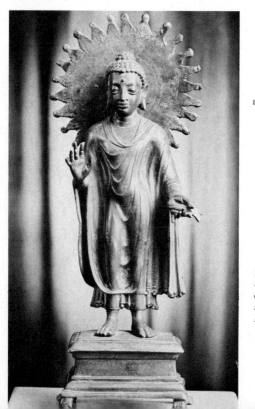

76, 77 (opposite) Udayagiri, Chandra Gupta II cave. Gupta, 401–2. Left: Vishnu as the Cosmic Boar, H. 12 ft 8 in. (3.86 m). Right: standing figure of Vishnu with personifications of his attributes

75 Standing Buddha from Banda District, Uttar Pradesh. Gupta, c. 400. Bronze, H. 14¾ in. (37 cm). Nelson Gallery-Atkins Museum, Kansas City, Mo. (Nelson Fund)

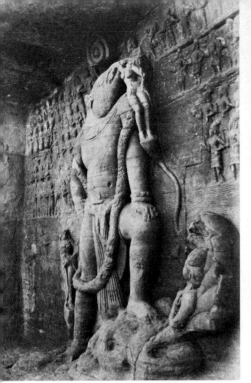

the left of the centre, carved in the living rock, is over 12 feet high. It 76
features the incarnation of Vishnu as the Cosmic Boar, Varaha, which is
his third descent (*avatara*) or manifestation as a cosmic saviour. According
to Brahmanical mythology, the creation resulted from a churning of the
milk-sea ocean (eternity) by the gods and the demons who were attempt-
ing to acquire the elixir of immortality. As the eternal sea was churned,
various auspicious objects appeared. Among these was the earth,
symbolized by a beautiful goddess. She was immediately drawn down
into the sea by the serpent power in the depths. Vishnu instantly assumed
his aspect as Varaha, rescued the goddess, and crushed the coils of the
multi-hooded serpent king under his foot. The Udayagiri relief shows
the climax when Vishnu, as a garlanded boar-headed giant, gently lifts
the goddess up to an awaiting assembly of gods and sages.

To the right of this relief is an entrance to a shrine carved more deeply
into the solid rock. Its door is flanked by two reliefs of guardian figures,
and beyond are several other relief panels. Next to the guardian on the
right is a figure of Vishnu standing in an alert frontal pose. The god 77

wears a *dhoti* (a male skirt or loin-cloth) and a jewelled crown, and his four braceleted arms hold a large garland which encircles his figure from shoulders to knees. A shrivasta jewel, the identifying symbol of Vishnu, hangs from a large heavy necklace at the centre of his chest. The upper right hand is mutilated, but it probably performed the boon-dispensing gesture (*varada* mudra). The upper left hand, also damaged, appears to hold the remnants of a conch shell to the figure's waist, an iconographic gesture inherited from Kushan sculpture. One of the most interesting aspects of the sculpture, however, is the anthropomorphic representation of Vishnu's two lower attributes or symbols. His lower right arm grasps the head of a vertical mace fronted by its small female personification, and the lower left hand touches the upper rim of the disc or wheel, whose male symbol stands before it. This Gupta icon has not yet developed very far beyond the style of its Kushan model, but the outstretched arms and personified attributes hint at a new style and symbolism which were to develop during future centuries (see pp. 174–6).

Another combination of tradition and innovation occurs at Udayagiri in the female figures that flank the upper lintel of the doorway. They are developments of the yakshi, now transformed from tree spirit into river deity. The transformation can be more clearly seen in a figure from the doorway of a Gupta temple at Beshnagar, near by. She stands upon a beast that is part crocodile and part elephant, the makara, symbolic of life-sustaining water. Woman and makara together represent the sacred river Ganges. The goddess, portrayed more realistically than the Kushan yakshis, stands voluptuously in the classic *tribhanga* or three-body-bends pose, and she is adored by a small figure to her right. A second small figure below is subduing the rampant makara. At Beshnagar a similar stone on the opposite side of the lintel would have been carved with a goddess standing on a tortoise, representing the sacred river Jumna. On later Medieval Hindu temples such river-goddess figures, enlarged and placed at ground-level, stand flanking the portal to the sanctuary.

Paramount among Hindu sculptures of the Gupta period are the reliefs on the exterior walls of the ruined Dashavatara Temple at Deogarh, about seventy miles south of Jhansi in Central India. This is one of the earliest known Gupta temples in the North Indian style (*Nagara*), dating from about 425. Among the three deep-set relief panels which decorate

121, 131

78 The river goddess Ganga standing on a makara, from the lintel of a temple at Beshnagar. Gupta, c. 500. Sandstone, H. 29⅞ in. (76 cm). Museum of Fine Arts, Boston, Charles Amos Cummings Bequest

79 Deogarh, Dashavatara Vishnu Temple, relief on the south wall showing Vishnu Anantasayin. Gupta, c. 425

the walls of the square shrine is a scene depicting Vishnu *Anantasayin.*
Here in an expanded manner the Buddhist sculpture style of Sarnath is
adapted to a Hindu motif. The Lord of Preservation, Vishnu, is shown
asleep on the coils of the giant multi-headed serpent, Ananta, who drifts
endlessly on the eternal sea of milk. As the lord sleeps, he dreams the
cosmos into reality by experiencing the 'nightmare' of maya where all
beings take on their temporal forms. Normally such an iconographic
presentation would show a lotus plant blooming from Vishnu's navel,
with in its centre Brahma, the four-headed Hindu god of creation.
Here Brahma is depicted separately above, seated on a lotus blossom
and accompanied in the upper register of the relief by other deities
including Indra and Shiva. Lakshmi, as a dutiful Hindu wife, massages
her sleeping consort's legs. The panel's composition is completed at the
bottom by a row of six figures which again include the personifications
of Vishnu's symbols and two armed demons. Originally all the reliefs
and the entrance to the shrine stood behind open porticoes. Around the
base of the entire structure ran a series of reliefs depicting events from the
Vaishnava epic poem, the *Ramayana.*

AJANTA

It is the Gupta period which provides us with some of the earliest sur-
viving examples of Indian painting, found in various stages of preserva-
tion on the walls of Buddhist rock-cut sanctuaries in the north-west
Deccan. The greatest number and the best preserved are located in
the complex of twenty-nine chaitya and vihara caves (see pp. 51 ff.) at
Ajanta.

The first Buddhist chisels probably echoed across Ajanta's horseshoe-
shaped ravine some time in the second century BC, but by the seventh
century AD they were heard no more and Buddhism was waning in
India. Abandoned, the empty stone chambers became overgrown and
lost. Then in 1817 several scarlet-coated soldiers, hunting tiger, were
led by a half-wild boy into the ravine and up to the cliff's wall. Pulling
away branches, they were confronted by a gigantic Buddha gesturing a
peaceful benediction from the elaborate stone wall pierced by a darkened
doorway. When the soldiers passed through this door the art of Ajanta
returned to the world of men.

The early investigators of the site assigned numbers to the caves
81 according to their sequence along the ravine's wall: obviously these
numbers have no connection with their order of creation. In fact, Cave
10, a chaitya hall, is believed to be the earliest chamber, since an inscription
appears to date it to the first half of the second century B C. It also con-
tains fragments of the oldest known examples of Indian wall-paintings.
Unfortunately, most of the painted surfaces are too fragmented to be
telling, but in one passage the patterns are complete enough to present us
80 with a royal scene from about the first century B C. A handsome raja and
his retinue (left) approach a garlanded tree (centre), where they are met
by a group of musicians and dancers (right). One is immediately struck
by the easy realism of the scene, a realism even more remarkable when
contrasted with the formalized sculptures at Bharhut, with which the
painting is very nearly contemporary. Each head here has a distinct
personality, and the moustached raja is especially remarkable, not only
for his good looks, but also for his stylish and elaborate hair bun bedecked
with jewels. At the right, two musicians near the sacred tree on the top
row hold long-stemmed trumpets, while below are two dançers with
exuberant gestures and expressive eyes. The general format of these

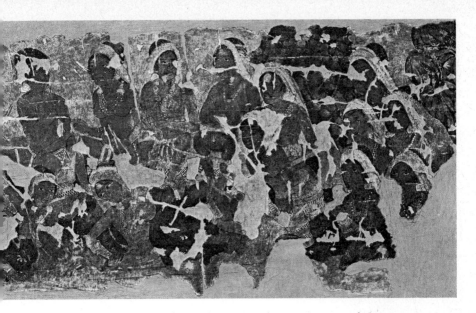

80 Ajanta, Cave 10, wall-painting of a raja, his retinue and musicians at a sacred tree. Shunga, probably 1st C. BC.

first paintings appears to indicate that they formed a continuous narration, within a narrow ribbon-like band along the wall, reminiscent of Chinese scroll-paintings.

Later paintings at Ajanta expanded in all directions to cover the whole surface of the wall, but the continuous narrative concept was retained and the resulting complexity immediately imbues the paintings of Ajanta with a crowded, throbbing vitality. The sequence is only interrupted occasionally by an architectural structure or a series of strange 'cubistic' forms which provide barriers between separate actions and even function occasionally as props for random figures. It is clear that the paintings in Cave 10, though they are the earliest examples of Indian painting that we know, had been preceded by an extended tradition, and considering the excellence of this lone example, that tradition's loss can only be lamented.

In Cave 1, a late fifth-century vihara, we see Gupta architecture *82* wrought from solid stone. The cave is also a virtual museum of Buddhist art. During the fifth century the function of the vihara was extended beyond its basic purpose of quartering and feeding the monks to make it also a place of worship. Here a cell in the back wall forms a shrine and

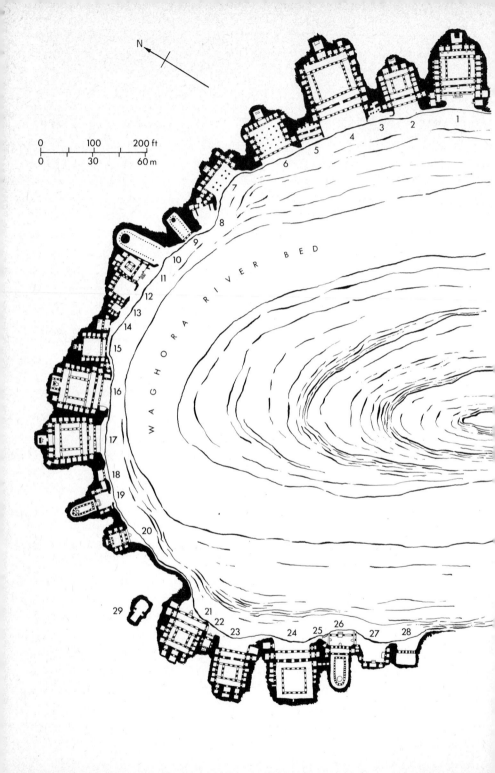

N

0 100 200 ft
0 30 60 m

1
2
3
4
5
6
7
8
9
10
11
12
13
14
15
16
17
18
19
20
21
22
23
24
25
26
27
28
29

W A G H O R A R I V E R B E D

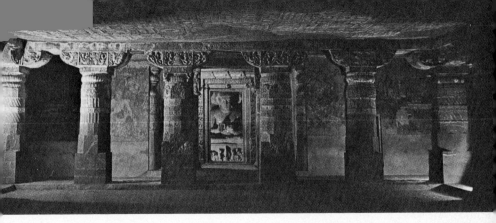

81 (opposite) Ajanta, the rock-cut chaitya halls and viharas around the gorge; 2nd C. BC–7th C. AD. The numbers refer to the caves' sequence, not their chronology

82 (above) Ajanta, Cave 1, view from the assembly hall towards the shrine. Gupta, late 5th C.

contains an image of the Buddha. But what overwhelms us in Cave 1 is the number and quality of the paintings which still glow from every surface, and transport us into the rich and complex Buddhist world of the late fifth century. 83, 84

The subject-matter of the paintings, as of most of the surviving examples from Ajanta, is the various lives and incarnations of the Buddha, told in the Jataka tales. As in Flemish Renaissance paintings, the stories are richly depicted in the settings of the artists' world. The whole mood is one of life and activity, and a calligraphic line gives a flowing action to the contours of the figures, whose hand positions are most expressive.

The Bodhisattva Padmapani, who stands languidly in the tribhanga 83
pose of sculpture, holding a blue lotus, is particularly fine. The Buddha-to-be wears a few rich pieces of jewellery, such as an elaborate pointed crown, and a sacred cord (indicating his high caste) which is delicately composed of many strands of small pearls. His expression of remote calm is enhanced by the figures which crowd in from all directions and establish him as an island of spiritual disengagement, unmoved and unattentive to the forces and sounds of maya which engulf him. The absence of shadows suggests an unworldly light appropriate not only to the subject but also to its location, deep within the rock. This light is present in all the paintings at Ajanta, and is partly the result of the techniques used by the artists.

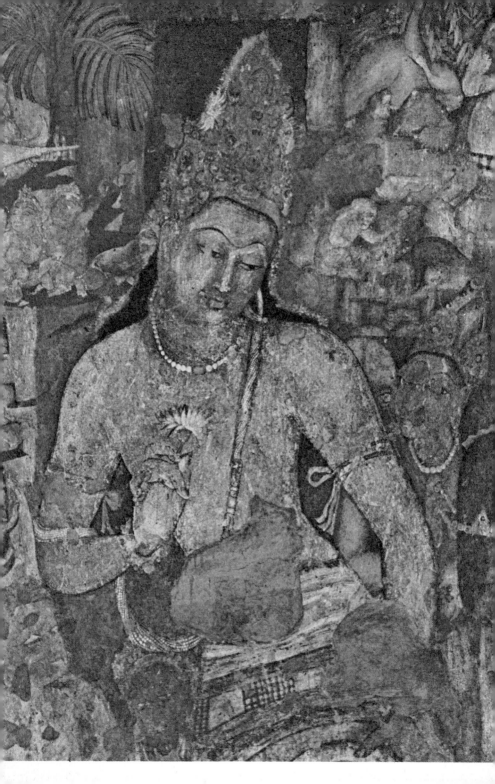

83 (opposite) Ajanta, Cave 1, wall-painting of the Bodhisattva Padmapani. Gupta, probably late 5th C.

84 Ajanta, Cave 1, detail of the painted ceiling. Gupta, probably late 5th C.

The surface of the stone was first prepared by a coating of potter's clay, mixed variously with cow dung, straw, and animal hair. Once this was levelled to a thickness of half an inch to two inches, it was coated with a smooth, fine, white lime plaster which became the actual painting surface. On the still-damp wall, the artist first laid out his composition with a red cinnabar line and then defined the subjects with an undercoat of grey or *terre verte*. This was followed by the addition of local colours, and once the whole wall was completely coloured, a brown or black line restated the drawing to finish the composition. A last burnishing with a smooth stone gave a rich lustrous surface. The colours, which were natural and water soluble, consisted of purple, browns, yellow, blue, white, green, reds, and black.

Another elegant Bodhisattva figure in Cave 1 is shown surrounded by his queen and ladies of the court. The painting re-creates an episode from a Jataka story, *Mahajanaka Jataka*, and it also provides a vivid glimpse into the regal settings which were well known to the artists. The same keen talent for observation appears in the painting of an ele- 84 phant in a lotus pond, one of many small panels decorating the ceiling.

The artist has captured the huge but deft-footed beast at the moment when it charges ashore, scattering lotus blossoms in his wake. The elephant is but one of the hundreds of animals – horses, bulls, birds, monkeys, and others – which are brightly woven through the pictorial fabric at Ajanta.

Cave 17 preserves some works also dating from the middle of the fifth century. Among them are several instances of a motif that was to be central to all Indian painting, right up to the last Rajput miniature in the nineteenth century: two lovers in an architectural setting. The scene occurs in a fresco illustrating the story *Simhala Avadana* that covers a complete wall. The story deals with the adventures of a virtuous merchant, Simhala, who is shipwrecked on an island inhabited by ogresses. By day the ogresses are transformed by witchcraft into beautiful women, but at night they revert to cannibalistic fiends. In one detail the hero is shown in the company of one of the transformed ogresses seated in a brightly coloured tent.

A similar scene appears in a fresco of the *Vishvantara Jataka*, where Prince Vishvantara informs his queen that he has been banished from his father's kingdom. The painting's erotic overtones, as well as its composition, link it to later Indian miniature painting. Among the clearly defined fifth-century architectural details are flat cushion-shaped capitals on columns hung with jewels. The same capitals top the stone columns used to frame a magnificently conceived royal couple carved on the left side of the porch to Cave 19. The two figures are actually a king and queen of the serpents (nagas), and, like the yakshis and yakshas, they are ancient fertility spirits of the earth who still, here in the sixth century, stand guard at the portals of the Buddha's sanctuary. Both sit naturally in a pose known as 'royal ease', with one leg pulled up close to the body and the other dropping to the floor. The naga king's head is dramatically enclosed within a multi-headed cobra hood which suggests a halo. It is curious to note that the throne on which this royal pair sit is decorated with a pattern of the same 'cubistic' motif that is used as 'set furniture' in the wall-paintings.

Cave 19 has a fully developed chaitya façade in Gupta style and forcefully proclaims, with an over-abundance of Buddha images, the triumph of Mahayana Buddhism (see p. 81), affording a dramatic contrast to the earlier and more austere chambers carved in the Shunga

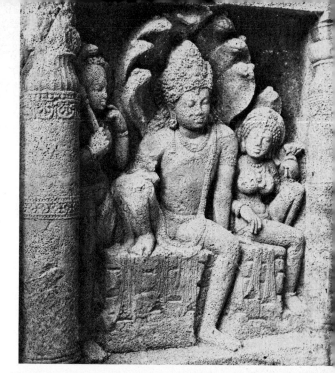

85, 86 Ajanta, Cave 19, relief of a
naga king and queen (right) and
façade. Gupta, probably late 5th C.

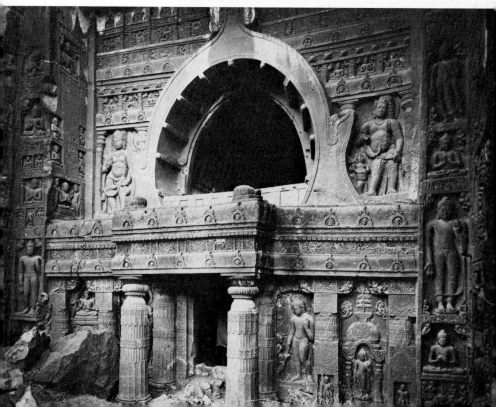

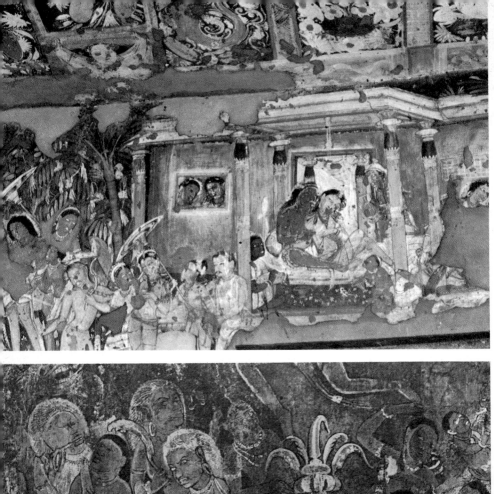

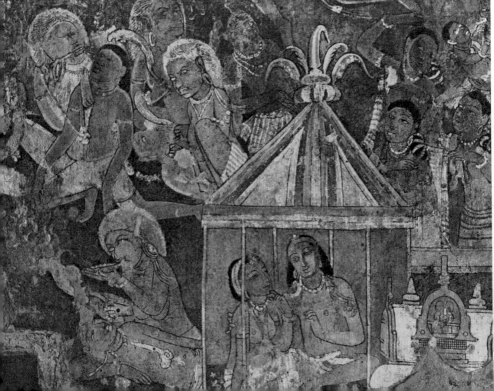

period. The theatrical lushness of Buddhist sculpture and painting, coinciding with an increase in Brahmanical sculpture, shows that the gods of Hinduism were now asserting themselves and offering a viable challenge to the Buddhist establishment. Not unlike the Roman Catholic Church in its reaction to the Reformation centuries later, Buddhism attempted to compete by beginning a transformation which would culminate in the Medieval period with a flowering of esoteric Buddhism (pp. 170–1). Ultimately Buddhism became so interwoven with Brahmanical practices that it is difficult to define the dividing line between the two. Late in the twelfth century, when Islam devastated Northern India, it was a dominant and thriving Hindu culture which received the greatest shock, while only remnants of a dying Buddhism were finally snuffed out.

POST–GUPTA PERIOD

During the sixth century the Huns, who had previously levelled Gandhara and put an end to the Gupta empire, were absorbed into the multi-stranded fabric of North India. With Gupta power gone, a new empire emerged in the Doab, ruled by the great King Harsha. Harsha was another of those impressive Indian personalities, not only a great administrator and warrior but also a poet and the author of at least three plays. One of his plays which popularized Buddhist ideals is still performed as an opera in the Bugaku theatre in present-day Japan. Favouring both Buddhism and Hinduism, he established a climate for learning and culture which rivalled that of the Guptas, who obviously were his models. Harsha's empire was centred at Kanauj, and as a cultural focus the city became one of the largest and most important in North India, lasting until the arrival of Islam in the twelfth century.

As evidenced by the remains of the Dashavatara Temple at Deogarh, embryonic stone temples dedicated to Brahmanical deities had begun to appear in Northern India and in the Deccan as early as the Gupta period. What appears to be the earliest known free-standing stone structure to have survived intact is Temple No. 17 at Sanchi, dated to about AD 415. It is a simple square cell, fronted with a porch supported by columns topped by bell and lion capitals. These capitals can be traced back to Mauryan times, but the temple's cubical severity gives it a look of Greek simplicity.

91

131

87, 88 Ajanta, Cave 17, wall-paintings illustrating the Vishvantara Jataka (above) and Simhala Adavana. Gupta, 5th C.

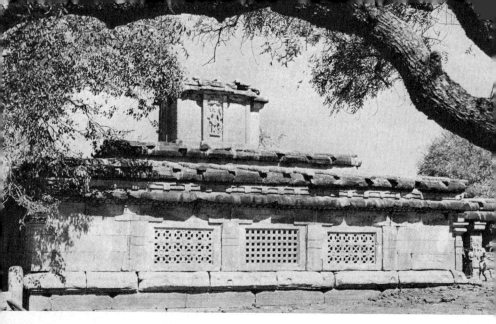

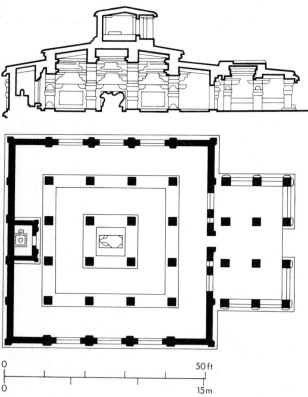

89, 90 (above and left)
Aihole, Ladkhan Temple,
view, section and plan.
Chalukya, c. 425–50

91 (opposite) Sanchi,
Temple No. 17. Gupta,
c. 415

0 _____ 50 ft

0 _____ 15 m

Much farther south, in the Deccan, a dynasty known as the Chalukyas had by the sixth century AD founded their capital at Badami. At a second location, Aihole, they had erected some of the earliest known Hindu temples evolved from previous architectural structures, such as chaitya and vihara forms. At first, Chalukyan temples were little more than simple columned halls, or *mandapas*, covered with a flat roof. The Gaudar Temple, recently excavated, may be as early as the first quarter of the fifth century. The so-called Ladkhan Temple, long considered the oldest Chalukyan temple at Aihole, is actually the second oldest and may (according to S. R. Rao) date from *c.* 425–50. 89, 90

Ladkhan's design is based upon a square mandapa raised upon a moulded plinth, with an attached porch, an interior shrine, and a two-tiered sloping roof surmounted by a square tower (*shikhara*) – a later addition, but even so an early manifestation of what became in Medieval times the dominant feature of Hindu temples. The shikhara (unlike the steeple of Christian churches) rises at the rear of the temple and marks the location of the sacred cell containing the deity. Originally the spaces between the exterior columns of a mandapa were open, but on Ladkhan they have been filled with pierced stone screens which define the structure as a walled volume. Its floor-plan, with the square columned interior, porch, and the cell standing against the back wall, is immediately reminiscent of the plan of a vihara; however, the cell contains not a Buddha icon but a *lingam*, the phallus representation of the god Shiva. 81

150

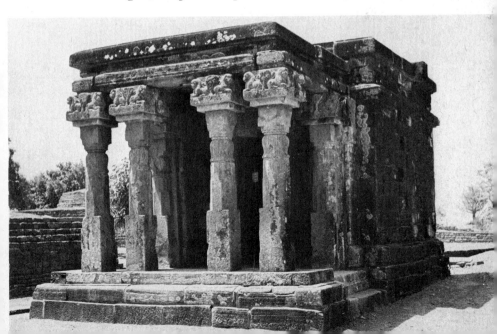

92, 93
26 The Durga Temple at Aihole, about a hundred years later in date, ends in an apse, a plan that suggests its derivation from the chaitya hall. The temple is approached at the front through a fairly large porch, and is complemented by excellent Chalukyan sculpture. A shikhara (now ruined) was subsequently added to adapt the building to later tastes.

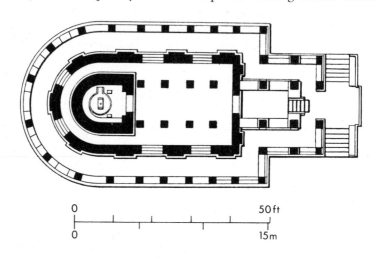

92, 93 Aihole, Durga Temple, plan, and view of the apse. Chalukya, c. 550

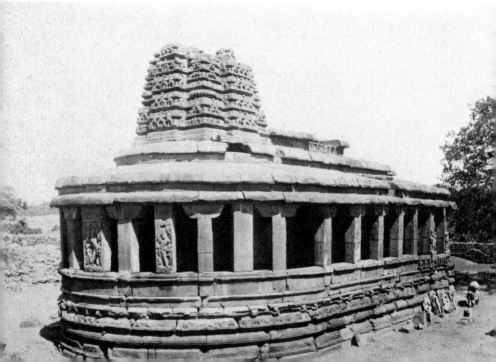

Farther south, the Chalukyan stronghold of Badami stands at the edge of a lake dominated by a rocky hill that looms above the town to the south-east. Here carved into the cliff above the town are four pillared halls. Three of these are Brahmanical caves, one dedicated to Shiva and two Vaishnava shrines devoted to Vishnu, while the fourth and later one is a Jain sanctuary. The earliest of the Vaishnava halls, Cave III, was dedicated in AD 578. The four are joined by an inclined causeway. Like the temples at Aihole, they consist of a veranda and a columned hall. A small sanctum cell is carved into the wall at the far end of each hall.

A superb sample of the sculpture found in the rock chambers at Badami is the image of a seated Vishnu on the veranda of Cave III. The 94 four-armed lord of preservation sits in relaxed ease upon the coils of the cosmic serpent, Ananta, whose many hoods hover protectively above the god's high crown. The sureness of the carving creates a series of geometric masses which combine to resolve the obdurate stone into a sensitively composed work of art. Originally the veranda of Cave III was enriched by sixth-century paintings, but unfortunately only fragments remain.

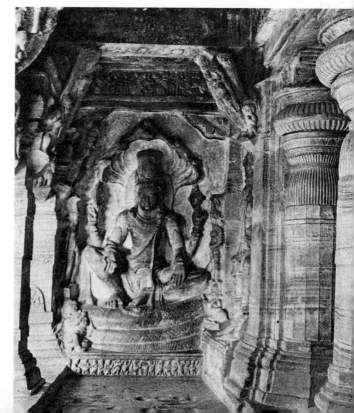

94 Badami, Cave III,
Vishnu enthroned on Ananta.
Chalukya, c. 578

95 On the north side of Badami a free-standing stone Chalukyan temple of slightly later date, the Malegitti Shivalaya, survives intact. It provides an example of Deccani architecture where the evolving North Indian style subtly mixes with that of the South; it also offers a contrast to the first Chalukyan shrines at Aihole. The temple is still basically a low rectangular structure fronted by a porch and standing on a tiered plinth. But its sides have become solidified into walls, since the pierced screens remain now only as small windows flanking panels carved in relief. The structural columns of the earlier mandapa design are retained on the exterior as decorative half-columns defining rectangular units which

93 contain reliefs and windows. The lower plinth and upper roof mouldings continue the style seen on the Durga Temple at Aihole, being ornately carved with small chaitya-arch motifs. The shikhara or tower above the sanctum (*garbhagriha*, literally 'womb-house') is still low, but more elaborately sculpted, and it is topped by a rounded dome which is echoed by two smaller domes on the temple's front corners. These elements are indicative of the South and make us aware that we are deep into the Deccan.

The Chalukyas were clearly one of the most powerful Deccani dynasties of the late Gupta period. Their founder, Pulakesin I, who founded Badami in the middle of the sixth century, exerted power over a considerable area, which included Ajanta. His fame reached Persia and even resulted in an exchange of embassies. Affluence and power did not, however, make the Chalukyas immune from the military contests which have punctuated all of Indian history. On the contrary, their wealth may have attracted attention: in the first half of the seventh century they were attacked by Harsha from the north and then by the Pallavas from the south. The Chalukyas survived both attacks; but in the middle of the seventh century a new dynasty arose in the Deccan which overthrew and scattered them, commencing a rule which would last over two hundred years. That dynasty was the Rashtrakutas.

The first Rashtrakuta raja, Dantidurga (ruled *c.* 725–60), defeated the Chalukyas at Badami in about 753 and established an empire which dominated the Deccan. His uncle who succeeded him, Krishna I (*c.* 756–74), not only enlarged the royal territory to the south but also created the most famous of all Rashtrakuta monuments, the rock-cut wonder of

96, 97 the Kailasanatha Temple at Elura.

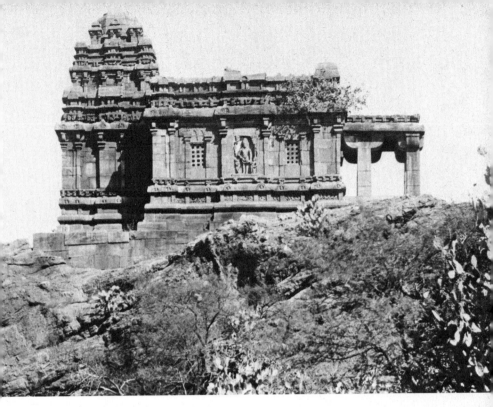

95 *Badami, Malegitti Shivalaya Temple. Chalukya, c. 600*

Located about fifteen miles north-east of Aurangabad, Elura has been an ancient pilgrimage centre for Buddhists, Jains, and Hindus. The site consists of a group of thirty-three shrines carved into an escarpment of volcanic stone which rises above the plain of the northern Deccan. Among the earliest, starting in Gupta times, are the twelve created by the Buddhists. The Jains were responsible for four caves, and the remaining seventeen are Hindu.

Elura is undoubtedly one of the greatest of all Indian sites for sculpture, and the masterpiece at Elura is the Kailasanatha Temple, a monolithic sculpture in the form of an elaborate temple of Shiva (see p. 140), carved from the hillside between *c.* 757 and *c.* 790. In its complex design it is a copy of the free-standing Virupaksha Temple at Pattadakal, of *c.* 740, which in turn was a copy of the Kailasanatha Temple at Kanchipuram, of the early eighth century.

96, 97

108

This cultural exchange between the deep South and the Deccan was the result of wars, and the Elura shrine represents the extreme northern point of penetration by the southern architectural style.

Like its models, the Kailasanatha Temple is composed of four basic units. First there is a high entrance gate (*gopuram*) which screens the sacred precinct from the outside world. The gate is followed by a shrine for the bull Nandi, the mount of Shiva. A statue of Nandi is traditionally located before Shaivite temples where, devotedly transfixed, he contemplates the Shiva lingam in the temple's cell. At Elura the Nandi shrine is flanked by two monolithic stone shafts or towers, 60 feet high, which originally supported trident symbols of Shiva. Also near by, at either side, are carved two life-size stone elephants. Beyond the Nandi shrine, the living stone looms upward into an elaborated mass of architectural and sculptural detail. This massive, unified volume actually contains the last two of the four basic architectural units. These are the columned assembly hall and, within the highest volume of the main tower, the major sanctum. The shikhara, centred over the cell containing the lingam, rises to a climax 96 feet above the carved courtyard floor. This cell and tower unit is strikingly borne on the backs of rows of carved elephants.

The temple complex functions on two main levels, since the floors of the Nandi shrine, the assembly hall and the processional path around the major cell are all higher than the courtyard floor. These upper sacred levels are approached by two stairways on either side of the assembly hall. This device adds a dramatic element to the devotee's experience of progressing through the wonder of a world carved from the stone heart of the earth, then ascending to an even more remote level of sacredness.

The Kailasanatha Temple's courtyard is 276 feet deep and 154 feet wide, and at the back the vertical incision into the hill drops 120 feet. One can hardly disbelieve the guidebook's claim that 'approximately three million cubic feet of stone' were excavated from the hillside to create this massive work of sculpture. It demanded the most sophisticated planning, since it depended not on what was added, as in conventional architecture, but on what was removed.

The central temple complex is so awesome that the numerous shrines and relief panels cut into the side walls of the courtyard take on a secondary importance. This is unfortunate because in any other setting

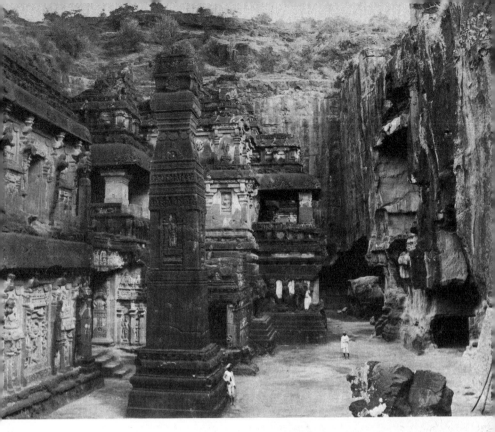

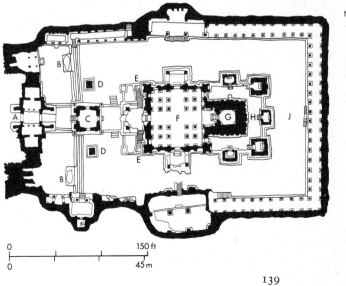

96, 97 Elura,
Kailasanatha Temple,
view from the west and
plan. Rashtrakuta,
c. 757–90.
A entrance gate,
B elephants, C Nandi
shrine, D freestanding
shafts, E stairs to the
upper level, F assembly
hall, G lingam shrine,
H processional path with
subsidiary shrines,
J courtyard surrounded by
galleries

0 150 ft
0 45 m

139

98 Elura, Kailasanatha Temple, sculpture in the northern gallery showing Ravana shaking Mount Kailasa. Rashtrakuta, 8th C.

each would be outstanding. The Rashtrakuta Post-Gupta sculpture style of Kailasanatha might be defined as a continuation of the Chalukyan style, but slightly modified by a Pallava or South Indian influence.

98 Chief among the sculptures is one in the northern gallery that depicts the demon Ravana shaking Mount Kailasa. The relief, so deeply carved that it is almost in the round, shows Shiva and his consort, Parvati, enthroned on their sacred Himalayan abode of Mount Kailasa (much like the Olympus of the ancient Greeks). The name Kailasanatha means 'the holy mountain residence of the Lord Shiva', and the temple was conceived as a mountain. Later, in Medieval times, shikharas were coated with white stucco to further the illusion that they were shimmering snow-covered peaks of the far Himalayas.

In the relief Shiva, Parvati, and their attendants are disturbed when the demon Ravana, who has been imprisoned beneath the mountain, begins to shake it with his many arms. The lithe figures appear to glow and move with each shift of reflected sunlight. Especially noteworthy is the effect of Ravana's many arms, which are central to the animation

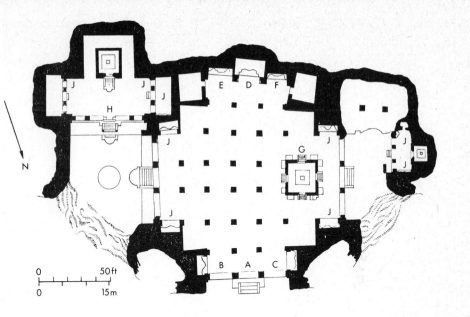

99 *Elephanta, Shiva Temple. Probably Rashtrakuta, early 7th C. A main entrance,*
B Shiva Yogishvara, C Shiva Nataraja, D Shiva Mahesamurti, E Shiva
Ardhanarishvara, F Shiva Gangadhara, G lingam shrine, H subsidiary Shiva shrine,
J locations of other sculpture

of the scene. The action is augmented by the lovely grace of Parvati's
frightened lady-in-waiting who, above, flees back from the composition
and creates the illusion of expanding space where there is only solid
rock. The decisive moment of this parable of Shiva's power occurs when
he gently presses the earth with his toe and restores all to calm and order.

A second great rock-cut shrine dedicated to Shiva is on the island of
Elephanta, about six miles offshore in Bombay harbour. There are other 99–102
rock-cut shrines on the island, but the most elaborate and important
is a large pillared excavation with more than 16,000 square feet of floor
space. It is tentatively ascribed to the Rashtrakutas, but its authorship
and its date (generally accepted as being the first quarter of the seventh
century) are under debate.

The columned chamber is oriented roughly east to west, and focuses 99
upon a square, four-door lingam cell at the western end. The main 100
entrance is through a large, carved porch on the north, but the great
hall also opens on to two courtyards, at its extreme eastern and western
ends, and each in turn contains smaller shrines. On the two side walls of

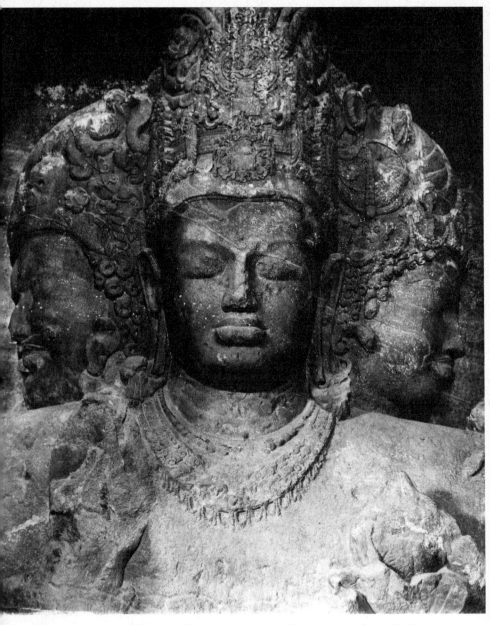

*100–102 Elephanta, Shiva Temple. Probably Rashtrakuta, early 7th C. Opposite,
above: the lingam shrine; below, Shiva Ardhanarishvara (far left) and Shiva
Mahesamurti. Above: Shiva Mahesamurti*

142

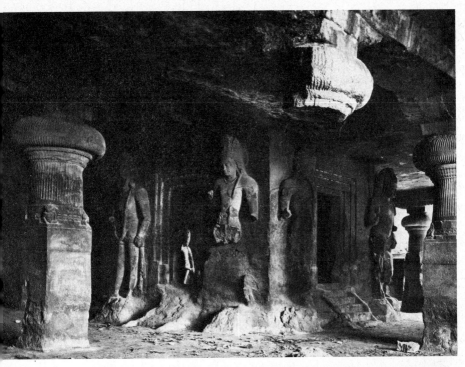

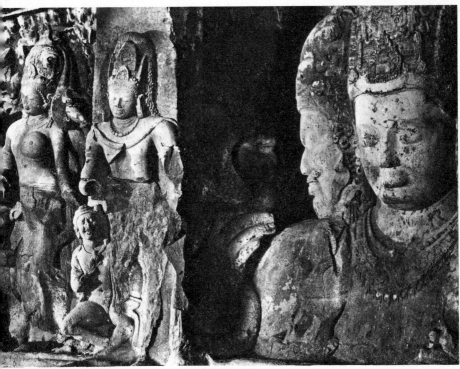

the northern porch and at seven other locations within the hall are reliefs depicting various episodes from the myths of Shiva. He is represented in numerous manifestations, such as the Great Ascetic (*Yogishvara*), Lord of the Dance or of Dancers (*Nataraja*), dual male and female aspect (*Ardhanarishvara*) and the Descent of the river Ganges (*Gangadhara*).

101

Also impressive among the sculptural works found here are giant door-guardian figures who stand flanking the four portals to the lingam shrine. Unfortunately these figures, and the majority of the relief panels, have suffered extensive damage, reputedly from an early Portuguese military garrison who playfully used the hall as a shooting-gallery. Before restoration a number of the massive square pillars were completely displaced and remained only as stalagmite stumps on the floor or as stalactite fragments of capitals hanging from the ceiling.

100

One sculpture, carved deep into the fine dark brown sandstone of the south wall opposite the main porch, miraculously survived the fusillade and has now become almost as famous as the Taj Mahal: it is the giant triple-headed Shiva *Mahesamurti*. This 18-foot-high sculpture represents the supreme aspect of Shiva, which embodies not only the creator and the destroyer but also the maintainer of the cosmos. The three massive heads have been conceived as a psychological and aesthetic whole, with the central serene face providing a focus for the formal design. To the left Shiva displays his wrathful and destructive aspect (*Bhairava*), which is illustrated by the hooked nose, cruel moustached mouth, and the head-dress ornamented with a cobra and death's head. This terrifying visage is complemented on the right by the aspect of creation (*Vamadeva*), whose feminine features have a blissful softness which is enhanced by the pearls and flowers in the hair and the lotus bud in the hand. The central image of the Great God (Shiva *Mahadeva*) presents a mood which is detached and otherworldly, not unlike the Gupta Buddhas, and represents Shiva in his *Tatpurusha* aspect, which is the supreme, serene, and beneficent one.

101, 102

This sculptural style, with its massive bodies and full lips, seems to remember the firmly fleshed mithuna figures of Karli, carved some four hundred years earlier only a hundred miles to the south-east. At Elephanta that archaic vitality has been modified by Gupta aestheticism and Chalukyan elegance to produce a provincial style which is gloriously unique.

30

144

South India: Pallavas, Cholas and Hoysalas

The successors of the Andhras in South-east India were the Pallavas, who are known to have existed as early as the first century BC. Originally they were Buddhists, but they were converted to Brahmanism in about the fifth century AD. From the first they seem to have been great traders and to have loved the sea: coins of the Bactrians, Andhras and Romans have been found in the sands of their chief seaport at Mamallapuram, about 37 miles south of the present city of Madras. It was during the reign of the great Narasimha Varman I (*c.* 630) that this seaside emporium began to flower as a great artistic centre. The very name of the site perpetuates the ruler's fame, for Narasimha Varman I was also called the 'Great Wrestler', *Mamalla.* Today the name has been corrupted into Mahabalipuram ('Town of the Great Demon King Bali').

Some of the Pallavas' greatest art works at Mamallapuram, begun in the middle of the seventh century and continuing for about two generations into the eighth century, are cave temples and gigantic open-air reliefs carved into the whale-back outcroppings of granite that spine this strip of coastal land.

An immense relief which depicts the descent to earth of the sacred river Ganges, mistakenly called 'Arjuna's Penance', is the outstanding work at the site. About 20 feet high and 80 feet long, it contains over a hundred figures of gods, men, and beasts. Its subject is the Shaivite myth which tells how the holy ascetic, Bhagiratha, performed great acts of austerity for a thousand years in order to persuade the gods to allow the heavenly river Ganges to flow down to earth where it would bless man. When the boon was finally granted, there was great concern lest the impact of the falling water should destroy the earth. Shiva himself stoically consented to receive the shock of the river on his own head. It then wandered for aeons through his matted labyrinthine hair, eventually meandering gently out upon the ground.

103

145

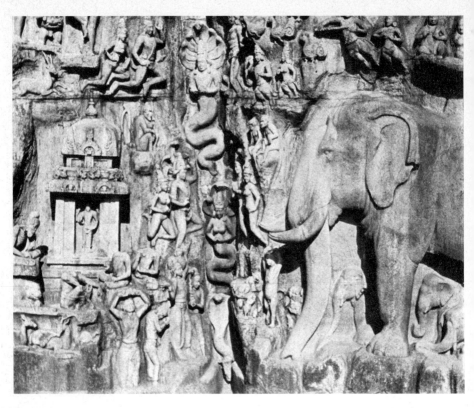

103 Mamallapuram, the descent of the Ganges (central section). Pallava, 7th–8th C.

103　　The relief at Mamallapuram depicts the auspicious moment when the river finally flows on to the earth. In the central cleft the king and queen of the nagas swim up the falling stream with their many hoods in full display, while all the gods and creatures reverently face inward to witness the miracle. At the upper left, just above the serpent king, is Bhagiratha, still in an ascetic stance. At the top of the boulder, centred above the relief, is a cistern: on special occasions it released water which rushed down the cleft to give reality to the tableau. The realism and soft monumentality of the elephants standing to the composition's right are especially well defined. Their massive weight is balanced on the left side by a plain area of stone which shows just the slightest indication that a pillared shrine was about to be excavated there, but for some reason it was early abandoned.

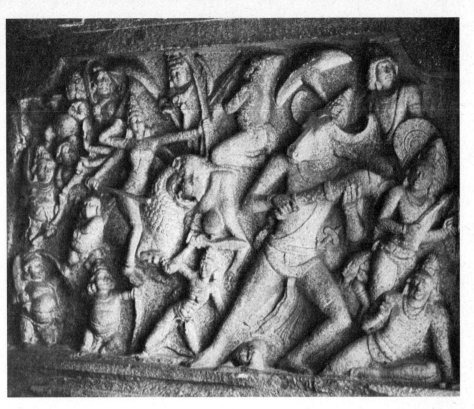

104 Mamallapuram, Durga slaying the Buffalo Demon. Pallava, 7th–8th C.

Farther to the left, and in the faces of adjacent boulders, are carved mandapas, fronted by typical Pallava pillars partly composed of squatting lions, and containing reliefs which illustrate Hindu mythology. Among the familiar subjects are Vishnu as the Cosmic Boar, Varaha; Vishnu asleep on the giant serpent, dreaming the Cosmic Nightmare (Vishnu Anantasayin); and, perhaps the most beautiful of all, Durga slaying the Buffalo Demon. *104*

Durga, 'She who is difficult [*dur*] to go against [*ga*]', is a feminine aspect of Shiva. The demon of which she is ridding the world is shown here not in its usual animal form, but as a human figure with a buffalo head. Durga sits astride her vahana, the lion, and is attended by a host; in her eight hands she holds the weapons given her by the gods, with which she draws blood and eventually triumphs.

The Mamallapuram reliefs, as well as other Pallava sculptures, carry the memory of Andhra art and have an elongated and elegant grace which is the mark of Pallava art. It is as if the action took place behind a gossamer screen which expands with the straining forms but always holds them to a constant plane. Their contours are described in a simplified and direct way which exhibits a highly sophisticated sense of design and vital geometry. Perhaps the obdurate nature of the granite contributes to the style, but in any case the results are magnificent.

At the southern edge of Mamallapuram is a group of free-standing *105, 106* temples, four of them carved (like large hunks from a loaf of bread) from one long granite boulder running north–south. A fifth temple stands slightly out of line to the west, and included in the group are a

105 *Mamallapuram, rock-cut raths of Dharmaraja, Bhima and Arjuna (from left to right), and rock-cut bull. Pallava, 7th–8th C.*

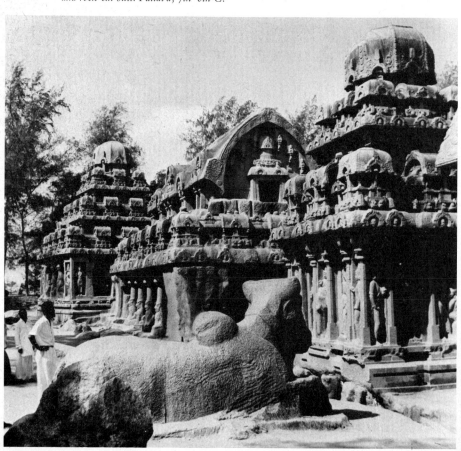

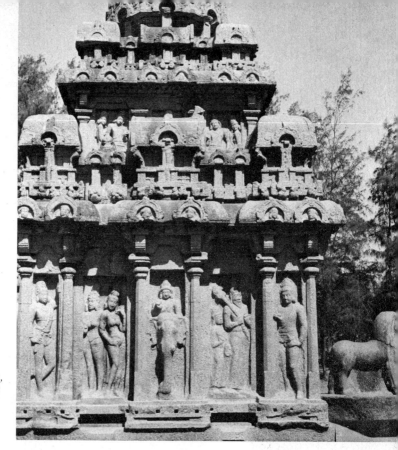

106 Mamallapuram, sculptures on the east front of the Arjuna Rath, and rock-cut lion. Pallava, 7th–8th C.

stone elephant, lion, and recumbent bull, all larger than life-size. The five temples are detailed replicas of ancient wooden structures. They are called *raths*, which means car or chariot, and indicates that they are vehicles of the gods. The smallest of them, on the north, the Draupadi Rath, reproduces a square, planed, thatched wooden temple. The next, the Arjuna Rath, is also square, but more complex in design: it emulates a vihara, with a pyramidal roof composed of three tiers of small pavilions crowned by a cupola. The third, the Rath of Bhima, is the largest and is remarkable for its oblong, barrelled chaitya-cave-type roof. The last 'structure', at the south end, is the Dharmaraja Rath. It is a larger, three-storeyed version of the Arjuna Rath. The small fifth temple to the east, Sahadeva, is an abbreviated version of the Bhima Rath. All these massively carved stones have on their sides excellent Pallava sculptures. 106

149

With the death of Narasimha Varman I in 668 work on the five raths stopped. However, other projects were undertaken at Mamallapuram and at the Pallava capital of Kanchipuram, thirty miles inland.

107 The early part of the eighth century saw the construction at Mamallapuram of the Shore Temple, so called because it stands by the sea. Since it was not carved of living rock, but was built up of granite blocks, it could be given a soaring tower. The surfaces were originally covered with carvings; but over the centuries most of them have been eroded away by the constant action of sun, wind, and salt spray, giving the temple a soft, melted look. Local legends claim that four other temples stood here, but one by one the sea claimed them.

107 Mamallapuram, Shore Temple. Pallava, early 8th C.

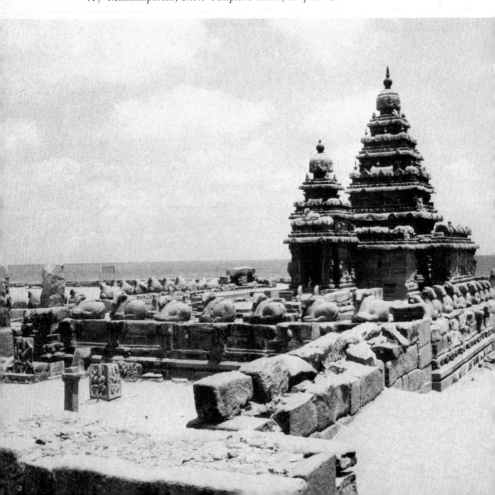

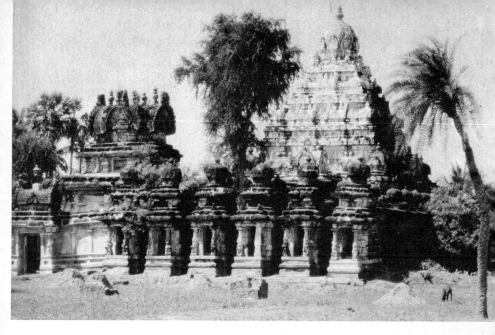

108 Kanchipuram, Kailasanatha Temple. Pallava, early 8th C.

The Shore Temple is a Shaivite shrine. The cell under the highest tower (*vimana*) opens directly on the sea, not only to permit the first eastern light of the sun to illuminate the cell but also, perhaps, to allow sailors to pay homage to the deity from their approaching boats. Directly behind the main shrine is a second cell containing a large sculpture of Vishnu Anantasayin. This cell is entered by a doorway on the south side of the temple. A second small, towered shrine completes the structure. Its cell faces west into a now ruined courtyard which is encircled by numerous small sculptures of recumbent Nandi bulls.

The design of the Shore Temple is important because it is the earliest known example of a stone-built temple in the South. It is closely related to the Kailasanatha Temple in Kanchipuram, which also dates from the *108* early eighth century and which served as a model for two major buildings farther north in the Deccan: the Chalukyan Virupaksha Temple at Pattadakal and the great Kailasanatha Temple at Elura (see p. 137). The Shore Temple also strongly influenced the architecture of the Cholas, who succeeded the Pallavas as the dominant dynasty in Tamil *110* country.

The last Pallava ruler, Aparajita, surrendered to the Chola raja Aditya in 897 after falling under a joint attack of the Pandyas and Cholas. Early in the tenth century the Cholas took the holy city of Madurai from the Pandyas, who had occupied the lower tip of the peninsula from early times, and then moved on to invade Sri Lanka. Their expansive nature culminated with their great king, Rajaraja I (985–1014), who not only dominated all of South India and subjugated Sri Lanka, but also successfully challenged the Chalukyas who had again

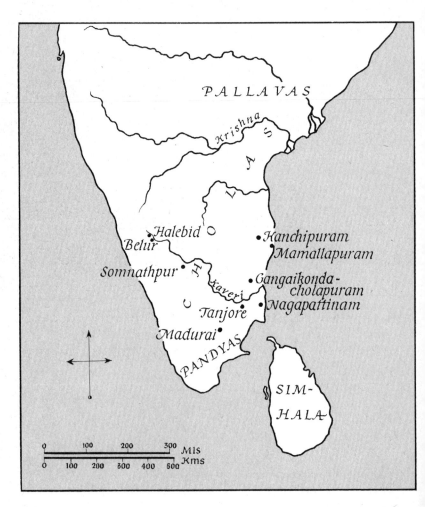

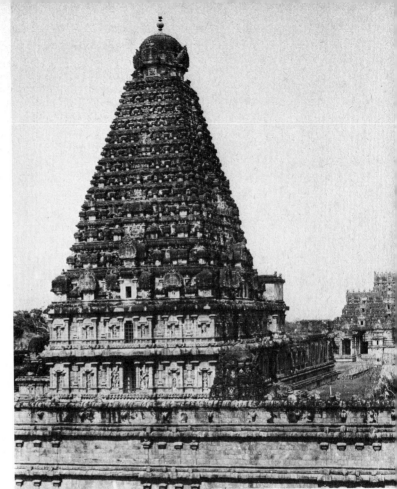

*109 (opposite)
Territory of the
Pallavas, Cholas and
Pandyas in South
India*

*110 Tanjore,
Rajarajeshvara
Temple. Chola,
c. 1000*

emerged in the north-eastern Deccan. After leading his victorious army
north, Rajaraja I returned to his capital at Tanjore, and about the year
1000 built a temple of victory and dedicated it to Shiva. The Rajarajeshvara *110*
Temple is the mammoth masterpiece of South Indian architecture, and
in its basic design it displays an obvious debt to Pallava inspiration.

Contained within a walled compound, the temple is 180 feet in
length. It has a Nandi shrine, a pillared porch, and an assembly hall.
The flat-sided, but sculpturally articulated, pyramidal tower over the
main shrine rises from a base 82 feet square to a height of 190 feet, and is
topped with an 80-ton domical capstone, probably raised into position
by means of an earth ramp.

153

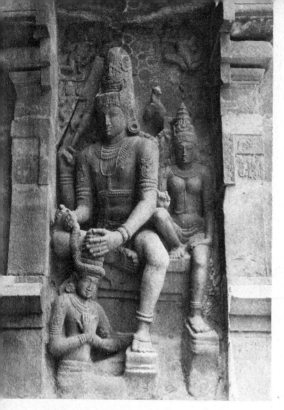

111 *Gangaikondacholapuram Shiva Temple, Rajendra Chola receiving a garland from Shiva and Parvati. Chola, c. 1025*

112 *(opposite, left) Brahmani. Chola, probably 9th C. Granite, H. 29 in. (74 cm). Asian Art Museum of San Francisco, The Avery Brundage Collection*

113 *(opposite, right) Shiva Dakshinamurti. Chola, 11th–12th C. Granite, H. 41¼ in. (1.05 m). Asian Art Museum of San Francisco, The Avery Brundage Collection*

Rajendra I (1012–44), the son of Rajaraja I, followed gloriously in his father's steps, using his naval supremacy to conquer territories as far away as Sumatra. His greatest achievement was to push his realm north to conquer in 1023 Mahipala, the king of Bengal, and to stand on the banks of the sacred Ganges with his victorious army. To celebrate this high-water mark of Chola greatness, he built his own regal city of Kumbakonam. About 1025 he constructed a new temple for Shiva there, called Gangaikondacholapuram, commemorating his march to the Ganges. In a niche beside one of the doorways a remarkable relief 111 depicts Shiva, with his consort Parvati, bestowing a floral garland of victory on Rajendra Chola. The relief also illustrates how, within two centuries, the Pallava stone sculpture style had been refined by Chola craftsmen.

A fine work from this interim period of Chola stone sculpture is a 112 figure of Brahmani, which probably dates from the ninth century and may have been created in Kanchipuram. As related in the *Markandeya*

154

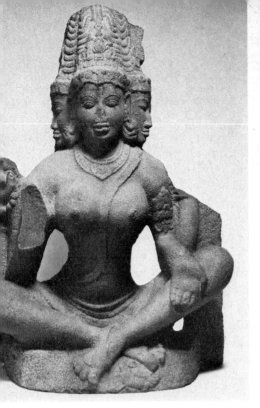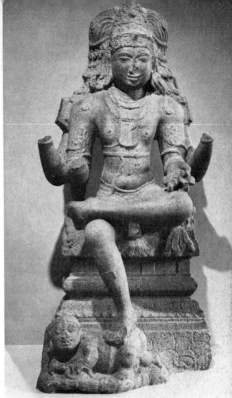

Purana, it represents the feminine energy (*shakti*) manifested by the four-headed god Brahma as an aid to Ambika (an aspect of Parvati), in the goddess's battle against the demon Sumba. The sculpture still has the contained simplicity of the earlier Pallava style, but within its elegant form resides a tension which grants the figure a feeling of latent vitality. The delicate tracery of the jewellery and other decorative elements is subtly and sensuously juxtaposed to the flowing simplicity of the body's surfaces.

 A third example of Chola stone sculpture, at least two hundred years *113* later in date, represents Shiva *Dakshinamurti* (literally 'south-facing'), or Shiva as the Great Teacher. In this benign form he is the expounder of knowledge and the arts, and as such he is reputed to have taught the scriptures (*shastras*) to the ancient seers (*rishis*). Shiva's left hand still holds a small palm-leaf manuscript. His hair is handsomely arranged and he is seated in the *virasana* pose, crushing a dwarf, symbolic of ignorance, under his right foot.

Bronze was to be the Chola sculptural medium *par excellence* from the tenth to the twelfth centuries. The earliest known bronze image in India is of course the famous Dancing Girl from Mohenjo-daro. Much later bronze icons were created in North India during the Gupta period. In the South, the Andhras were perhaps the first to use bronze for sculpture, and there is good reason to believe that it was their style and technique which were continued by the Pallavas. The early and important Buddhist centre at Nagapattinam is also famous for bronze images. Since the Pallavas used Nagapattinam as a site for one of their dockyards, some influence could have spread from there.

Only a few small Pallava bronzes are known. A comparatively large and well-preserved figure of Vishnu in Pallava style, produced in the late eighth century, is therefore of importance as evidence of a sophisticated knowledge of bronze-casting in South India. The four-armed Lord of Preservation stands in a rigid frontal pose and wears a high, decorated crown above his oval face. The face has been worn down slightly by worship. His upper right hand holds the disc or wheel, and the left holds the conch. The lower left hand is held at ease on the thigh, and the lower right performs *chin* mudra, which is symbolic of the realization of the absolute. The lower body is covered by a long cloth garment decorated with bows at the waist. Outstanding among the figure's jewels are a large crescent-shaped necklace of characteristic Pallava design and a sacred cord of multi-stranded pearls. The fact that this sacred cord falls across the right forearm clearly identifies this sculpture as a creation of the Pallava period. The feature is common to both stone and bronze Pallava figures, and is not (with only a few known exceptions) found on Chola sculptures. This particular image was perhaps made by the Cheras of Kerala, who were at the time politically and culturally dominated by the Pallavas.

The technique used to create Indian bronzes was the *cire perdue* or lost-wax process. A model of the object, complete in all details, is first made in wax. Various wax stems are then attached to it at strategic points, making it look somewhat like an arrow-impaled body, and it is coated with three layers of clay. The clay-encased wax figure is then heated. The wax melts out and leaves a cavity in the clay which exactly duplicates the original wax figure. Then the molten bronze, which in India always contained a high percentage of copper, is carefully poured

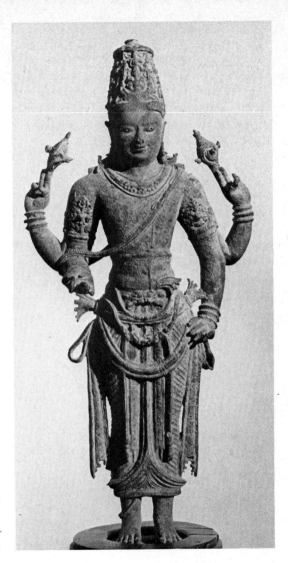

*114 Vishnu, perhaps
from Kerala, late 8th C.
Bronze, H. 14½ in.
(37 cm). Collection of
Dr and Mrs Arthur Funk*

through the channels left by the melted wax stems. Once the bronze has cooled, the clay is broken away, the channel stems are filed off, and what is left is the complete bronze image. During Chola times the moulds were so exactly made that the objects rarely required any additional re-tooling.

Since the mould is destroyed in the *cire perdue* process, each metal icon is unique. The similarity between so many Hindu bronzes is

explained by the fact that the craftsmen were religiously required to follow strict canons of measurement and iconography, set out in the *shilpa shastras*, the manuals of sculpture, architecture, and other crafts. Basic to the rules were the measurements defined by the width of the craftsman's finger and the length of his palm.

116 A tenth-century Chola bronze image of Parvati shows the consort of Shiva in the likeness of a Chola queen or princess. The svelte form appears at first to be completely nude because the folds of the one lower garment are minimized as they cling to the upper legs. Even the pointed crown and the jewels appear to merge with the body and to provide only the slightest variation to the modulating contours of the whole. The absolute grace of the slight tribhanga pose, the pendant breasts, the flowing arm and hand positions, all contribute to a unified stylization of the figure and elevate it beyond its human aspect to that of a celestial manifestation. The double lotus base on which the figure stands is fitted at its corners with four square lugs, through which poles passed to support the image when it was carried in processions. The figure still retains some of the fluid grace of the Pallava stone figures on the Arjuna Rath at Mamallapuram.

115 A second fine Chola icon in bronze depicts the *Vinadhara* aspect of Shiva and dates from the eleventh or twelfth century. Although the figure is not as stylized as the Parvati image, it displays the same basic grace, and its masculine power is enhanced by the multiple arms. Shiva here is the Lord of Music and his empty lower hands are posed to hold the stringed instrument with double gourd resonators (*vina*) with which he instructs musicians in the proper forms of *ragas* (see p. 223). He wears a high crown and a short pants-like dhoti. His upper left hand holds the deer which is a symbol of his victorious encounter with a group of jealous rishis. The upper right hand would have held an axe, but this is now lost. Two casting channels, normally filed off, strangely survive on the shoulders. Such holy metal images were always cast of solid metal, and although few were ever made life-size, their weight was considerable. The larger bronze images of deities, when installed in a temple for worship are treated very much like a living king. They are awakened in the morning, bathed, fed, dressed, entertained, and so on. Most are so bedecked with rich cloth and floral garlands that their forms are all but hidden from the devotees before the shrine.

115 (below) Shiva Vinadhara.
Chola, 11th–12th C.
Bronze, H. 27⅛ in. (69 cm).
Musée Guimet, Paris

116 (right) Parvati. Chola, 10th C.
Bronze, H. of figure 36½ in. (92
cm). Courtesy of the Smithsonian
Institution, Freer Gallery of Art,
Washington, D.C.

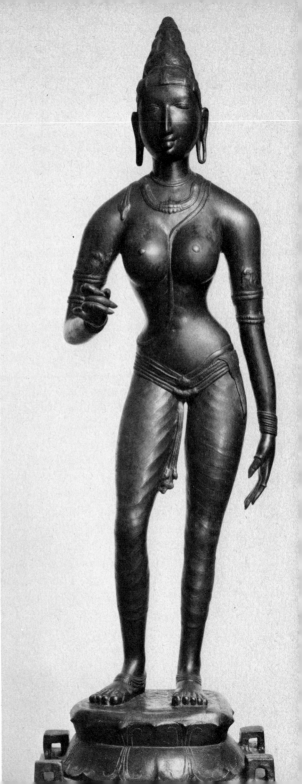

One of the most important and famous of all Hindu icons is intimately associated with Chola bronzes – the great image of Shiva Nataraja, Lord of the Dance or Lord of Dancers. Large numbers of this icon were created during the Chola period, and in South India their manufacture has continued into the twentieth century.

117

Shiva is depicted in the cosmic dance of creating and destroying the universe. His hair flies out wildly as he dances, transfixed by the rhythm of the small hour-glass-shaped drum held in his upper right hand. The rhythm is the heart-beat sound of the cosmos (maya), and it comes into being through the beneficent action of the creative dance. The cosmos itself is represented as the ring encircling the deity, which springs from the fertile mouths of the makaras on the sculpture's base. Complementing this moment of creation is the simultaneous destruction of the cosmos, symbolized by the flames edging the circle and the single flame held in the god's left hand. The single flame reduces all to naught: it significantly balances the creative drum in the deity's right hand. The lower right hand offers solace to his devotee by performing the reassuring abhaya mudra of benediction. The blessing is further affirmed by the lower left hand's pose of *gaja hasta*. The 'flag' position of the hand is formed by dropping the fingers into an imitation of an elephant's trunk, which here points to the left foot as it springs from the back of the dwarf of ignorance. This symbolic pose promises the devotee release from the sufferings of maya, while the right foot crushes, with the full force of the dance, the back of the dwarf. A poisonous cobra is held by the dwarf, but the same deadly serpent is worn as an ornament over Shiva's blessing right arm.

Among the many other significant details is a skull, visible at the crown of the god's tangled hair. Here also is the crescent moon which symbolizes Shiva's phased presence in and out of the cosmos: even when hidden, he is always there. In his hair, matted with the ashes of the dead, Shiva received the Ganges when it fell from Heaven (see p. 145), and a diminutive figure of the goddess Ganga stands on a strand of hair to the right. She is a hybrid mermaid figure, her female form combined with that of the makara. The symbolism (discussed in detail by Zimmer and by Coomaraswamy in *The Dance of Siva*) is endless, and to a Shaivite devotee the icon is a visual sermon expounding the unbounded compassion and universal power of the dancing creator-destroyer god.

103

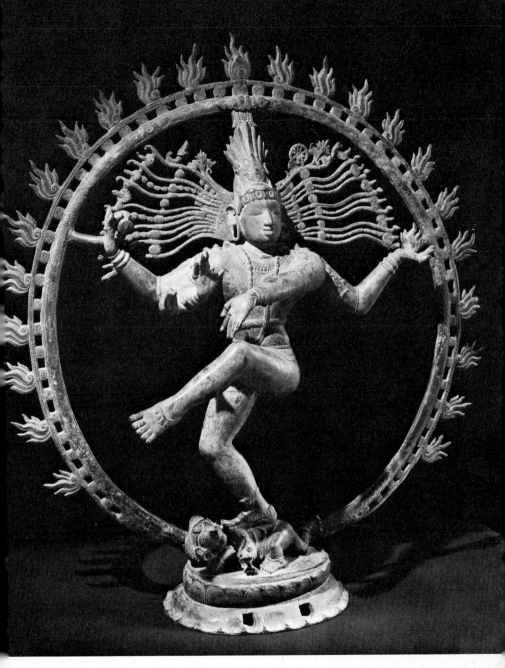

117 Shiva Nataraja. Chola, 11th–12th C. Bronze, H. 32¼ in. (82 cm). Von der Heydt Collection, Museum Rietberg, Zürich

By the middle of the thirteenth century the Cholas had been superseded by their old enemies, the Pandyas of Madurai to the south. And to the west a group of hill chieftains, the Hoysalas, who had previously been feudatories of the Chalukyas, now rose to power in the area of Mysore.

From the twelfth century through the early part of the fourteenth the Hoysalas created a series of temples in the cities of Halebid, Belur, and Somnathpur. These temples appear as low piles of filigree carvings where surface textures dominate and obscure the architectural forms. Their 'Rococo' ornateness is certainly diametrically opposed to the geometric clarity of the earlier Pallava temples.

118 The Keshava Temple at Somnathpur, the best preserved, was founded by a Hoysala general in 1268. Three star-shaped sanctuaries holding triple manifestations of Vishnu stand on a platform composed of narrow horizontal panels carved with complex reliefs. (The sculptors were able to carve such elaborate details because the material, steatite or soapstone, is soft when first quarried. After a period of exposure to the air it hardens and turns dark.) The towers over the cells are very low, and the whole temple, which is squat and intimate in scale, is cloistered within a walled compound.

118 Somnathpur, Keshava Vishnu Temple seen from the back. Hoysala, 1268

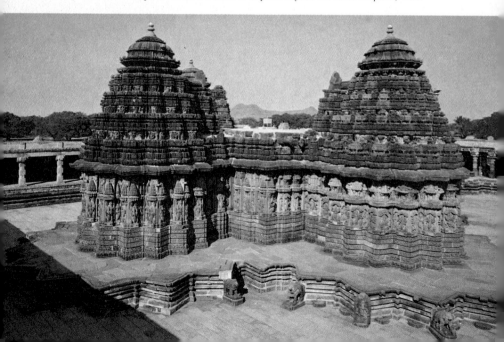

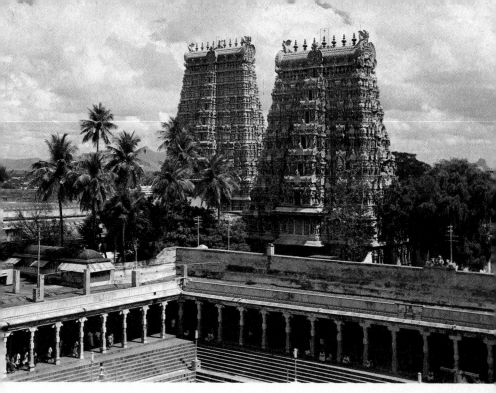

119 Madurai, Great Temple. Nayak, 17th C.

An excellent if relatively restrained Hoysala sculpture is a figure of 120
Ganesha in San Francisco. The elephant-headed, 'mind-born' son of
Shiva and Parvati is shown with four arms, seated and wearing an
elaborate crown and jewels. Behind him is a highly ornate pierced stone
screen. Ganesha is lord (*isha*) of the hosts (*ganas*) of Shiva, and is the
god of prudence and sagacity. As the latter, his image is often placed
over the doors of Indian banks, shops, and libraries. He is also the 'remover
of obstacles', to be propitiated before any undertaking: his image is
painted at the front of illustrated manuscripts, he is attached to the tops
of letters, and he is also saluted before beginning a journey. The rat,
which is equally capable of overcoming obstacles, is Ganesha's vahana,
but is not included in this particular sculpture. As the son of Shiva,
Ganesha holds an axe in his upper right hand and probably once sup-
ported a Shaivite trident in the left. His lower hands hold the point of

163

one of his tusks, which was broken off in a mythical battle, and a bow
of sweets which he delights in eating. Among the other symbolic
details are the three-headed cobra used as a waistband and the *kirttimukha*
or 'face of glory' at the top of the back screen. This grotesque face is all
that remains of a demon created by Shiva as the supreme destructive
force in the cosmos, who with an annihilating hunger consumed his
own body. Symbolic of Shiva's destructive powers, it is commonly
placed over the doorways of Shaivite temples as an auspicious and
protective device.

119 The last manifestation of Hindu temple architecture in the South is
represented by the temple city at Madurai. The ancient capital of the
Pandayas had passed from one conqueror to the next, until it came
under the sway of the Vijayanagar kingdom which established its vice-
roys there about 1370. When the combined forces of the Deccan
sultanates crushed Vijayanagar in 1564, the vicroys continued to hold
Madurai independently as the Nayak dynasty. In the seventeenth
century they transformed it into a complex temple city and enclosed
its numerous shrines and huge bathing-tank within a walled compound.

The temple structures themselves are comparatively low, and the
various mandapas are renowned for their many rows of elaborately
carved stone columns. The largest and most famous of these is called
the Hall of a Thousand Pillars.

The main feature of Madurai, however, is the tall *gopurams* or gate-
ways. These flattened towers with their tiers of sculptural decoration
appear to owe their origin to the shikharas of Pallava and Chola temples.
Many other gopuram-dominated temple complexes are found dotted
across South India.

In the fifteenth century the influence of the Islamic sultans at Delhi
had begun to penetrate the Deccan. Soon after, the greater power of the
Mughals would make its impact felt in the South. We must now, how-
ever, return to the North, and resume the story where we left off
during the Post-Gupta period in the seventh century.

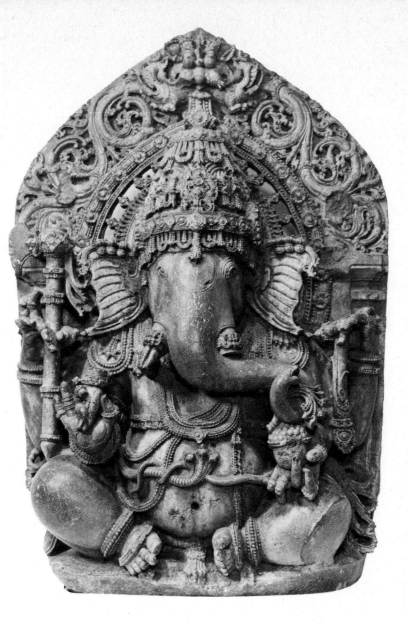

120 Ganesha. Hoysala, 12th–13th C. Chloritic schist. Asian Art Museum of San Francisco, The Avery Brundage Collection

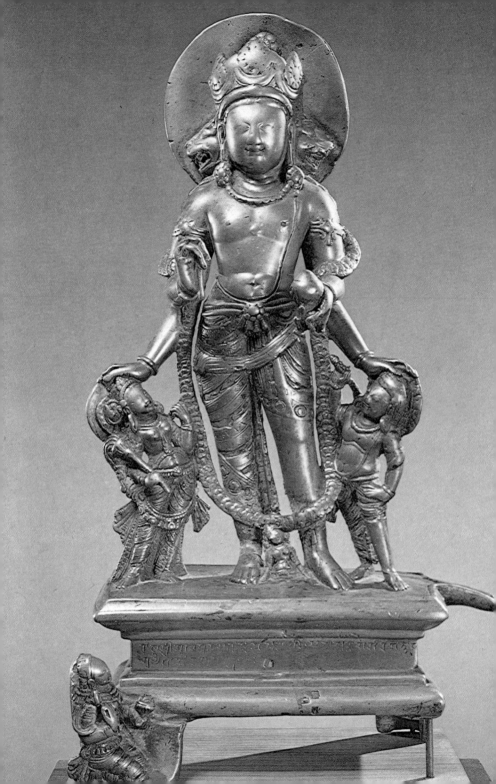

The Medieval period in North India

The use of the term 'Medieval' in Indian history is, at best, confusing. Some historians define the period broadly to include the time between the middle of the sixth and the middle of the sixteenth centuries. From the point of view of art a more logical span would be the five centuries between the appearance of Islam in the Indus delta in the early eighth century and its domination of North India and the Ganges valley during the thirteenth century. Throughout this era great works of Brahmanical and Buddhist art were created in Northern India. Afterwards Buddhism disappeared and Hindu culture slowly became coloured with Islamic influences.

In North India, beginning in the eighth century, the former royal capital city of Kanauj became the object of an obsessive power struggle between three leading kingdoms. Involved were the Deccani Rashtra-kutas, the Palas of Bengal and Bihar, and the Pratiharas from Rajasthan. The struggles eroded these major administrative powers and paved the way for the emergence of numerous small regional kingdoms in the North which were weak and jealously competitive. Also, almost unnoticed, the Arabs conquered Sind in 712, and as the quarrelling, introverted northern Hindu kingdoms continued to ignore the world beyond them, Islam gathered strength in Central Asia.

Meanwhile, Buddhism, which had been all but engulfed by a sea of Brahmanism, retracted into a select number of holy places where it would linger on until it finally fell under the sword of Islam in the late twelfth century. Sites sacred to Buddhism, such as Bodh Gaya, Sarnath and Nalanda, still functioned, and in some cases flourished, under a vacillating Indian patronage and the support of Buddhist pilgrims from South-east Asia who now flowed into India as a steady stream.

One of the major pilgrimage centres was the site of the Buddha's enlightenment at Bodh Gaya in Bihar. The Mahabodhi shrine was

167

121 Four-faced Vishnu with personifications of his attributes, from Kashmir,
9th C. Bronze inlaid with silver and copper, H. 18¼ in. (46.5 cm). Nasli and
Alice Heeramaneck Collection, Los Angeles County Museum of Art

established by Ashoka in the third century BC, but the first major structure was probably erected in Kushan times. The temple we see today has been much changed by numerous restorations, including a major one in the nineteenth century. Its basic form dates chiefly from the seventh or eighth century, but it was drastically repaired in the twelfth century by the Burmese, who added four turrets at the corners. The shrine stands on a wide square base some 20 feet high and 50 feet wide, and its pyramidal tower rises to a height of about 180 feet. It must have represented a considerable departure from the concepts of the simpler and smaller Mauryan and Kushan structures, which had centred on a living Bodhi tree.

123

122 Medieval sites of North India

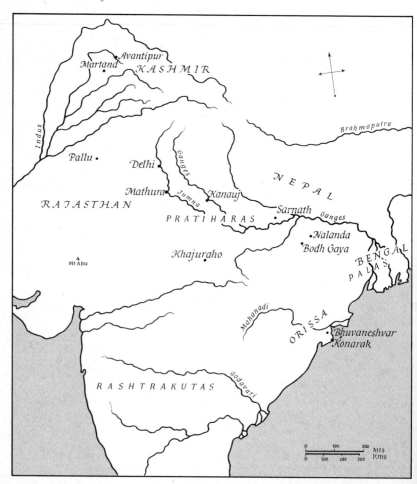

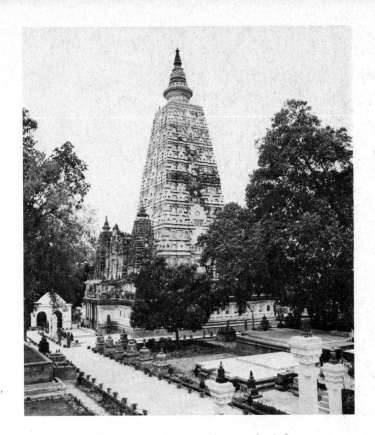

*123 Bodh Gaya,
Mahabodhi Temple.
Built in the 7th–8th C.,
altered in the 12th C.,
restored in the 19th C.*

Along with the devotees from far lands, who simply searched for
darshana (a mysterious ecstasy generated by being in the presence of a
holy person or place) – in the dusty footsteps of the Buddha, came
envoys of powerful kings, who wished to aid in the support of sacred
sites, repair old monuments, and pay for the construction of new
monasteries. Such an act is recorded in a copper-plate inscription of the
great Pala ruler Devapala, who in 850 dedicated five villages for the
upkeep of a monastery at Nalanda which had been built by the Shalendra
prince, Balaputradeva of Java.

Nalanda, the great university city of North India, was associated
with the Buddha when a monastery was built there during his lifetime.
The city reached the height of its splendour under Harsha of Kanauj
(see p. 131) and began to decline in importance only in Pala times, when
patronage shifted to other monastic centres. In the first half of the ninth
century the famous Chinese monk Hsuan-Tsang visited Nalanda and

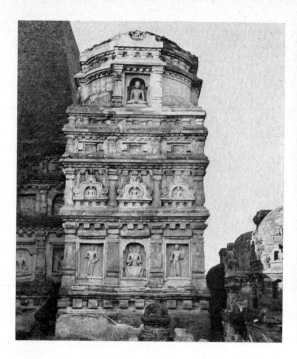

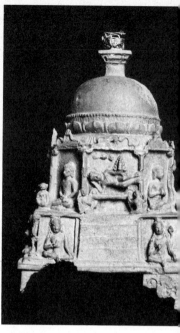

recorded that it then had an establishment of 10,000 students and that
its lofty towers were lost in the morning mist. Today very little remains,
and most of what survives can be dated close to the period of Nalanda's
destruction at the end of the twelfth century. The central large stupa,
now ruined, appears to be closely related to the temple at Bodh Gaya,
124 being complemented by smaller tower-like votive stupas at its corners.
126 The small stupas still display a number of stucco images which show
how the Gupta style was perpetuated as a model into the Medieval
period, a fact further illustrated by the numerous stone and bronze
sculptures created at Nalanda and elsewhere throughout the Pala and
Sena periods.

125 A fascinating small sculpture from Nalanda is a votive stupa made of
bronze, which dates from the ninth century. P. Pal's recent study
showed that the work is conceived as a three-dimensional mandala,
related to the metaphysical structure of the world. It features on its lower
corners the eight Bodhisattvas, guardians of the four cardinal and
intermediate points of the compass. The upper and larger register con-
tains the eight great events or miracles of the Buddha's life.

This object, with its elaborate iconography, signals that we are now

170

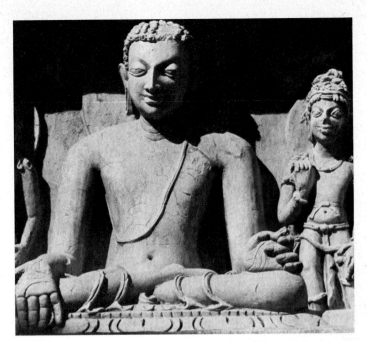

124 (far left) Nalanda, tiered votive stupa. Early Medieval, 7th–9th C.

125 (left) Small votive stupa from Nalanda. Pala, 9th C. Bronze, H. 7½ in. (19 cm). National Museum, New Delhi

126 (right) Nalanda, Buddha on a votive stupa. Probably 8th C. Stucco, H. about 24 in. (60 cm)

dealing with a new and complex form of Mahayana Buddhism. Known as Vajrayana, or esoteric Buddhism, it takes its name from the *vajra* (thunderbolt or diamond) which is its central symbol. The vajra was sometimes also seen as a bundle of arrows or a trident weapon for the gods. Later it took on the identity of the diamond, which signifies the pure indestructible virtue, or absolute knowledge or wisdom, that cuts through ignorance.

This school of Buddhism was an outgrowth of Tantric thought, which after the seventh century permeated not only Buddhist institutions but Brahmanical ones as well. Tantra, the 'doctrine and ritual of the left hand', asserted that the female principle (shakti) is the dominant force in the universe, since it alone has the power to move the dormant male force to action. Here obviously was an outgrowth, or a re-emergence, of the 'mother goddess' cults of ancient times. In Buddhism powerful 'saviouresses' called *Taras*, female counterparts of the Buddhas and Bodhisattvas, evolved. The deities of Hinduism, such as Brahma, Vishnu and Shiva, are complemented by consorts who appear even more active and powerful than they themselves. The term Tantra is also used to refer to specific texts which are collections of magical and

mystical formulae. As their use increased in Buddhism, elements of sexual symbolism and demon worship, understood only by an initiated few, became included in the ritual and served to alienate the common devotee.

22, 55 The Bodhisattva concept, which had its iconographic origins in the
67, 68 ancient yaksha figures (see pp. 45–7), was well developed by Kushan times, but it was in the Vajrayana Buddhism of the Medieval period that Bodhisattvas proliferated. One of the earlier Bodhisattvas who remained important was Maitreya, the Buddha of the Future. He was directly related to and served the 'Buddha of immeasurable glory', Amitabha, who was the Buddhist Heavenly Father. The Amitabha Buddha was a product of early Gupta times, and gathered strength as the concept of *bhakti*, or devotion to a personal deity, grew in popularity. The humble devotee envisioned a blissful life following death, in the heaven of Amitabha, the 'pure land of the west', and within this context Maitreya, the Messiah, would come and save the devout of the world.

Of extreme importance also is Padmapani, 'the one who holds the lotus', who is the chief Bodhisattva of mercy. We have already seen him
83 in a wall-painting in Cave I at Ajanta. He is the same as Lokiteshvara or Avalokiteshvara, 'the Lord who looks (shines) down', and as the servant of the Amitabha Buddha he always displays a small figure of Amitabha in his head-dress or crown. Later in China he was curiously transformed into the female goddess of mercy, Kuanyin.

Two Pala period figures of Padmapani or Avalokiteshvara from Bihar well illustrate both the iconographic details of the deity and the
127 transformation of the Gupta sculptural style. The first figure, from Nalanda, dates from the ninth century. The clarity and simplification of
73, 74 form seen in fifth-century Gupta images can still be glimpsed, but they have been reduced by repetition to a formula, becoming overly stylized
128 and desiccated. In the second Bodhisattva, which dates from the tenth century, the frozen Gupta cliché has been modified, and the Pala love of ornamentation overtly manifests itself. (It should be noted that it was this sculptural style which influenced the taste of Buddhist pilgrims from South-east Asia, and is reflected in figures created in Central Java in the ninth and tenth centuries.) In the head-dress of both Bodhisattvas is the Amitabha Buddha, seated in meditation (*dhyani*), and both hold a long-stemmed lotus in their left hand. The more ornate figure is slightly

172

animated by a tribhanga pose. On its base a seated donor/monk burns incense at the left, and an image of the *Dharmapala* Hayagriva, one of the defenders of Dharma, stands with one foot on an axe at the right. Above, at the left, balancing the lotus blossom, is a seated Buddha figure which (according to van Lohuizen-de Leeuw) possibly represents Shakyamuni.

Not only did Vajrayana Buddhism expand the Bodhisattva pantheon, but it also elaborated the Buddha concept into numerous theological and iconographical manifestations. A tenth-century Pala sculpture shows the Buddha seated on a throne surrounded by representations of 129 the eight great events of his life. The holy master who gave his clothes away, cut his hair, and rejected the world, and was first depicted as a humble ascetic monk (see p. 84), now calls the earth to witness his Enlightenment bedecked with a crown and jewels. The dichotomy is symbolic: jewels stress the power of an earthly ruler, and so the Buddha's yogi body is embellished to show him as an ecclesiastical Chakravartin, or as the ultimate universal king of the spiritual world. This figure obviously is no longer a compassionate image for individual devotion. It has become a formalized, impersonal cult icon, a receptacle for endless magical incantations and chanted *mantras*.

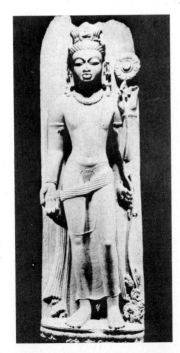 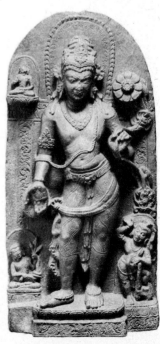

127 (right) Padmapani/ Avalokiteshvara from Nalanda. Pala, 9th C. Stone, H. 4 ft 7¼ in. (1.40 m). National Museum, New Delhi

128 (far right) Bodhisattva Padmapani/ Avalokiteshvara or Lokanatha, from Bihar. Pala, 10th C. Black basalt, H. 32⅝ in. (83 cm). Von der Heydt Collection, Museum Rietberg, Zürich

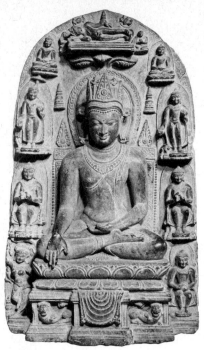

129 *Crowned Buddha surrounded by the eight great events of his life, from Bengal or Bihar. Pala, 10th C. Black basalt, H. 17¾ in. (45 cm). Rijksmuseum voor Volkenkunde, Leiden*

130 *(right) Vishnu with his consorts, from Bengal. Sena, probably 12th C. Black basalt, H. 33⅝ in. (85.5 cm). Courtesy of the Smithsonian Institution, Freer Gallery of Art, Washington, D.C.*

131 *(far right) Vishnu attended by personifications of his attributes, from Bengal. Pala period, 11th–12th C. Bronze inlaid with silver and brushed with copper, H. 17⅞ in. (45.5 cm). The Cleveland Museum of Art, Purchase from the J. H. Wade Fund*

129 The Lord is seated on a double lotus throne supported by two lions, and performs bhumi sparsha mudra (see p. 90). Behind his head is a flaming halo topped by three stylized leaves which symbolize the Bodhi tree of enlightenment. Encircling him are representations of the great events of his life. Clockwise from the lower left, they are 1. the Nativity, 2. the first sermon, 3. the descent from the *trayatrimsha* heaven (where the Buddha had ascended to teach the Law to his reborn mother), 4. the great Parinirvana (indicated by the recumbent Buddha), 5. the subduing of the maddened elephant (see p. 78), 6. the miracle of *shravasti* (where, in an apocryphal public competition with a saint of a rival sect, the Buddha gyrated in air and caused water and fire to shoot from his body), 7. the monkey's offering, and 8. the Enlightenment, represented by the large central figure. At the top, above the head and feet of the recumbent Buddha, are clouds which contain hands holding a drum and cymbals. These objects symbolize the universal rhythm (pulse of creation) and sound (the vehicle of speech). Together they can be interpreted as the divine truth of the Law which is personified by the Buddha. Also above, to either side of the Parinirvana scene, are seated meditating Buddhas which possibly combine with the work's large crowned image to

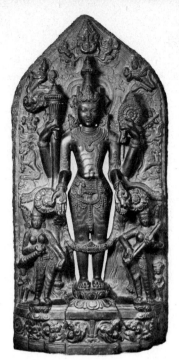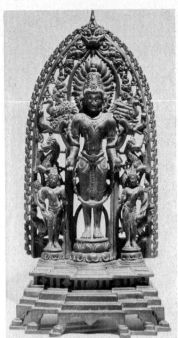

complete the triune manifestation of the *trikaya* iconography, in which the three figures would represent the 'Law Body', the 'Body of Bliss' and the 'Noumenal Body' of the Buddha.

By the eleventh century the forms of Buddhist icons were still indebted to the Gupta style, but they had become completely stereotyped, the only variety being in the degree of decorative detail. Despite their rich symbolism, they ultimately became cold, remote, and inhuman.

During late Pala–Sena times Buddhism felt various pressures from the surrounding Hindu community. In fact, by the twelfth century Buddhism and Brahmanism had much in common, and even the Buddha had become accepted by Hindus as the ninth incarnation or avatar of Vishnu. Brahmanical icons were created in the same style as Buddhist images. A standing figure of Vishnu and his two consorts (now in Washington, D.C.) *130* is typical. Deeply cut into the black stone, the crowned deity is shown with four arms whose hands hold a mace, a disc, and a conch. The lower right hand holds a miniature lotus as it performs the *varada* mudra of bestowing gifts. Vishnu's consorts are depicted as smaller figures, standing in graceful tribhanga poses. On his left, Sarasvati, the goddess

of learning and arts, can be identified by her vina; Lakshmi, the goddess of beauty and good fortune, holds a fly-whisk. On the legs of both is a wave-like pattern which represents the folds of a thin fabric, and is also used to indicate the dhoti of Vishnu. The wavy fabric is characteristic of both Hindu and Buddhist sculptures of this late period, and is typical of the 'Baroque' style in North India before the advent of Islam. The rest of the stele pulsates with writhing images of heavenly beings, makaras, elephants and leogryphs; at the top a 'face of glory' wards off evil.

As one might expect, during such a period of great production and high craftsmanship, many excellent metal sculptures were created. A *131* small bronze image of Vishnu almost duplicates in miniature the previous stonework, but the technique of bronze-casting allowed more elaborate detailing, even on a much-reduced scale. The images of Lakshmi and Sarasvati have been replaced by small figures representing Vishnu's conch and disc (see p. 118). The back screen is ornately pierced, and Vishnu's eyes have been inlaid with silver. Great numbers of even smaller images, many cast in silver and gold, are known. They were used as portable, personal icons.

121 A remarkable bronze, created in Kashmir in the ninth century, presents a four-faced Vishnu attended again by personifications of his attributes. Here, considerably removed from the Pala area, the Gupta influence is even more obvious, not only in the general style of the image but in its iconography as well. The multi-headed form of Vishnu occurs in stone sculptures from Mathura and other sites of the Gupta period. Here the features have been worn down by devotional prayer or *puja*. The top of the base contains a spout at the right to carry off libations, and at the left kneels a female devotee who may represent a donor. Her skirt, Vishnu's, and those of the figures personifying the disc and club are inlaid with strips of copper, and Vishnu's eyes have been inlaid with silver. His crown owes its origins to Kushan or early Gupta styles. The two animal heads on either side of the forward-looking face are references to Vishnu's manifestations as the Man-Lion (Narasimha), and as the *76* Cosmic Boar (Varaha) which rescued the earth goddess. At the back of the image's central head, unseen from the front, a demonic fourth face looks outward through the halo. It appears that Kashmir was the chief centre for the cult of the four-faced form of Vishnu and the famous temple at Avantipur was dedicated to his worship.

Perhaps the best-known early Medieval structure in Kashmir is the ruin of the Surya Temple at Martand. Built within a large rectangular courtyard (220 by 140 feet), edged by a massive stone wall, the Sun Temple is situated on a high plateau with a magnificent view of distant snow-covered mountains. A main cell with high trefoil vaults now lacks its pointed roof, but it is still fronted by a portico. The roof, undoubtedly originally of wood, may have reached as high as 75 feet. The architectural mode, with its pilasters and trefoil arches, is derived from Gandharan models (known from reliefs and from remains at Bamiyan and other sites) which were themselves adaptations of the provincial Roman style practised in Syria and elsewhere in the Middle East. On the façade and around the plinth are sculptures in a late Gupta-esque style. This majestic shrine was erected by the great Kashmiri king Lalitaditya Muktapida, who is recorded in the Kashmiri chronicle *Rajatarangini* as conquering most of Northern India and the Deccan, and as occupying about 747 the much-fought-over city of Kanauj. The riches gathered from this campaign embellished not only the Surya Temple but others in Kashmir, and later made them in turn objects of plunder.

132 Martand, Kashmir, Surya Temple: view (right) and sculpture of Surya in a trefoil-headed niche. Mid-8th C.

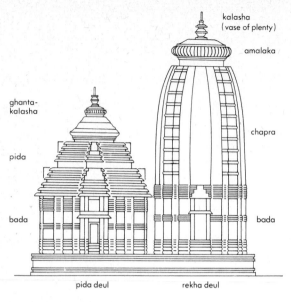

kalasha
(vase of plenty)

amalaka

ghanta-
kalasha

chapra

pida

bada

bada

pida deul

rekha deul

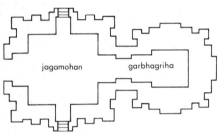

jagamohan garbhagriha

133 *The principal elements
of an Orissan temple, in
elevation and plan*

134 *(below) Bhuvaneshvar,
Parasurameshvara Temple,
c. 750*

135 *(opposite) Bhuvaneshvar,
Mukteshvara Temple, c. 950
(the gateway to the enclosure
lies outside the picture to the left)*

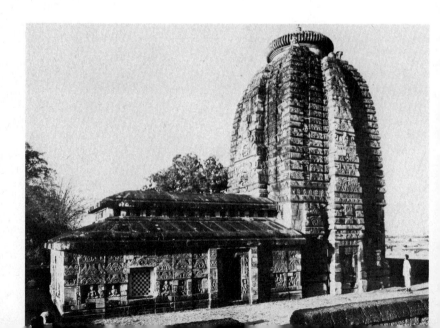

To conclude our discussion of Brahmanical art before the Muslim invasions, we must look at the evolution of the Hindu temple in the Post-Gupta period in North India. Already we have observed how the Hindu temple developed in Central India from a simple square, flat-roofed shrine, such as those at Deogarh, Sanchi, and Aihole. The climax of the North Indian style of temple architecture occurred, however, to the north and north-east in Bundelkhand and Orissa.

In the Orissan temples of the Bhuvaneshvar region we have a clear picture of the evolution of a style which begins with the Parasurameshvara Temple of *c.* 750. Here the tower rises at the end of a plain, rectangular, clerestoried assembly hall (*jagamohan*) whose basic geometric qualities are simply defined. But the tower, or *deul* as it is called in Orissan texts, has already developed into a distinct form known as a *rekha*: it rises from a square base and forms a beehive-shaped structure crowned with a flat, round, ribbed capping stone and a rounded 'vase of plenty'. Rekhas are, in reality, no more than four corbelled walls whose sides curve gently inward as they reach the top. On the Parasurameshvara Temple the separate stone courses on the faces of the tower are emphasized by alternating inset courses whose shadows create strong horizontal patterns which are eventually subordinated to the mass of the whole. Among the many sculptural details found here and on other Orissan temples are small chaitya-window motifs (see p. 53) which are by now reduced to mere surface decoration or to frames for figures of humans and animals.

133

134

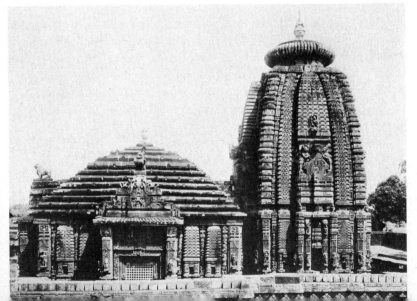

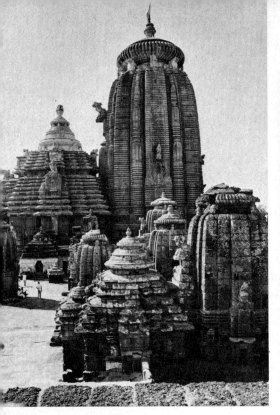

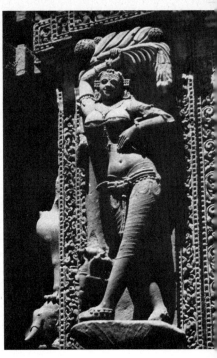

136 (left) Bhuvaneshvar, Lingaraja Temple, c. 1000

137 (right) Bhuvaneshvar, Rajarani Temple, shalabhanjika or dancer, c. 1000

135 With the Mukteshvara Temple, two hundred years later in date, the jagamohan has acquired its typical pyramidal roof. Dating from the so-called middle phase of Orissan architecture, this small shrine is completely covered with the chaitya-window motif in overlapping linear designs. The appearance of the tower has been greatly modified by the vertical ribbing carved up the four corners. The temple is enclosed within a walled compound and is approached through a rounded stone gateway, which is exceptional.

136 The largest temple at Bhuvaneshvar is the great Lingaraja Temple, which dates from about 1000. The contemporary Rajarani Temple, 137 smaller and unfinished, is noted for its superb sculpture. But it is the 138 ruined Surya Temple at Konarak, the so-called Black Pagoda, that is the masterpiece of the Medieval Orissan style.

Standing on the edge of a wide beach on the Bay of Bengal, the magnificent pile of weathered and oxidizing ferruginous sandstone (whence the name Black Pagoda) soars to a height of 100 feet, forming a landmark for sailors far out at sea. Built during the reign of Narasimhadeva I, c. 1238–64, the temple was conceived as a gigantic stone representation of the Sun God's chariot. Twelve huge wheels are carved into the plinth, *140* and the building is preceded by seven sculptured horses.

The temple's gigantic deul was probably never completed because the sandy foundation proved incapable of supporting a tower that would have been some 225 feet high. Only the crumbling outline of its square lower cell remains, surrounded by fallen, uncarved, and roughly finished stone. All Medieval temples relied upon gravity to hold their courses of stone together, so mortar was rarely used; and carving was usually done only when the stones were in position. Such procedures were prescribed by the *shastras*, ancient manuals of building rules, which equated various parts of the Medieval temple with the human body. Excellence of construction was normally assured by threatening the limbs of the architects and donors with ills comparable to the flaws in a temple's construction.

The major unit of the Sun Temple, still intact, is the jagamohan *138* with its pyramidal roof. The assembly hall faces the sea, and is preceded in its eastward orientation by the remaining plinth and massive square piers of a separate dancing-hall or *nata mandir*. In the nineteenth century the jagamohan threatened to collapse and was shored up, and the hall was filled with sand. This room, a cube of about 40 feet, was one of the great interiors of Indian architecture. The original builders had had difficulty with the stone corbelling that formed the room's ceiling, and had installed forged iron beams, 8 inches thick and some 35 feet long. For the thirteenth century the forging of the beams was in itself an amazing feat.

The jagamohan and nata mandir are covered with a filigree of sculpture of the highest quality that includes hosts of erotic couples (mithuna) *139* performing every possible variety of sexual act. The mithuna couple symbolizes the ecstatic bliss experienced by the separated soul of man when reunited with the divine. It is also tied to the Tantric concept of the shakti, the female force (see p. 171). The masculine force was generally represented by Shiva, whose shakti was personified by the

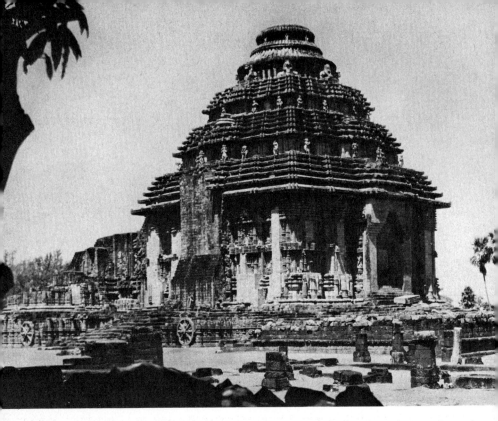

138 *Konarak, Surya Temple. Eastern Ganga, c. 1240. In the centre is the jagamohan;
to the left, the plinth of the garbagriha cell; to the right, ruins of the nata mandir*

goddess Devi. The temple of Konarak may indeed have been a centre
for a Tantric cult. Medieval Tantric cults were originally comparatively
secret groups or organizations, but eventually, apparently through their
erotic excesses, they were suppressed by the Hindu orthodoxy. The
invading Muslims must have been particularly thorough in their
destruction of temples displaying Tantric themes, for the Surya Temple
and the twenty-odd shrines at Khajuraho (pp. 188–91 ff) stand almost
alone as the few remaining flowers of Medieval art in North Central India.
In addition to Tantric philosophies, the Konarak sculptors must have
known the *Kama Sutra*, then already an ancient text on erotica, which
describes, among other things, the sixty-four positions of sexual inter-
course. But despite all this, the profusion of erotic sculpture at Konarak
remains an enigma.

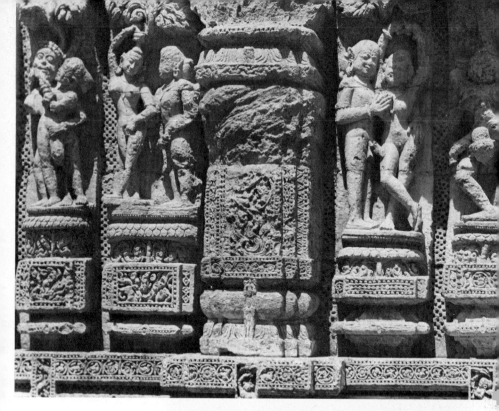

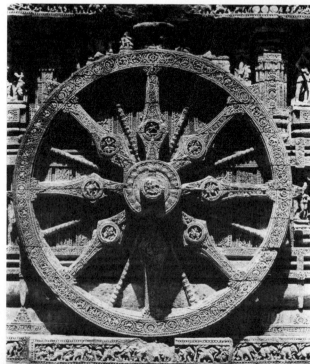

*139, 140 Konarak, Surya
Temple, sculpture on the
base of the south wall of the
nata mandir (above), and one
of the wheels carved on the
plinth. Eastern Ganga, c. 1240*

On the pyramidal roof of the Surya Temple two wider spaces between the narrow horizontal courses were originally lined with

1, 141 sculptures of female musicians, who provided music for the passage of the god's chariot through the heavens. They are some of the most impressive examples of the style of the Eastern Ganga dynasty. A

143 separate female figure from another area of the temple's fallen façade depicts a dancer posed gracefully in the three-body-bends position which is strikingly reminiscent of the yakshis or shalabhanjika figures on ancient Buddhist gateways.

One of the life-size sculptures from the side of the temple shows the

142 standing god Surya. Its debt to Pala-Sena sculpture is immediately noticeable, but there are other elements, including remote Gupta antecedents, all of which mix to create a viable art form. For example, the back slab of the stele is now completely pierced, and the figure stands almost clear in space. The trefoil arch at the top, an element borrowed

132 from Kashmiri sculpture, has become a characteristic Orissan feature. Both arms of the deity are broken at the elbow, but the large lotus blossoms which originally topped the stems held by the missing hands are still intact on the slab. Below, the seven chargers which drew the Sun's radiant chariot across the heavens are held in rein by Aruna, the half-bodied god of dawn.

This image of Surya, with its monumental presence, seems classically plain when compared with two contemporary stone figures of

144, 145 Narasimhadeva I, the builder of the Surya Temple, where the carver's skill approaches that of a jeweller. Working the stone into such exact detail as to depict each separate link of the chain supporting the Raja's swing, the sculptor is more concerned with documenting the various details of an event than with creating an aesthetic whole. In fact, these *tour-de-force* carvings impress us more as three-dimensional snapshots than as sculptures, and they delight us with an intimate glimpse into regal life. The trefoil-arch motif appears in one sculpture at the top of the swing, and in the other as a detail on the miniature shrines at the left of the devotional scene.

The two miniature shrines are fascinating because they show ritual

146 objects in use which are related to an important icon of the period, a bronze image of Vishnu with his consorts, standing in a space representative of the inner sanctum or cell of a temple. (Now in the Freer Gallery

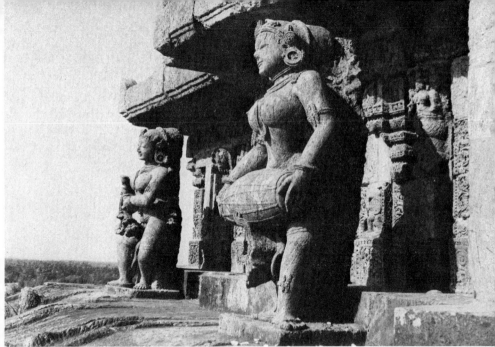

141 Konarak, Surya
Temple, figures of musicians
on the roof. Eastern Ganga,
c. 1240

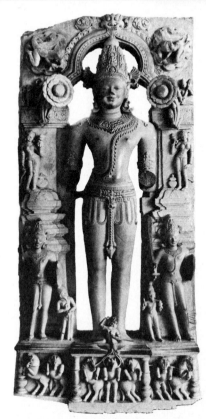

142 (right) Surya, from
the Surya Temple at
Konarak. Eastern Ganga,
c. 1240. Green chlorite,
life-size. National
Museum, New Delhi

143 (far right) Dancer
from the Surya Temple
at Konarak. Eastern
Ganga, c. 1240. Sandstone,
H. 4 ft (1.22 m). Asian
Art Museum of San
Francisco, The Avery
Brundage Collection

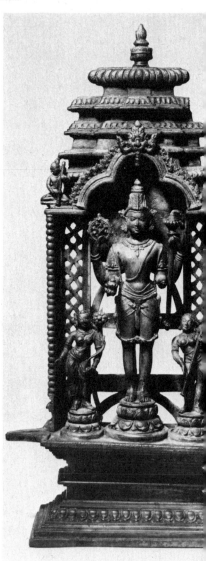

*144, 145 Raja Narasimhadeva I
swinging in his harem (left) and
worshipping Jaganath (below left).
Eastern Ganga, mid–13th C. Stone,
H. 34⅜ in. (90 cm). National Museum,
New Delhi*

in Washington, this image has been the subject of a special study by *146* Sadash Gorakshkar.) The cell dominates the space below a tower, whose architectural details include the flat ribbed capping stone and 'vase of plenty' which terminate the full-scale deuls of Orissan temples. Below, the god's head is encircled by the now-expected trefoil arch topped by a face of glory. The face is almost a duplicate of the one on the stone sculpture of Surya. *142*

In the eleventh century Abu Rihan Alberuni, the Muslim historian, told of a town in North Central India called 'Khajuraha', 'the City of the Gods'. The poetic name and renowned wealth of this temple city of the Chandella kings of Bundelkhand no doubt attracted the attention of Alberuni's Afghan patron Mahmud of Ghazni, but amazingly Mahmud never raided it, though at this time other fabled cities of Hindustan – Delhi, Kanauj, Somnath, and Mathura – were falling before the iconoclastic armies of Islam. In 1193, when the forces of Muhammad of Ghor struck into the heart of India and Muslim historians gleefully recorded the devastation of temples, those in the scrub jungle of Central India were once more miraculously bypassed. Many times cities were burned, temples despoiled, and images broken down into stepping-stones for mosques. At Delhi a tower of victory and mosque were raised *147, 155* on the site of the city's largest temple (see p. 195).

146 (opposite) Vishnu with his consorts. Eastern Ganga, 13th C. Bronze, H. 17¼ in. (44 cm). Courtesy of the Smithsonian Institution, Freer Gallery of Art, Washington, D.C.

147 Delhi, Quwwat ul-Islam Mosque, plundered Jain columns incorporated in the north colonnade about 1199

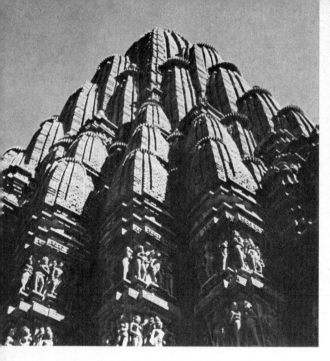

148 (left) Khajuraho, shikhara of the Kandariya Mahadeo Temple. Chandella, c. 1025–50

149 (right) Khajuraho, Parshvanatha Temple, sculpture of Vishnu and Lakshmi. Chandella, c. 950–70

Of the magnificent temples at Khajuraho, mostly built between 950 and 1050, only some twenty survive from an original total of more than eighty. But though maimed by time, they are still among the greatest examples of Medieval Hindu architecture and sculpture in North India.

Scattered today across an open and dusty landscape – once filled with the brick and wooden buildings of a thriving city – the shikharas of buff sandstone stand etched against the constant blue of the Indian sky. Their white gesso coating is gone, but they still suggest the crests of the distant Himalayas; for the Medieval Hindu temple was regarded as a 'world mountain', and its snowy whiteness fitted it to be the abode of the gods (see p. 140). The illusion is carried further in this architectural style by the way in which the central shikhara is buttressed at various levels on its sides by many lesser editions of itself. These lesser towers (*urushringas*) grow from the body of the temple below, where in multi-layered bands sculptures writhe in a pulsating tableau of human and divine activity.

148

188

Inside the structure and directly beneath the shikhara is the 'holy of holies' which enshrined an image of the deity to whom the temple was dedicated. Around this central cell there is often a circumambulatory passage, and adjacent to the assembly rooms, facing the cell, are small side porches. Here a soft light filters across the surfaces of sculptured figures which overflow into the chamber from the active and textured exterior.

No imagination is needed to conjure up a vision of the temple dancers, or *devadasis*, who once swirled before the deity's cell, for the sculptors at Khajuraho have frozen their grace into the sandstone of the ceilings and walls of the various temples. In the form of *apsaras*, or heavenly nymphs, *149* their lithe bodies, highly ornamented and full-bosomed, display all the attitudes of dance and gesture. Here one applies *kohl* to her eyes, another removes a thorn from her foot. There one feeds a bird sitting on her shoulder, while a companion wrings out her hair. Multi-armed gods stand formally supporting symbols of their actions and identities, while between them fantastic monsters threaten. Elephants resplendent with harnesses of jewels proceed between stylized lotus blossoms. There is also an abundant display of erotic sculpture, for reasons which – as at Konarak – are not fully understood. Again as at Konarak (see p. 182), it may reflect the activity of Tantric cults.

The shrines at Khajuraho, unlike the multi-unit temples of Orissa, consist of one compact architectural unit standing on a high plinth. Khajuraho is further notable in that both the style and the site were shared by Vaishnavite and Shaivite sects, and even by the Jains.

Khajuraho is dominated by the great Kandariya Mahadeo Temple *150* dedicated to Shiva, built from about 1025 to 1050. Buttressed by eighty-four subordinate towers and ringed by sculptural friezes, its tower soars 102 feet into the air and is the most impressive structure at the site. Kandariya Mahadeo is matched in excellence only by the Jain temple dedicated to the twenty-third Tirthankara, Parshvanatha, which is *151* smaller and earlier (*c.* 950–70), and may in fact have served as the model for the larger temple.

The sculptures on the Parshvanatha Temple are the very finest examples of the famous Khajuraho style, which can best be described as an extension and elaboration of architectural form. The figures not only mass into unified decorative panels, to create monumental surfaces, but

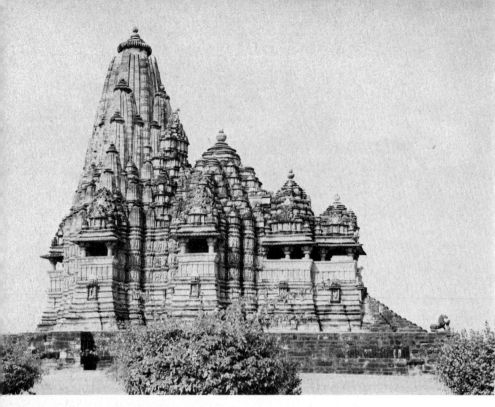

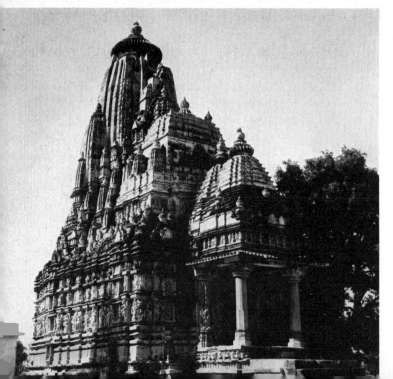

150 Khajuraho, Kandariya Mahadeo Temple. Chandella, c. 1025–50

151 Khajuraho, Parshvanatha Temple. Chandella, c. 950–70

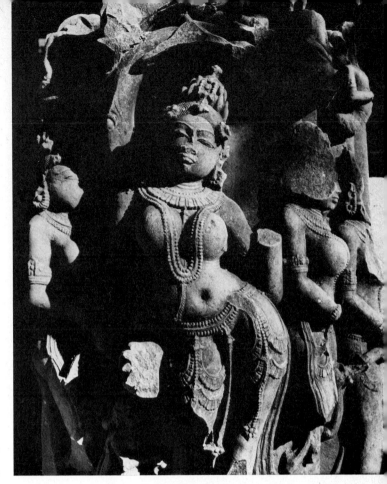

152 Khajuraho, crowned figure of a female deity. Chandella, c. 950

also emerge as individual human images which are pervaded by a languid eroticism. Carved with an eye to geometric simplicity, the stone is styled into distinct angular planes (suggesting somewhat stilted actions) and rounded volumes. This can lead to clichés, but also to vivid images of grace and vitality. On the southern façade of the Parshvanatha Temple Vishnu and Lakshmi appear accompanied by a lissome apsaras *149* applying make-up to her eyelid. At ground level near by is an exceptionally beautiful crowned female deity, who radiates the sensual *152* vitality for which these Khajuraho beauties are celebrated. She is richly bejewelled, and her full, high breasts and narrow eyes combine with the tribhanga pose to suggest an almost feline movement. The grace of her pointed nose is now lost, but the full, square-set jaw is intact.

191

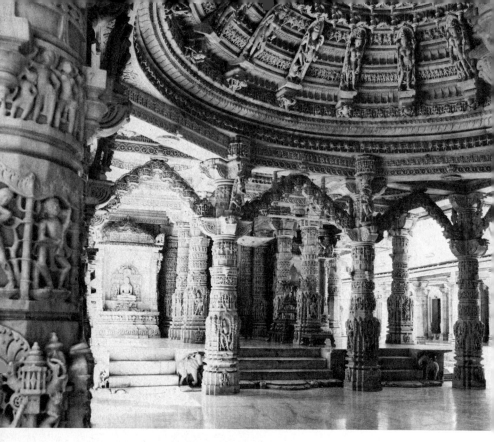

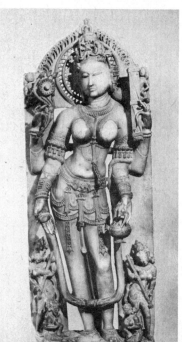

153 *Mount Abu, Vimala Sha Temple, 1032*

154 *Sarasvati, Jain statue from Pallu, Bikaner. Solanki, probably 12th C. Marble, H. 37 in. (94 cm). National Museum, New Delhi*

Jainism, like Buddhism, had spread across most of India, and by the late Medieval period had attracted a strong following among the mercantile communities of Western India. In South India the sect had been persecuted out of existence, but the West became a haven for Jain monks, as wealthy merchants accrued merit by establishing temples and monasteries. Throughout Saurashtra, Gujarat and west Rajasthan are countless Jain monuments which survived the devastating Muslims or which were restored or commissioned after the invasions. Their survival testifies to a continued and impassioned support of this austere faith.

Exemplary among the numerous Medieval Jain temple complexes are the shrines of Mount Abu in south-west Rajasthan. Here in the flat, arid wastes of Western India rises a singular peak, 4000 feet high, which in ancient times, according to mythology, had been created by the gods. On this holy summit from 1032 to 1233, at the very time when the Islamic invasion was elsewhere destroying temples, the Jains brought the late Medieval architectural and sculptural styles of Western India to a last flowering. The two outstanding examples are the Vimala Sha Temple (1032) and the Tejahpala/Vastupala Temple (1233).

The Vimala Sha Temple, the earlier and more important, was dedicated *153* to the first Jain Tirthankara, Rasabhanatha. It stands in an open rectangular court defined by fifty-eight subordinate cells which contain small icons duplicating the saint's image in the main shrine. The plan is reminiscent of the Kashmiri Sun Temple at Martand. Elaborate columned porticoes surround the main shrine and front the cells lining the courtyard. Everything is carved from white marble.

From outside the temple, with its low domes, appears undistinguished; but inside a shimmering filigree of marble gathers into complex patterns of frozen beauty. The delicacy of the design makes believable the traditional account that the sculptors did not carve the marble with tools but worked it with abrasive cords, and were paid according to the amount of marble dust amassed by the end of the day.

The same sculptural style appears in an ornate free-standing image of the goddess Sarasvati, whose presence in a temple at Pallu in the desert *154* State of Bikaner, more than 300 miles north of Mount Abu, illustrates how statues were exported far beyond the places of their creation in south-west Rajasthan or Gujarat.

Sarasvati, goddess of learning and music, is of ancient origin and is mentioned in the *Rigveda* as the 'word' which bestows wealth and is the possessor of knowledge. At times she is associated with Vishnu, but she is generally acknowledged to be the consort of Brahma. Her vehicle is a swan or goose. She is especially honoured by the Jains. Her four hands hold attributes illustrating her virtues. The upper right hand supports a white lotus, which is matched in the left hand by a long palm-leaf manuscript. The lower right hand performs the gift-bestowing varada mudra, and the remaining one holds the ritual water-vessel. Sarasvati's main attribute is the classical musical instrument, the vina, which is here played by two small duplicate images of the goddess standing below and behind the worshipful donor figures seated on the base.

The figure has an almost Mannerist fluidity which is reminiscent of the work of the mystical English artist William Blake. Anatomical details are stylized and exaggerated until the body's elements seem merely symbolic, without muscle or bone. The aesthetic of polished stone surfaces, which produced the finish on Mauryan sculptures in the third century BC but is relatively rare in Indian sculpture, here re-emerges as a central aspect of late Medieval art.

The Northern Medieval sculptural styles eventually deteriorated through endless repetition, their forms becoming angular clichés devoid of life and grace. It is as if the once-breathing sculptures had flinched and frozen under the cold iconoclastic eye of Islam.

Islamic India: architecture and painting

Islam first came to India by sea when Arab traders conquered Sind in 712. The main thrusts started, however, almost three centuries later, when the banners of Islam began to be carried through the northern passes of the Hindu Kush by nomadic bandits and raiders. Eventually, when they caught the smell of empire, the Afghans, the Turks, and the Persians came to stay.

The city of Delhi had no clear history until the advent of the Muslims in the late twelfth century. It is first recorded in the late tenth century, when as Lalkot it was a provincial Rajput centre. It was in fact the ruler of Lalkot, Prithvi Raj, who rallied Rajput forces for an unsuccessful stand against Muhammad of Ghor's Afghan army in 1192.

To commemorate this decisive victory of Islam over the Hindus, Muhammad's general and viceroy, Qutb-ud-din Aibak, raised the earliest surviving mosque in India at Delhi. A mosque, or *masjid* ('place of prostration'), is a communal place of worship for Muslims and its first and most primitive forms used on the subcontinent were probably no more than open compounds defined by ropes hung with rugs, or single walls oriented (to the west in India) towards Mecca.

The magnificent Quwwat ul-Islam or 'Might of Islam' Mosque, erected on the site of Delhi's largest Hindu temple, is distinguished first by a 212 by 150-foot open rectangular courtyard. This is contained, on three sides, by rows of stone columns pillaged from some twenty-seven *147* local Hindu and Jain shrines. The western or Mecca side of the courtyard is dominated by an open cloister or hall (*iwan*) emphasized by a grandly carved arcade of five pointed arches, of which the central one is 45 feet high. To the south-east of the courtyard soars the great Qutb ('pole' or *155, 156* 'axis') Minar, which rose originally to a height of some 238 feet. It was haughtily erected as a tower of victory, and its inscriptions proclaim its purpose – to cast a long shadow of God over the conquered city of the Hindus.

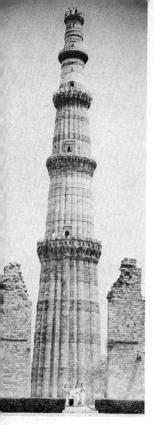

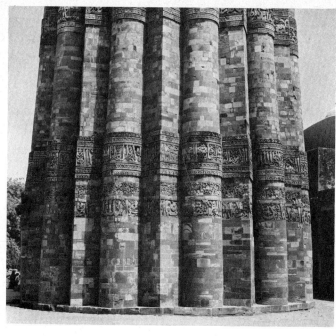

155, 156 Delhi, Qutb Minar. Slave Dynasty, begun 1199

The minaret appears to have originally evolved from the low square towers found on pre-Islamic temples in Syria. Later in Western Asia it seems to have been further influenced by a Persian type of burial-tower that was circular or fluted in plan. The immediate models for the Qutb Minar must have been those of Ghazni in Afghanistan, the home of the Turkish-Afghan conquerors of Delhi, which have star-shaped ground-plans.

Qutb-ud-din employed the local Hindu craftsmen of Delhi, and their beautifully detailed stonework is everywhere in evidence. The pointed arches of the mosque's western screen were constructed using only traditional Hindu corbelling techniques; and around these arches and on the decorative bands encircling the minar the craftsmen carved *156* inscriptions from the Koran, in elegant Naskhi script, interspersed with floral designs of Indian origin. Thus a new, hybrid art form was created for Islam's first major monument in India.

196

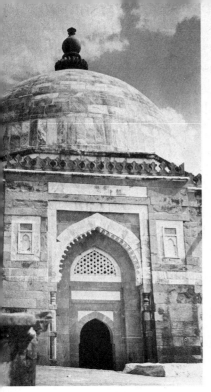
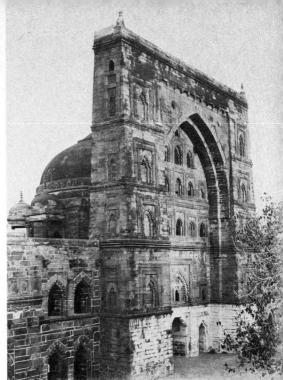

57 (left) Delhi, tomb of Ghiyas ud-din Tughlaq Shah I. Tughlaq, 1325

58 (right) Jaunpur, Jami Masjid. Sharqi, 1470

Between the time of the establishment of the Slave Dynasty at Delhi, early in the thirteenth century, and the arrival of the Mughals in the sixteenth century, various Muslim dynasties crossed the historical stage of North India. The Tughlaqs, later in the thirteenth century, built austere and monumental buildings in the Afghan style at Delhi. In the 157 fifteenth century their successors to the east, the Sharqis, created at Jaunpur in the Doab a group of unique mosques distinguished by lofty 158 iwan gateways whose flat, massive façades obscure their central domes. At the same time the Afghans established the Lodi sultanate at Delhi. Its rulers again cultivated a transplanted Persian culture and once more brought it to a brief but lustrous flowering in North India. They practised sophisticated courtly manners, and appreciated elegant literature and poetry. They also constructed numerous buildings around Delhi, whose low domes and thick walls significantly influenced 159 architectural tastes long after the Lodis were gone.

197

At the end of the first quarter of the sixteenth century the Lodis were displaced by a new invader, and the Indo-Islamic culture reached an apogee of brilliance under the early rulers of the Mughal empire at Delhi and Agra.

The blood of Timurlane and Chinghiz Khan flowed through the veins of the conqueror who founded that empire, Babur (ruled 1526–30). He was a soldier, but he was also a man tempered by a sensitivity to scholarly and aesthetic pursuits. His son, Humayun (ruled 1530–56), became its first true emperor.

In 1540 Sher Shah, an Afghan rebel from Bihar, rose and forced Humayun to flee to Persia into a fifteen-year exile. In the course of this flight across the Western Desert, Humayun's son was born – Akbar, who was to be the star of the dynasty (ruled 1556–1605). While at the Persian court of Shah Tahmasp Safavi, Humayun became enamoured of the art of miniature painting and resolved to take Persian artists back to India when he reconquered it. So when in 1555, with the aid of Shah Tahmasp, he retook Delhi, he brought to India two Persian masters, Mir Sayyid Ali and Abdus Samad. They were to become the nucleus of the new Mughal School of Indian painting.

159 Delhi, tomb of Isa Khan. Sur dynasty, in Lodi style, 1547

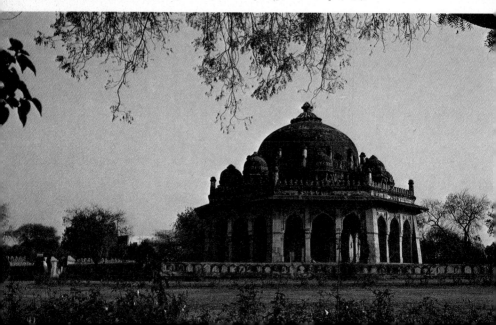

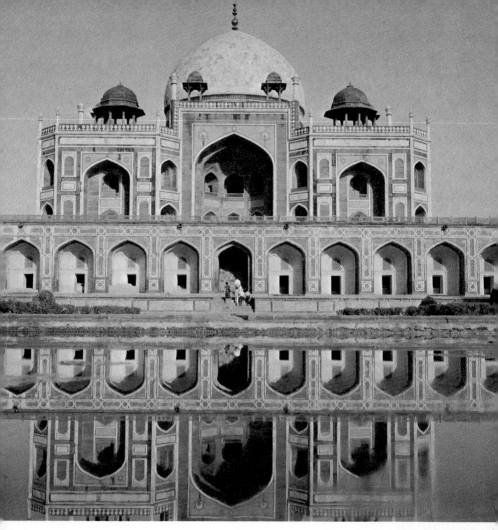

160 Delhi, tomb of Humayun. Mughal, Akbar period, 1565–72

A year after regaining his Indian empire Humayun was dead, and the fourteen-year-old Akbar sat on the Mughal throne. He never learned to read or write, but he had a great intellect and remembered every word read to him, taking great delight in this manner of instruction. As a boy with his father in Kabul, on the way back to India from exile in Persia, he had taken drawing lessons and had developed an avid love for paintings.

His curiosity was robust in matters of religion, and he eventually founded a new religion (Din-i-Illali), composed of what he considered the virtues of several religions, which he and his close associates followed, to the dismay and discomfort of the devout Muslims at court. A cardinal element in the success of the Mughal empire resulted from Akbar's policy of tolerance for his non-Muslim subjects.

165 It is paradoxical that such a man as Akbar, with interests in animals and outdoor life, who enjoyed such dangerous sports as elephant fighting, would delight in music, poetry, and painting. His most trusted friend was a Hindu musician, and his writers and painters were honoured for their activities.

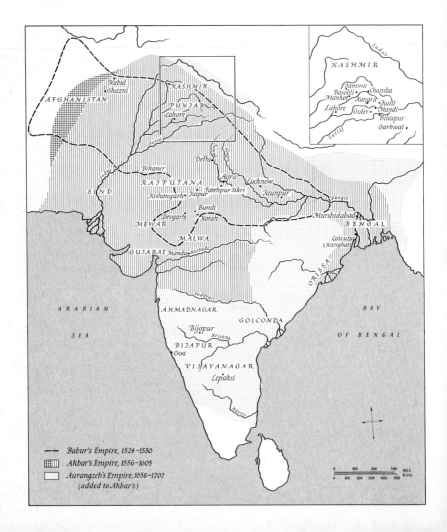

Babur's Empire, 1524–1530
Akbar's Empire, 1556–1605
Aurangzeb's Empire, 1658–1707
(added to Akbar's)

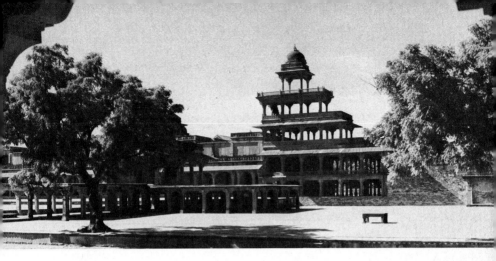

162 Fatehpur Sikri, Panch Mahal (Palace of Five Storeys). Mughal, Akbar period, begun 1571

Akbar's impassioned interests also included architecture, and this led him to build a royal city at Fatehpur Sikri, near Agra, and a fort and palace in Agra itself. In these structures Islamic and Hindu elements were deliberately blended, reflecting the emperor's desire to integrate culturally his diverse nation. *162*

One of the earliest and most significant manifestations of the new style is the design for Humayun's tomb, constructed in 1565 at Delhi by the late emperor's widow. Despite its low dome and use of red sandstone, ornamented with inlaid white marble decoration, this masculine synthesis of Persian and Indian design probably formed the basic model for a later Mughal architectural wonder, the Taj Mahal. *160* *169*

Inspired by the fulfilled prophecy of a Muslim saint who had predicted the birth of his son and heir Salim, the future emperor Jahangir, Akbar undertook the construction of a completely new city – Fatehpur Sikri – on the remote site of the holy-man's retreat, 26 miles west of Agra. For a period of about fifteen years, starting in 1571, a ceremonial capital, including elaborate palaces, formal courtyards, reflecting pools, harems, tombs, and a great mosque, was erected. Over an area two miles long and a mile wide the city rose to completion out of the feverish activity of an army of masons and stone-carvers. They had hardly completed their labours when, due to royal distractions and a lack of an adequate water-supply, the pristine stone palaces were abandoned. *162*

161 The Mughal empire, and centres of miniature painting

One of Akbar's most significant contributions was the creation of the Mughal School of painting. He established a State atelier where about a hundred artists, mostly Hindu, worked under the guidance of the two Persian masters brought to India by Humayun. At the time of Akbar's death in 1605 his library contained some 24,000 illuminated manuscripts.

163 The first major production of the Mughal studio was probably begun under Humayun, but was completed about 1579 under Akbar's attentive eye. This was the Persian *Dastan i-Amir Hamza* or *Romance of Amir Hamza* (also known as the *Hamza-nama*) which consisted originally of twelve unsewn folios with over 1400 individual paintings on cloth. The pictures are unusually large – over two feet high – and have the text written on the back, apparently so that they could be displayed while the romance was read aloud at court. The 'Akbari Style' was a blend of Persian art with native Indian elements, distinguished from its decorative Persian prototypes by an extended sense of space and an agitated action rarely seen in Persian art. The finest examples of Mughal painting are not only lively and realistic, but even contain elements of individual portraiture. These distinctive qualities would not only continue in later Mughal painting but would eventually affect Rajput art as well.

Early in Akbar's reign the Portuguese had established trading-posts in India, and in 1578 Akbar requested that a delegation of Jesuit Fathers from the Portuguese colony of Goa attend him in Fatehpur Sikri. As gifts for the emperor whom they hoped to convert to Christianity they brought illustrated Bibles and religious pictures. These so fascinated Akbar that he immediately instructed his own painters to emulate their qualities. Thus European realism was added to the embryonic Mughal style; and a number of miniatures even depict Christian subjects.

164 A characteristic example of this hybrid art is a page from a manuscript of the *Khamsa* of Amir Khusrau, made for Akbar about 1595. It shows an apocryphal event in the life of Alexander the Great, when he was lowered into the sea in a glass 'diving bell'. The subject is given a contemporary setting, with figures that are typical of the artist's time, including even some Europeans; but the most remarkable aspect of the painting is its subtle colour and the atmospheric treatment of the landscape. Here for all practical purposes a sixteenth-century Flemish scene, complete with aerial perspective, has been transplanted into an Indian miniature. The sure, descriptive draughtsmanship, the refined elegance

163 Gardeners beating the giant Zamurrad entrapped in a well, from the Romance of Amir Hamza. Mughal, Akbar period, 1555–79. Paint on cloth, $26\frac{3}{8} \times 19\frac{5}{8}$ in. (67×50 cm). Victoria and Albert Museum, London

of the colour, and the imaginative organization of the composition are distinctive elements of the now-mature style. In its latest phase the style moved even further towards realism, and another late Akbari miniature, from the *Akbar-nama* or history of Akbar, depicts an action-filled incident: 165 Akbar on one elephant chases another across a pontoon bridge as the bridge collapses into the river Jumna.

Akbar's encouragement of painting, like his excursions into religious liberalism, was strongly opposed by the orthodox members of his court.

These traditionalists smeared faces on miniatures with moist thumbs in obedience to the Koranic prohibition against portraying any soul-possessing creature. But Akbar's reply was: 'It appears to me as if a painter had quite a peculiar means of recognizing God; for a painter in sketching anything that has life ... must come to feel that he cannot bestow individuality upon his work, and is thus forced to think of God, the Giver of Life, and will thus increase in knowledge.'

Mughal painting that reflects Akbar's policies of cultural synthesis can be traced from its flat decorative beginnings through a blending with the lively Rajasthani style, and finally to its move towards realism. This last phase, stimulated, as we have seen, by European pictures, included such novel features as golden haloes and cherubs above the emperor's *167* head, shading on faces, atmosphere in landscapes, and a more frequent *164* and more accurate use of perspective.

From the study of unfinished paintings the working procedures of Mughal artists have been reconstructed. Kuhnel writes, 'On the paper which had been carefully burnished, the preliminary drawing was made with red ink – which, after necessary corrections, was restated in black. Then the sheet was coated with a thin wash of white pigment. On this surface, with gouache colours, the actual miniature was painted. Finally, gold was placed where necessary, and the complete miniature was burnished again.'

When the great Akbar died in 1605, his son became emperor as Jahangir (ruled 1605–27). Although never the giant his father had been, *167* Jahangir was a true connoisseur of art and encouraged high-quality productions from the imperial atelier. He prided himself on his ability to recognize the works of individual artists: as some specialized in certain aspects of painting (such as faces, costumes, or landscapes), one picture could contain the work of several men.

The emperor also had a great love of animals, birds, and flowers, and his artists were pressed to record the many varieties from all regions of the empire. The chenar or plane tree, which grows in Kashmir, is the *166* subject of a particularly fine painting of the Jahangir period. There the sparkling rich colours and patterned textures emulate the squirrels' agitated voices as they scatter above the fowler climbing the trunk.

Jahangir was less interested in book production, preferring por-traiture and illustrations of the various events which occurred during

164 Alexander lowered into the sea, from the Khamsa of Amir Khusrau. Mughal, Akbar period, c. 1595. Paint on paper, 9⅜ × 6¼ in. (24.7 × 15.8 cm). The Metropolitan Museum of Art, New York, Gift of Alexander Smith Cochran, 1913

205

165 *Miniature from the Akbar-nama of Abul Fazl. Outline by Basawan and painting by Chatai; Mughal, Akbar period, c. 1595. Paint on paper, $13\frac{7}{8} \times 8\frac{3}{4}$ in. (35.2 × 22.2 cm). Victoria and Albert Museum, London*

166 *Squirrels in a chenar tree. Attributed to Abul Hasan; Mughal, Jahangir period, c. 1615.*
Paint and gold on paper, $14\frac{3}{8} \times 8\frac{7}{8}$ in. (36.5 × 22.5 cm). India Office Library, London

his reign. His artists recorded the pomp and colour of the court, and in the end they became more accurate chroniclers of the times than were the historians with their flattery. They went on hunts and into battle; elephants, women, generals, slaves – all became subject-matter for the royal miniature paintings.

In his later years, Jahangir became less and less effective. He became addicted to wine well laced with opium, and as his physical powers slipped, so did his ability to rule effectively. A group of brilliant paintings made near the end of his reign vividly record his pitiable condition.

Richard Ettinghausen (Delhi, 1961) has perceptively discussed the amazing assemblage of symbolism which permeates one miniature. It shows Jahangir, whose name means 'the World-Seizer', enthroned on an elaborate hour-glass. He is backed by a huge halo composed of the sun and moon which in its dramatic scale is reminiscent of the large nimbuses of Mathuran Buddhas of the Gupta period. Such celestial brilliance may allude to the emperor's name of Nur ad-din (Light of Religion) since Jahangir is also shown handing a book to a bearded *mullah*, or religious teacher. An inscription suggests that the emperor is more piously concerned with spiritual matters, and that 'although to all appearances kings stand before him, he looks inwardly towards the dervishes [for guidance]'. Below the mullah are portraits of the Ottoman sultan conquered by Jahangir's ancestor Timurlane and James I of England. The figure at the bottom holding a painting may be the artist, Bichitr, who created this remarkable work. The excellent portraiture is an aspect of miniature painting that reached its peak under Jahangir. The two *putti* flying away at the top appear to lament the emperor's rejection of statesmanship in favour of religion, while larger cupids at the bottom of the throne/hour-glass attempt to counter the effect of the steady flow of the sands of time by writing over the glass, 'O Shah may the span of your life be a thousand years.'

Rich and elegant as they are, the art works of the court of Jahangir's son, Shah Jahan (ruled 1628–58), show the first signs of decline. They are perfect, but of a perfection that is beginning to become lifeless and cold. Such was the mood of the many regal buildings of white marble erected across the empire.

Even in his early years, architecture seems to have held the attention of Shah Jahan more than anything else. The central masterpiece inspired

167 (left) Jahangir seated on an allegorical throne. By Bichitr; Mughal, Jahangir period, c. 1625. Paint and gold on paper, 10 × 7¼ in. (25.3 × 18.1 cm). Courtesy of the Smithsonian Institution, Freer Gallery of Art, Washington, D.C.

168 Portrait of Shah Jahan, inscribed 'a good portrait of me in my fortieth year, by Bichitr'. Mughal, Shah Jahan period, c. 1632. Paint on paper, 8¾ × 5¼ in. (22.1 × 13.3 cm). Victoria and Albert Museum, London (Crown Copyright)

by his interest is without question the mausoleum for his queen, Mumtaz Mahal, at Agra – the Taj Mahal (1632–54). Situated in a formal garden, backed by the Jumna river, its formal white marble façades and minarets float in the shimmering Indian sunlight and project a vision of beauty and grandeur which is remote from the realities of the world. *169*

The Taj's basic plan of a faceted cube is thought to have originated with the tomb of Humayun and the now-ruined mausoleum for the Khan i-Khanan, both at Delhi. But unlike these Akbar period structures, which were finished with red sandstone, the Taj has pure white marble façades. The fabric contributes to the over-all effect of delicacy and denies the existence of the heavy rubble construction inside it. The *160*

169 (above) Agra, Taj Mahal. Mughal, Shah Jahan period, completed in 1653

170 (left) Agra, Fort, pietra dura inlay in the Musamman Burj. Mughal, Shah Jahan period, c. 1637

171 (opposite) Delhi, Red Fort. Shah Jahan period, after 1638. Painting by a Delhi artist, c. 1820. India Office Library, London

translucent whiteness of the marble is subtly contrasted with a tracery of black stone, inlaid in geometric patterns and Islamic inscriptions. Additional grace is given by the dome, which rises on a high drum over a lower internal dome, as in the tomb of Timurlane at Samarkand. Ultimately the Taj Mahal must be experienced in person, not in two-dimensional photographs. Photography consorts with the building's formal geometry to deny its mammoth size and simultaneous lightness. One can only agree with a contemporary Mughal reaction that the Taj defies an 'ocean of descriptions'.

Shah Jahan also enriched the Red Fort at Agra, not only with the Moti Masjid or Pearl Mosque (1646–53), so called because of its white marble fabric, but also with a series of palaces in its western wing where *170* their elegance strikingly separates them from their robust surroundings, built of red sandstone by his father and grandfather.

He also renovated the fort at Lahore and in 1638, in anticipation of transferring the royal court from Agra to Delhi, began laying out a new walled city, Shahjahanabad (the present city of Old Delhi), along the west bank of the Jumna. There he erected another Red Fort – its *171*

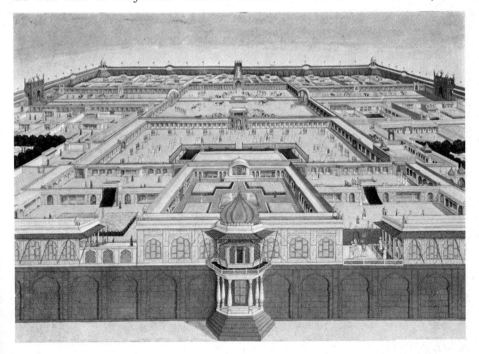

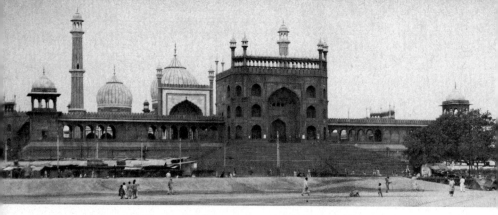

name, as at Agra, alluding to the red sandstone of its walls – and furnished it with superb white marble pavilions decorated with gold, precious stones, and inlays of *pietra dura* work. The latter, an exacting technique

170 of creating multicoloured stone mosaics of flower patterns, etc., may have originated with Italian craftsmen working at the Mughal court. Each stone is fashioned perfectly to fit a complementary shape carved into a marble panel. When all the component pieces have been inset, the surface is polished to a glittering smoothness.

172 An integral element in the design of Shah Jahan's Delhi was the Jami Masjid, built on a high plinth not far from the palace-fortress. The largest mosque in India, it has an open courtyard enclosed by a low arcade with three grand gates at north, east, and south, approached on the exterior by stairways. On the west side three bulbous domes and two massive minarets rise above the covered iwan containing the *mihrab*, or niche which orientates the worshipper towards Mecca. This holy building provided the new city not only with an imposing place of worship but also with an imposing ceremonial centre.

The Mughal empire maintained its splendour and its power as long as the momentum of Akbar's strength and enlightened attitudes prevailed. The power extended through three successive reigns, but when Akbar's great-grandson, Aurangzeb (ruled 1658–1707), violently wrenched the Peacock Throne from his father, Shah Jahan, the decline could not be disguised. He reinstituted the strict orthodox laws of Islam and withdrew imperial patronage from the arts. His change of attitude had an equally devastating effect upon the hitherto tolerated Hindu subjects of the empire and upon many Mughal painters and musicians, who drifted into the service of petty nobles and of the Hindu courts of Rajasthan.

Aurangzeb, who had perhaps approached the Mughal throne with more resolve and piety than either his father or his grandfather, after twenty-four years of fruitless campaigning in the Deccan saw the empire he had so purposefully administered and sought to strengthen crumble and collapse. Following his death in 1707 the Mughal empire shrank to the environs of Delhi and began to wane into legend.

The imperial atelier, however, had not been completely disbanded during Aurangzeb's reign, and many artists were still on hand when a revival of patronage occurred under his great-grandson, Muhammad Shah (ruled 1719–48). The Mughal painting style was revitalized, and although in 1739 Delhi was sacked and its inhabitants massacred by the Persian invader Nadir Shah, an elegantly idealized depiction of *173* royal lovers, of about 1740, denies the terrors of the period in which it was created. Like others of the meticulously finished paintings of the 'Muhammad Shahi Revival', it contains certain stylistic elements, such as romantic faces and a lavish rendering of nature, which would soon infuse new refinements into the Hindu school evolving at Guler in the *192* Himalayan foothills.

Finally, in sections of the former empire, such as Murshidabad in Bengal and Lucknow in Oudh, a shadow of the former imperial style was kept alive, and subjects a hundred or more years old were copied, as if to recapture the heroic grandeurs of the past.

172 (opposite) Delhi, Jami Masjid. Mughal, Shah Jahan period, 1644–58

173 A Prince offering Wine to his Mistress (detail). Mughal, Muhammad Shah period, c. 1740. Paint on paper, complete miniature 5¼ × 4¼ in. (13.3 × 10.7 cm). Collection of Edwin Binney, 3rd

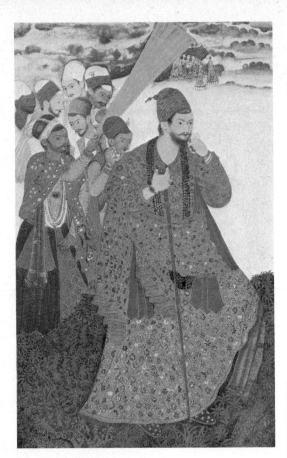

174 (left) Ibrahim Adil Shah II of Bijapur. Deccani, Bijapur, c. 1590–95. Paint and gold on paper. Collection of the Maharaja of Bikaner

176 (opposite) Subduing an enraged Elephant. Deccani, Bijapur or Golconda, c. 1600. Paint and gold on paper, $11\frac{1}{4} \times 8\frac{1}{4}$ in. (28.5 × 20.9 cm). Collection of Edwin Binney, 3rd

175 A Tree blossoms at the Touch of a beautiful Woman, from the Tarif i-Husayn Shahi. Deccani, Ahmadnagar, c. 1565–9. Paint and gold on paper, $7 \times 5\frac{1}{4}$ in. (18 × 13.3 cm). Bharata Ithasa Samshodaka Mandala, Poona

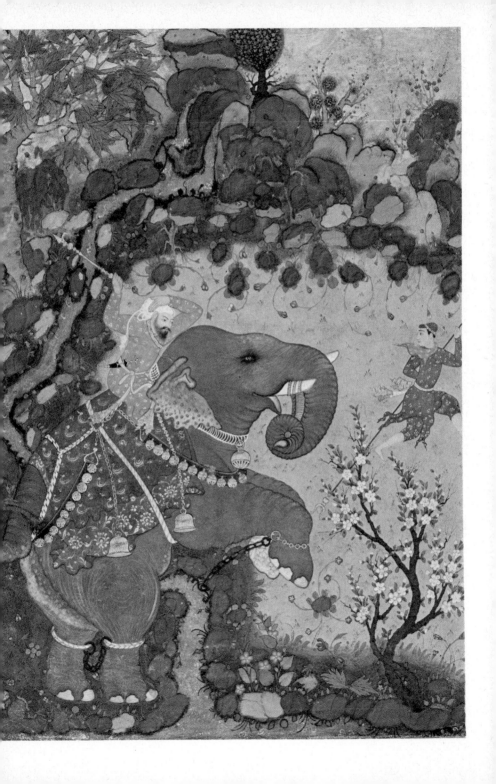

While Mughal painting was developing under Akbar, in the second half of the sixteenth century, the art form was evolving independently in the Islamic kingdoms of the Deccan.

Here in the middle of the fourteenth century the Afghan followers of Muhammad Tughlaq of Delhi had revolted to establish an independent kingdom under the Bahmani dynasty. For almost a hundred years a certain unity was maintained, but in the late fifteenth century several areas began breaking away. Finally in 1526 the Bahmani dynasty disappeared and the Muslim courts of Ahmadnagar, Bijapur, and Golconda emerged as the dominant powers in the South. There they became the effete and quarrelsome neighbours of the great Hindu kingdom of Vijayanagar. In 1565 they united briefly and destroyed the rich capital of Vijayanagar, but the alliance at once dissolved, and the three returned to their languid and introverted ways, to await the ultimate dominance of the Deccan by the Mughals.

The evolution of the Deccani painting styles and their exact provenance are still the subject of scholarly investigation. However, it is generally accepted that the earliest known Deccani miniature paintings 175 are those illustrating the Persian-style epic *Tarif i-Husayn Shahi*, which is a poetic account of the Ahmadnagar ruler Husayn Nizam Shah I (ruled 1553–65), and was commissioned by his mother when she served as regent, *c.* 1565–9. The page shown complements the text and flatters the feminine patron, while being a bold, virile work which in its totality is unlike any previous Indian creations. The elongated faces, oversize jewellery and tall, slender figures draped in saris that cross their breasts in the Southern fashion, are Deccani inventions. The same faces and large ornaments had already appeared in the *Ni'mat-nama*, painted some fifty years earlier at Malwa in Central India (see p. 225), and the elongated faces and figures are also dominant motifs in the Vijayanagar-style wall-paintings in a Hindu temple at Lepaksi, south of Ahmadnagar, created about 1540.

In general the painting styles which developed in the Deccani sultanates were marked by refined elegance, sensitivity to colour, and love of decorative detail. Beside those elements which appear to be of Hindu origin, Iranian, Turkish, and European influences seem to have arrived directly in the South through a flourishing sea trade, instead of coming

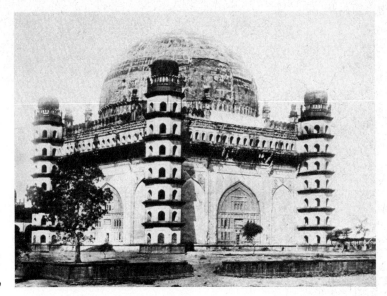

177 Bijapur, Gol Gumbaz, left unfinished in 1660

second-hand from the Mughals in the North. The Deccani works perhaps never reached the Mughal level of technical excellence, but they have an easy-going opulence, reflected in elaborate detail and dramati- 176 cally conceived compositions, rich with gold. In fact, unlike Mughal painters, the Deccani artists from the beginning tended less to realism and more towards an idealized imagery. This suggests strongly that Hindu painters displaced from Vijayanagar after its fall in 1565 may have been leading figures in the Deccani workshops.

One of the greatest of the royal Deccani patrons was Ibrahim Adil 174 Shah II of Bijapur (1580–1626). Ibrahim was not only an accomplished musician but also a painter equal to any in his atelier. There are several famous paintings of *ragamalas* (Hindu musical modes) known to have originated at Bijapur during his reign, and one painting is believed to show him holding wooden rhythm clappers used by musicians.

Ibrahim died in 1627, as did Jahangir, and that year might be said to mark the beginning of the decline of both Mughal and Deccani painting. Ibrahim was followed on the throne of Bijapur by Muhammad Adil Shah (ruled 1626–56), who is remembered chiefly for his tomb, the Gol 177 Gumbaz. With a dome 178 feet high, the tomb is one of the world's largest domed spaces, and it is also the most significant Islamic building in the Deccan; but its architectural presence is less than distinguished – a fault that might perhaps have been remedied if it had ever been finished.

178 Detail from a Jain Kalpa-Sutra manuscript. Western India, early 16th C. Paint on paper. Private Collection

179 Bilhana and Champavati, from the Chaurapanchasika series. Possibly Uttar Pradesh, c. 1525–70. Paint on paper, 6½ × 8½ in. (16.5 × 21.6 cm). N.C. Mehta Collection, Culture Centre, Ahmadabad

Jain, Rajasthani and Pahari painting

Long before the first century A D paintings were used in India as illustrations for volumes of sacred scripture. These first 'books' were composed of slim, delicate palm leaves, seldom more than two inches in height, *180* threaded on cords which secured them between flat wooden covers. The oldest to survive date from the eleventh century. They are the Pala Buddhist manuscripts from Bihar and Bengal and those of the Jains of Western India.

The calligrapher who dealt directly with the sacred text was considered the paramount craftsman, and (as W. N. Brown observed in his detailed studies of Jain paintings) while ruling in the guidelines for his script he indicated the area and subject-matter for the illustration. Only after he had written out the text was the leaf handed over to the painter.

The few remaining Pala palm-leaf illustrations are sophisticated in line and colour, with figures modelled closely upon the Pala sculpture of the late Medieval period. Scattered before the wrath of Islam in the late twelfth century, the Buddhist community and their Pala-style art were transplanted to Nepal and Tibet, where in remote Himalayan monasteries the style was repeated endlessly, in a static and desiccated form, down to recent times.

WESTERN INDIAN PAINTING

The 'Western Indian School' of Jain palm-leaf painting was treated *180* more kindly by history. It flourished under the patronage of the Jain merchants and shipbuilders of Gujarat, whose wealth permitted them to fill the libraries with sacred texts. The style is flat and decorative. Its early palette was generally restricted to simple reds, yellows, some blue, gold, black, and white. The vigorous quality of the drawing line is its most distinctive virtue, though even that remained formalized.

A distinguishing characteristic of early Jain painting is that in profile heads both eyes are shown – a device that anticipated twentieth-century Cubism's attempt to display all sides of an object simultaneously. The feature may be due to the artists' use as models of temple sculptures of the type seen at Mount Abu and elsewhere, which had bulging glass eyes added to enhance the realism of the image.

We know that paper came to India through Persia during the second half of the 1300s, and that the transition in Western Indian painting from palm-leaf to paper had more or less taken place by the beginning of the fifteenth century.

The same Jain trading vessels that had brought paper to India were responsible for importing blue pigment, and it too was to have an effect on Jain painting. By the sixteenth century the solid red backgrounds, traditionally used as the basic panel for each illustration, had changed *178* to blue. The change is a key factor in determining the date of Western Indian paintings. More greens and blues were added to a brightening palette, and with the adoption of a paper ground the brushwork became more elaborate and detailed than had been possible on the palm-leaf surface.

The use of paper also allowed the paintings to expand vertically, and in the vertical format they tend to have a Persian flavour. Nevertheless the artists often retained a number of strong horizontal elements inherent to the palm-leaf tradition, and at first they stacked their pictorial elements on top of one another. Unlike the earliest paintings, which *180* featured Jain saints, gods and patrons, the later works began to contain more narrative and to make wider use of foliage, animals, and elaborate architectural settings.

The gradual acceptance of the 'Persian' or vertical format is particularly noticeable in the development of Rajput miniatures, as they evolved out of Western Indian art. An example is what is believed to be a late fifteenth-century manuscript from the Uttar Pradesh area of *181* North Central India, illustrating the *Laur Chanda* (a love-romance, still popular today). The angular outlines of the bodies and two-eye profile proclaim it to be an offshoot of the Jain painting style, but its vertical format is dramatically different. A preference for that format in Indian painting was later reinforced by the influence of Mughal painting upon Rajasthani styles.

180 *Detail from a Jain palm-leaf manuscript, showing a monk and disciple. Western India, from the region of Udaipur in Mewar, 1260. H. 2 in. (5 cm). Museum of Fine Arts, Boston, Ross Collection*

181 *(below left) Page from a Laur Chanda manuscript. Uttar Pradesh (Delhi or Jaunpur?), late 15th C. Paint on paper, $7\frac{1}{2} \times 4\frac{1}{2}$ in. (19 × 11.5 cm). Bharat Kala Bhavan, Banaras*

182 *Malasri Ragini. Rajasthani, from Chawand in Mewar, 1605. Paint on paper, $8\frac{3}{8} \times 7\frac{3}{8}$ in. (21.2 × 18.7 cm). Nasli and Alice Heeramaneck Collection, Los Angeles County Museum of Art*

The pioneer scholar of Rajput painting, Ananda Coomaraswamy, divided the Hindu styles into two distinct schools based upon areas of provenance. These are the Rajasthani, from the Central Plains, and the Pahari, from the Himalayan foothills. The exact evolution of the Rajasthani style out of early Western Indian painting, with all its complex ramifications, and its further mutation under the impact of Mughal art, is still imperfectly understood and documented.

A very important factor which affected the early development of Hindu miniature painting in Central India was the rise of a vernacular movement. After the destruction of the Medieval Hindu kingdoms by Islam, the Sanskrit tradition had broken down, but with the rise of an indigenous literature in the fourteenth century Hinduism began to experience a renaissance. The scriptures and epics, formerly the prerogative of the priests and nobles, now became more directly available and entered the mainsteam of everyday life. The devotional (bhakti) cults grew more popular, and paramount among the personalized gods *186, 196* emerged the bucolic Radha-Krishna manifestation of Vishnu, with its setting in the world of cowherds and its erotic overtones. Religion found new life, and all the arts expanded under this revitalizing impetus.

Among the popular literary works profusely illustrated in the early Rajasthani painting styles were the *Bhagavata Purana*, the *Gita Govinda*, the *Chaurapanchasika*, the *Rasikapriya*, and the *Baramasas*. The last are descriptions of the various seasons of the year. The *Bhagavata Purana* deals with the multiple aspects of Vishnu and tells the symbolic life story of Krishna from his birth in Mathura and his adventures as a herdsman in Gokul, through a second phase as a prince ruling in the city of Dvaraka. The *Gita Govinda*, written by the twelfth-century Bengali court poet, Jayadeva, was a favourite with Rajasthani painters because it deals exclusively with the romantic exploits of Radha and Krishna in a pastoral setting. Radha, one of the loveliest of all the *gopis*, or herdswomen, was a married woman who was transfixed by a passionate obsession for Krishna and rejected her husband for him. The allegory is clear: the adoring Radha represents the soul while Krishna is God, and together they represent the ecstatic reunion of man's soul with the Godhead. *179* The *Chaurapanchasika* was also composed by a court poet, Bilhana, but in Kashmir in the eleventh century. It is a group of fifty love lyrics

reputedly composed by the poet as he was led to execution for falling in love with his ward, a princess. The king was so moved that he pardoned him and granted him his daughter in marriage.

Heroes and heroines (*nayakas* and *nayikas*) are frequently depicted in the guise of the celestial lovers, Radha and Krishna. This is especially so in the case of the *Rasikapriya*, which was composed in 1591 by the court poet of Orcha, Keshavadasa. It is a poetic catalogue of heroes and heroines and the various emotional characteristics and circumstances associated with them.

It is essential for the appreciation of Indian miniature painting to realize that while Mughal art was basically realistic, Rajput painting was – like Hindu literature – consistently symbolic and suffused with poetic metaphor. One might relate this quality to the Hindu and Buddhist concept of maya: since all life is an illusion, art, which is an interpretation of life, is valid only as a vehicle for deeper, hidden meanings. Indeed the art of painting itself, by its very nature as a visual illusion, is symbolic.

To the Rajput artist all men are symbols and all nature is symbolic. When he painted the figure of a woman, her appearance would duplicate that of other women in the picture, and they in turn were symbolic of all femininity. The artist's ultimate desire became to clarify man's relationship with God: it was recognized that the simplest manifestations of nature, everyday events, and basic drives and emotions, were all means to express noble ideas. Different colours were given distinct meanings: red connoted fury, yellow the marvellous, brown the erotic, and so on (see Mehta and Chandra, *The Golden Flute*). Colours were also used to represent specific musical notes, and this fact brings us to one of the most striking manifestations of Indian art, the *ragamala* paintings.

Ragamala means garland of melody or mode. It refers to a particular type of miniature painting in which poems dealing with musical senti-ments are illustrated by representations of specific human situations. Through the verbal imagery of a poem, the content of the musical form (*raga*) was made more exact, and the painting in turn made this imagery visible. A raga, the classical Indian musical mode, literally means some-thing that colours, that imbues the mind with a definite feeling, passion, or emotion. There are six basic male ragas with five 'wives' or *raginis* each, accounting for the total of thirty-six fundamental modes in North

Indian music. Each raga is further associated with a particular season and time of day. One speaks of a raga as being either a 'morning' or 'evening' raga. To perform one at an inappropriate time is thought to be not only unaesthetic but hazardous.

Ragas are always improvised by the performing musician from a limited number of basic notes directly related to the emotional content of the music. In order to understand this emotional content more perfectly and to assure an accurate interpretation, the performer looked to ragamala verses and paintings to reveal the distinct flavour and emotional quality of the music. Such paintings are unique in the world of art. It is only in India that painting, poetry, and music come together in such a unified and interdependent grouping.

182 An early ragamala painting, dated 1605, comes from the Rajasthani State of Mewar, which was an important seat of Rajput culture. The earliest paintings created there are Jain works in the conventional *180* Western Indian style. Even during the difficult times of Mughal harassment in the sixteenth century paintings continued to be produced: this ragamala work was painted nine years before Jahangir's final conquest of Mewar in Chawand, a small remote village at the extreme south-west edge of the State. The subject is a feminine mode which suggests longing for the missing lover. The lady waits by an empty bed plucking the petals from a lotus and wonders, 'loves me, loves me not?'. This early Rajasthani style, which shows some affinities to the *Laur* *181* *Chanda* imagery (see p. 220), is marked by a stark simplicity. Its spaces are defined by rectilinear planes of vivid red, yellow, green and black. The flat open spaces are modified by superimposed figures, animals, urns and trees which disguise the composition's geometric austerity, reminiscent of folk art.

179 A *Chaurapanchasika* illustration depicting the hero and heroine Bilhana and Champavati is thought to have been painted in Uttar Pradesh between 1525 and 1570. Here a hint of some of the sources of the early Rajasthani style is provided by two elements in the costume of the hero. One is the four pointed ends of his transparent coat (*caka dar*), and the other is his remarkable headgear, a turban with a lattice design in front and a central pointed cap (*kulah*). It has been surmised that these dress characteristics were of Afghan origin and were fashions of the Lodi and provincial sultanate courts during the pre-Mughal period

in North and Central India. The many paintings which feature them are collectively known as the Kulahdar group. The origin of this early style of painting is not yet completely certain, but Khandalavala and Chandra (in *New Documents of Indian Painting*) recently narrowed the field down to Uttar Pradesh, with a strong focus on Delhi.

In the *Chaurapanchasika* miniature Western Indian painting has clearly turned towards an entirely new form. The change was influenced not only by contemporary Islamic styles but also, one must conclude, by yet unrecovered Hindu paintings of the fifteenth and early sixteenth centuries. Early examples of Rajasthani painting are slowly being identified, and will no doubt help to clarify the situation.

Yet another of the leavening forces at work is revealed by one of the most famous Islamic manuscripts of the pre-Mughal period, the *Ni'mat-nama* or 'Book of Delicacies', a cookery book executed for *183* the sultan of Mandu in Central India about 1500–1510. The artists – undoubtedly Indian – were influenced by the Turkoman style of Persian painting.

By about 1625 Hindu miniature painting no longer showed Western Indian features, and various regional styles were developing. From the Central Indian State of Malwa comes another ragamala painting. The *185* composition is now comfortably at home in a vertical format, and the elegantly elongated trees and figure emphasize the vertical space. The colour is still applied in a flat manner, with no attempt at shading or tonality, but its mosaic-like patterns, especially on the trees, create a complex effect of variety and richness. The subject is Todi Ragini, a feminine musical mode of the rainy season – indicated by the narrow band of rain clouds boiling across the top of the picture. It appears that the youthful Todi has attracted deer out of the forest with the sweet sounds of her vina, but their presence only adds to her feeling of loneliness at being separated from her beloved during the rains. (For another use of rain symbolism, see p. 240.) The luxuriant trees with their plumes of new growth underline the ripening beauty of the heroine and add an air of agitation and suspense to the mood.

Much more than years separates *Todi Ragini* from an eighteenth-century Bundi miniature depicting Krishna approaching the tryst, *186* dressed as Radha. The style and execution have considerably advanced, and there is a sophistication which was the result of Mughal influences.

183 (left) Miniature from the Ni'mat-nama, showing the sultan overseeing the preparation of delicacies. Central India, Mandu, c. 1500–1510. Paint and gold on paper, 4½ × 5 in. (11.5 × 13 cm). India Office Library, London

184 (opposite) Raja Umed Singh of Kotah shooting Tiger. Rajasthani, Kotah, c. 1780. Paint on paper, 13 × 15¾ in. (33 × 40 cm). Victoria and Albert Museum, London

Starting in the seventeenth century, the rajas of Bundi State had been intimately associated with the Mughal court. Either Mughal artists actually migrated to Bundi about the middle of the eighteenth century or a group of Bundi painters fell under the spell of certain Mughal themes and techniques of the Shah Jahan atelier. This is suggested by a peculiar manner of rendering shadows, the quality of the paint surfaces, and the subtle colorations which infuse certain Bundi pro-

186 ductions. The present miniature shows these characteristics and also other typical Bundi elements – the lotus pool, Brahminy ducks, and scarlet railing. The tableau is dramatically dominated by a blind sun which casts an eerie, timeless light over the otherworldly landscape – the enchanted land of Radha and Krishna's cosmic romance. The profuse plantain trees, a constant trademark of Bundi art, writhe with lush ferocity and force their presence to centre stage where they all but engulf the hero and heroine.

226

Among the moods and attitudes of the hero and heroine described by Keshavadasa in his love poem, *Rasikapriya*, is the state of *hava*, which relates to external manifestations of the emotions of love. One such manifestation is the lovers' exchange of clothes, which is illustrated here. The miniature shows Krishna, who has just crossed a lotus pond in the small red boat, approaching Radha, who awaits him at the trysting-place. He holds a vina and has disguised himself for the journey with Radha's scarf. The poetic charm of this delightful painting is typical of many works created in Bundi in the eighteenth century. Its excellence makes it apparent why Bundi is considered a major centre of Rajasthani painting.

Since the near-by Rajput State of Kotah was ruled by the junior house of the Bundi rajas, it is not surprising that the style of painting that developed there in the eighteenth century grew out of the Bundi fashion. The Kotah style is cruder and somewhat exaggerated. It features buildings which are architectural freaks: they appear not only out of square but even unresponsive to gravity. Elements of the landscape, such as foliage, loom largely out of scale and have lush, exaggerated textures. This delightful, easily identifiable mode is well represented by *Raja Umed Singh of Kotah shooting Tiger*. Under the moon and stars of an Indian night, the raja (ruled 1771–1819), safe in his *machan* in the tree to

184

185 (left) Todi Ragini. Central India, Malwa, c. 1630. Paint on paper, $7\frac{3}{8} \times 5\frac{3}{4}$ in. (18.7 × 14.6 cm). Museum of Fine Arts, Boston, Gift of Denman Waldo Ross

186 (right) Krishna approaching the Tryst dressed as.Radha. Rajasthani, Bundi, c. 1760. Paint on paper, $10\frac{1}{4} \times 7\frac{1}{2}$ in. (26 × 19 cm). Private Collection

the left, fires his musket at a tiger which has attacked the water-buffalo decoy in the jungle below. There is a direct simplicity in the delineation. The lotus, tigers, rocks, and each leaf of the trees reveal the artist's delight in rendering details, and the details in concert present us with a tapestry of richness that recalls, as W. G. Archer has observed, the canvases of the French artist Douanier Rousseau.

Another regional style evolved at Kishangarh, some 60 miles north-west of Bundi. A typical miniature gives us a startling portrait of Radha

which is believed to be also a portrait of the courtesan-poetess Bani 189
Thani. Raja Savant Singh of Kishangarh (ruled 1699–1764) was dis-
possessed by his younger brother and abdicated to become a recluse-poet
at Brindaban, the holy Hindu city associated with Krishna. There he
and Bani Thani lived in imitation of the divine Krishna and Radha.
Already before the abdication an unusual and unmistakable style of
painting had emerged that departed so drastically from the provincial
Mughal style originally practised at the Kishangarh court that it must
have been due to the personality of Raja Savant Singh, or rather Nagari
Das, his *nom de plume* as a poet. His poems and the paintings which
complement them deal with the passionate love of Radha and Krishna
on the banks of the Jumna and in the dark forests of Brindaban. The face
of the heroine is so singular that it suggests that the model was prescribed
by Nagari Das in his description of his beloved, whose 'nose, curved and
sharp like the thrusting saru cypress plant', had merged in his mind
with that of Radha. (See Karl Khandalavala and Eric Dickinson in
Kishangarh Painting, 1959.)

An unusual feature of Kishangarh paintings created at the height
of the style, from about 1757 to 1770, is their large size, which may
reach eighteen inches or more.

At the neighbouring Rajput court of Jaipur early paintings almost
duplicated, in a Hindu idiom, the hybrid style of Mughal art. Their
superb quality and draughtsmanship are eloquently shown in *Love's* 187
Burning Fever. Here again is a painting that describes an attitude of a
heroine, in this case the extreme stage of 'love in separation'. The
heroine is shown in a state of such anxiety that she is ill. The dark,
dominant night sky is symbolic of her anguish, and the hot orange floor
is a further reference to her feverish state. A servant fans her; her atten-
dants have brought her cool mangoes and other refreshments, and try
in vain to console her. The realistic Mughal-style portraiture and subtle
shading are in marked contrast to the still-flat setting and the strong
Hindu colouring. Even so, such works created at Hindu courts with
Hindu subject-matter can only, in the last analysis, be termed provincial
Mughal. One of Akbar's first Rajput generals was Raja Bhar Mal of
Jaipur (ruled 1548–75), who even married one of his daughters to the
emperor. It is therefore not surprising that the Jaipur court, close to
Delhi and Agra, retained a strong Mughal flavour up to the beginning

187 (left) Love's Burning Fever. Rajasthani, Jaipur, c. 1750. Paint on paper. Private Collection

188 (right) Lovers, or a Kiss at Court. Attributed to Chokha; Rajasthani, Devgarh, c. 1810. Paint on paper, 8⅜ × 6⅜ in. (21.9 × 16.2 cm). Collection of Mr and Mrs John Gilmore Ford

of the nineteenth century, when one of the late Rajput styles flowered under Raja Pratap Singh (ruled 1779–1803).

 Occasionally high quality is found in nineteenth-century Rajput art: *Lovers, or a Kiss at Court* comes from a minor court in the State of Mewar and is attributed to the artist Chokha. It is startling not only for its handsomely orchestrated colour but also for its erotic composition. Two courtly lovers, intertwined in an abandoned embrace, have scattered numerous cushions across a white marble terrace. The pale simplicity of the terrace intensifies the colours of the pillows and serves to anchor their random patterns into a bold but at the same time elegant composition.

188

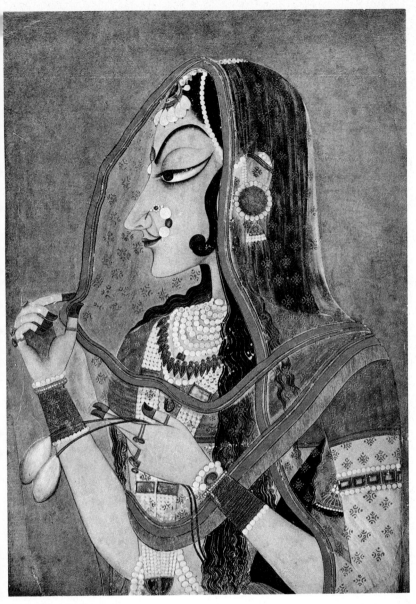

189 Portrait of Radha. Rajasthani, Kishangarh, c. 1760. Paint on paper, 19 × 14 in. (48.2 × 35.5 cm). Kishangarh Darbar, Rajasthan

The exact origins of the miniature-painting styles practised at the Hindu courts in the Himalayan foothills remain unknown. The mystery is intensified by the fact that the first known examples in the States of Basohli, Kahlur (Bilaspur), and Mankot, painted about 1650, are already stylistically mature. The hints of Rajasthani colour and space in these *191* works, executed in what is known as the 'Basohli Manner', have led scholars to assume a significant cultural exchange between the Punjab Hills and the Plains; but so far we have no proof. Some Pahari (Hill) rajas had to pay homage periodically to the Mughal emperor at Delhi, and on occasion they visited related Rajput families in Rajasthan. But the leading Pahari scholar, W. G. Archer, hardly believes that such casual contacts would have been enough to produce a fully developed painting style in the Hills by the middle of the seventeenth century.

A number of paintings dating from the second half of the eighteenth century which, because of their strong Central Indian qualities, were considered to be products of Malwa and Datia, are now known to have originated in Nepal. Might some earlier Hill paintings still be concealed among creations thought to be Rajasthani? In any case, the question of origin is just one of the numerous problems still to be resolved regarding dates, styles, and provenance of both Rajasthani and Pahari paintings.

The invasion of India and sack of Delhi in 1739 provided one of the catalysts for the ultimate refinement of Pahari art. As we have seen, with the collapse of Mughal power at Delhi many artists moved away and sought sympathetic patronage elsewhere. Some of them ultimately brought to the Hills elements of realism and Mughal craftsmanship from *173* the 'Muhammad Shahi Revival' which contributed significantly to the evolving Pahari aesthetic (see p. 213). The development of the Hill styles accelerated from then on. The Rajasthani Hindu courts perhaps welcomed the greatest number of displaced Mughal artists; but it was Pahari painting that would flower into India's last vital Hindu art form before the neutralizing impact of Western civilization made itself felt in the nineteenth century.

The first identifiable Pahari style, the Basohli Manner, is characterized *191* by a flat use of bold, intense colour and a distinctively aggressive profile. From Basohli it spread to the Hill States of Kulu, Mandi, Chamba,

Guler, and elsewhere. Here again what appear to be simplified Malwa 190
elements haunt us, along with echoes of other Rajasthani styles. For
example, a typical eighteenth-century Plains technique for rendering
pearl necklaces – to load the brush heavily with white pigment and make
a line of three-dimensional dots – is found in Basohli paintings.

A Basohli painting now in London that illustrates a scene from the 191
Rasamanjari of Bhanudatta shows well the characteristics of the style.
The regally dressed hero and heroine, in the guise of Radha and Krishna,
are displayed against a flat red background and an ornate pavilion. The
painting's rich colour scheme approaches the intensity of a cloisonné
enamel. The use of dark, iridescent fragments of beetle wings in the
jewellery is a Basohli trademark. Another feature common to a group
of Basohli paintings of the late seventeenth century, though not seen
here, is a gargoyle-like ornament on the base of the pavilion.

A similar style appears in a painting from the key State of Guler, south 190
of Basohli. Guler was closer to the Plains and the Mughal courts, and its
earliest works already display greater finish and a much more sophisti-
cated realism than those from Basohli. These elements would increase
dramatically following the fall of Delhi in 1739, when paintings of the
'Muhammad Shahi Revival' influenced Guler artists.

One of the most renowned sets of Pahari paintings is the series known
as the *Siege of Lanka*, of *c.* 1725–30, which illustrates the various activities
of Rama and his animal allies before Lanka, the fortress of the demon
Ravana in Sri Lanka, prior to the climactic battle of the *Ramayana* and

*190 The arrest of
the spies, from the
Siege of Lanka
episode of the
Ramayana. Pahari,
Guler, c. 1725–30.
Paint on paper,
23¾ × 32¾ in.
(60.3 × 83 cm).
Museum of Fine
Arts, Boston, Ross
Coomaraswamy
Collection*

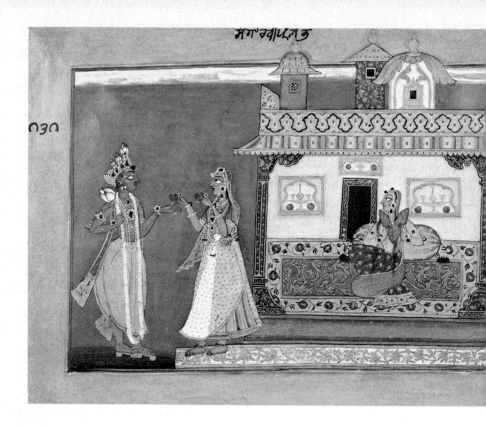

030

the rescue of the kidnapped Sita. A number of these unusually large paintings are known; some of them are half-finished works, while others are only drawings. They are inscribed on the reverse with the texts of the great epic poem, so it is thought that they were designed to be displayed to an audience while the text was read aloud (as was the case with the early Mughal *Hamza-nama*: see p. 202).

190 The episode depicted in the illustration is the moment when two demonic spies have been discovered in the ranks of the rescuing army. The intense orange background provides an ample field for the high, simple ramparts and the rising hills with their decorative Basohli-esque trees, which alternate downward to the silvered waters. The fish-filled sea looks strangely like a river: its painter had undoubtedly never seen the ocean. Monkey and bear warriors animate the flattened scene, which reaches a climax at the water's edge where the armoured heroes hold council.

191 (opposite) Krishna arriving at
Radha's House, from the
Rasamanjari of Bhanudatta.
Pahari, Basohli, c. 1660–70.
Paint on paper, 9⅛ × 12½ in.
(23.3 × 31.8 cm). Victoria and
Albert Museum, London

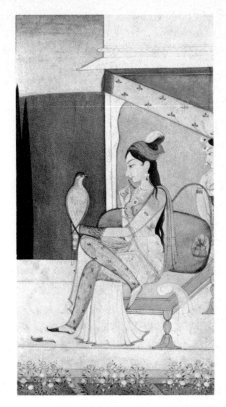

192 Lady with a Hawk. Pahari,
Guler, c. 1750. Paint on paper,
8⅛ × 4¼ in. (20.6 × 11 cm).
Victoria and Albert Museum,
London

Soon such overt Basohli elements as are seen in the *Siege of Lanka*
series gave way to a new, refined elegance, immediately apparent in the
next example from Guler, *Lady with a Hawk*. *192*

The painting was executed some twenty to twenty-five years later
than the *Siege* set, and we can see that the decisive Mughal influence has
been taken into the mainstream of the style. An elegant lady sits on a
terrace, smoking her *hukka* and gazing at a hunting hawk perched on
her gloved hand. The subtle tones and shading skilfully depict the
opulent flesh tones, sheer fabrics, and the setting in the inner apartment
of a palace. But Mughal realism has not forced out Hindu symbolism
and vigour. W. G. Archer analysed the miniature in his *Indian Painting
in the Punjab Hills* (1952):

Its theme and attitude illustrate a preoccupation with problems of
romantic love which . . . is now far franker and more deliberate. In
the present picture, this early convention [the cypress against a flaming

red ground] is once again employed but for poetic and emotional reasons. The cypresses are reduced to slim spear-like forms, while the background itself becomes a flat wash of Indian red. The cypresses reinforce the subject of the picture – a lady brooding on her absent lover – for their very shape hints at the nature of her sharp desires. At the same time the red background evokes all the ardour and passion implicit in the situation. Similar expressive imagery appears in the foreground where the open flowers are parallels for the girl's juvenescence and the hawk . . . suggests the (missing) lover.

It appears that about thirty-five States in the Punjab Hills produced miniature paintings. Some styles, such as the early one of Basohli and the later one of Kangra, dominated Pahari art during certain periods of development, but each centre also evolved its own characteristics. Paintings which portray specific individuals, such as rajas and courtiers, may be helpful in separating the styles of different courts, but many times they can be misleading: a raja would visit a neighbouring court, and as a courtesy his portrait would be painted – in an alien style.

194 An example of a Hill raja's portrait is *Raja Shamsher Sen of Mandi* [ruled 1727–81] *receiving his Son, Surma Sen*. Smoking his hukka and leaning against a bolster, his dark red *jama* loosened at the throat, the raja is attended by a servant who fans him with a cloth. The obsequious son is dressed for court and attended by a retainer bearing a sword encased in a cloth scabbard. The plain, vivid, powder-blue background and the stiff, boldly striped carpet project the main figures forward from the picture plane, and establish their importance. Although the prince is more elaborately dressed, his smaller size suggests the father's dominance and hints at his character, which has been described as 'excessively timid'. One is also tempted to see the raja's larger head as symbolic, but oversize heads had been a mannerism in Mandi painting since the seventeenth century. The attentive portraiture defines each of the individuals, including the less important retainers.

193 An unusual portrait of another Hill raja, who was a great patron of painting, is the miniature *Raja Balwant Singh of Jammu smoking alone on a Palace Roof in the Rains*. It is by the master artist of the Jammu court, Nainsukh, who painted the raja in many private and semi-private activities. Here, in what Archer has called his 'midget period', Nainsukh has set the exceedingly small figure against the massive façade and gate

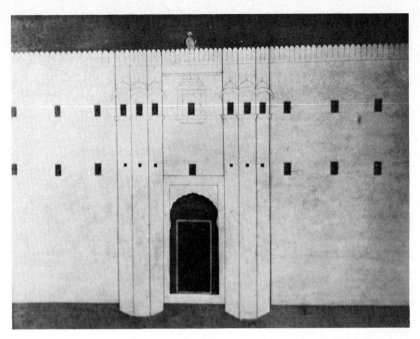

193 Raja Balwant Singh of Jammu smoking alone on a Palace Roof in the Rains. By Nainsukh; Pahari, Jammu, July–August 1751. Paint on paper, 8⅜ × 12 in. (21.2 × 30.5 cm). Indian Museum, Calcutta.

194 Raja Shamsher Sen of Mandi with his Son, Surma Sen. Pahari, Mandi, c. 1775. Paint on paper, 7¾ × 10 in. (19.7 × 25.4 cm). University Gallery, University of Florida, Gainesville, Gift of George P. Bickford

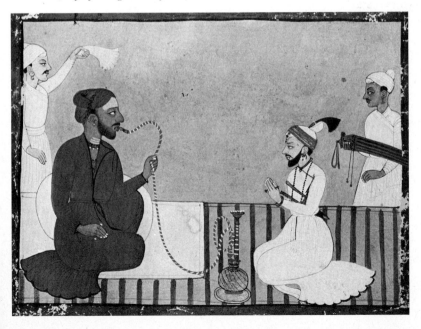

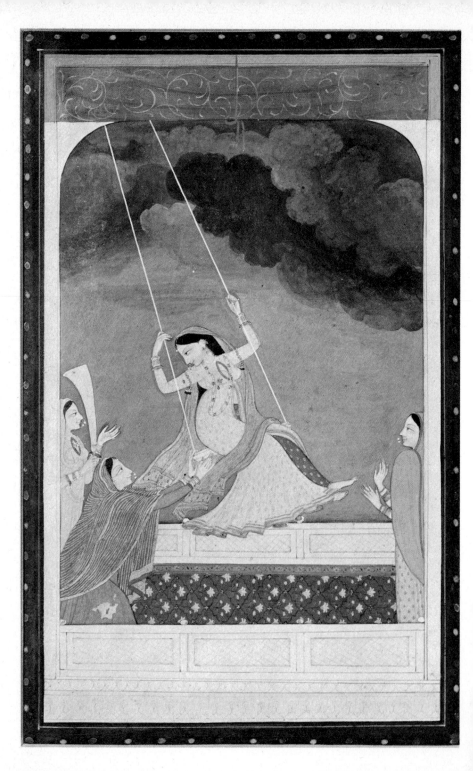

*196 Radha and Krishna in the Grove. Pahari, Kangra, c. 1780. Paint on paper,
5⅛ × 6¾ in. (13 × 17 cm). Victoria and Albert Museum, London*

of a fortress. The artist flatters his royal patron by portraying him as a
man sensitive to the beauty of lightning-filled monsoon clouds (a
rasika). But in a masterly stroke of symbolism he has also used the over-
whelming architectural setting as the visual summation of the power
focused within the one central figure both of the painting and of the
State, the raja.

In the Hill State of Kangra, in 1765, a royal patron was born who
would establish the outstanding school of painting in the Punjab Hills
in the eighteenth and nineteenth centuries. During the reign of Raja
Sansar Chand (1775–1823) the art of miniature painting in Kangra was
brought to its zenith. Its major flowering is believed to have occurred *195, 196*
between 1780 and 1805, with a second important phase from 1810 to
1823. Sansar Chand ascended the throne at the age of ten, and soon
showed an active interest in painting – a fact documented by miniatures
depicting the boy inspecting paintings with his friends and retainers.

*195 (opposite) The Swing. Pahari, Kangra, c. 1790. Paint on paper, 7⅞ × 4¾ in.
(19.6 × 12 cm). Victoria and Albert Museum, London*

Early in his reign Sansar Chand took arms to press a number of neighbouring States back under the Kangra standard. But in 1805, when Gurkha forces from near-by Nepal invaded the region, several of those States, spurred no doubt by a desire for revenge, joined in the attack. After vainly appealing to the British for aid, the raja desperately turned to the emerging Sikh power at Lahore for relief. In return for victory in 1809 the Sikhs demanded most of his kingdom: Kangra had only traded one conqueror for another.

In 1810, virtually without power and under close Sikh surveillance, Sansar Chand withdrew – accompanied only by a few retainers, but certainly with some of his artists and dancing girls – to live out the remainder of his life in small palaces at Sujanpur, Sujanpur Tira, Alampur, and Nadaun along the Beas river. There Kangra masterpieces continued to be painted until his death in 1823.

The subject-matter of Kangra miniatures shows the cult of Krishna to have been a passion with Sansar Chand. That is understandable in the context of Rajput society: where arranged marriages were the norm and where romance in the Western sense of the word was unknown, the myths of Krishna's dalliance with the gopis, and especially with Radha, a married woman, became a logical outlet for pent-up emotions. A similar phenomenon is seen in the literature of courtly love in early medieval Europe.

196 An early work from the atelier of Sansar Chand is *Radha and Krishna in the Grove*. Radha and Krishna lie on a bed of plantain leaves beside a churning stream filled with pink lotus blossoms and leaves. As the lovers unite, all nature springs to rejoice in the couple's ecstasy. Blossoms shower forth from tree branches, and all forms of plant and animal life appear in sets of twos, manifesting the dual aspect of fertility. The forms of stems and leaves find counterparts in the various features of the lovers, and their tender embrace is echoed by the vine encompassing the tree.

195 A miniature some ten years later in date depicts a Kangra beauty on a swing. The elegant female form is central to the Kangra style. The embodiment of an ideal, she is composed of rhythmically curved lines and expresses an innocent and open sensuality. This work seems at first merely a celebration of feminine beauty; but it features elements that are traditionally symbolic. The dark clouds gathering beyond the marble veranda indicate the lady's burgeoning desires. Once they flash

*197 The Svayamvara of Damayanti (detail), from a Nala-Damayanti series. Pahari, Kangra,
c. 1790–1800/c. 1810–14. Drawing on white primed paper, slightly coloured; detail about
9⅞ in. (25 cm) wide. Museum of Fine Arts, Boston, Ross Coomaraswamy Collection*

with lightning and release their rain, they will become the symbol for the
climactic act of physical love. The swing itself not only symbolizes the
sex act, but had also long represented springtime.

The delight in feminine beauty which obsessed Sansar Chand is
clearly seen in a series of exquisite drawings intended to illustrate the
poem *Naishadhacharita* by Shriharsha (discussed in detail by A. C. East-
man in *The Nala-Damayanti Drawings*). They are variously dated by
scholars to *c.* 1790–1800 or within the last period of Sansar Chand's
patronage, *c.* 1810–14. The drawing reproduced here depicts the moment
when Damayanti is carried on a palanquin by her ladies-in-waiting to
choose Nala from among her many suitors who crowd a courtyard. The
event is complicated by the jealousy of four gods, who have disguised
themselves as Nala and sit with the hero in a pavilion at the right.
Since Nala is human, he sits solidly upon the couch, while the gods
hover slightly in the air: thus they are discovered and are foiled in their
attempt to gain Damayanti's hand. Eastman has convincingly suggested
that the series of drawings, which contains known individuals and

197

*198 The Road to Krishna. Pahari, Garhwal, c. 1780. Paint on paper, 8 × 5⅝ in. (20.3 ×
14.3 cm). Victoria and Albert Museum, London*

scenery appropriate to Sansar Chand's court, embodies the raja's desire
to equate his court and personality with the classical times and lives of
Nala and Damayanti. This particular drawing shows the constant
Kangra device of dramatically setting off the figure of a woman, with
her flowing grace, against an angular architectural setting.

The Kangra style was to have considerable influence on the art of the
remote State of Garhwal. There, in a more austere landscape than that
of most other Hill States, a style of painting had continued without
distinction from the time of the arrival of several Mughal artists in the
middle of the seventeenth century. A little more than a hundred years
later, with the arrival of artists perhaps from Guler, a distinctive Garhwal
school emerged with Guler/Kangra overtones.

198 *The Road to Krishna*, painted about 1780, illustrates an episode from
the second half of the *Bhagavata Purana*, where Krishna is portrayed as a
king ruling from his golden capital of Dvaraka on the west coast of
India. Driven by a nagging wife, the impoverished brahman Sudama
goes in search of his friend Krishna: here, in a setting of green hills

edged by dotted tree forms, which are Garhwal trademarks, he has just discovered the god's lustrous city. The poetic fantasy of the painting is delightful; the painter, who had certainly never seen the ocean, has filled it with monsters and given it the swirling currents of a mountain stream.

With the death of Sansar Chand in 1823, the true inspiration for the Kangra style also expired. In 1829 Sansar Chand's son and successor, Anirodh Chand, retreated south to Tehri-Garhwal to avoid marrying his daughters to Sikhs, and a new 'Garhwal School' emerged, producing paintings in a waning Kangra style up to the 1860s. But in general Pahari painting was no more.

Our last example of a painting from the Hills is a Sikh portrait which 199 still commands some of the best qualities found in the late Guler style. By the end of the eighteenth century the warlike Sikhs, whose religion combined elements of Islam and Hinduism, not only dominated the Punjab but had also successfully moved into the Hills. There they quickly acquired a taste for paintings, but under their patronage the miniatures soon deteriorated into cheap bazaar-type productions with garish colours and little life. Here a chief or *sardar*, perfectly at ease upon his white stallion, is attended by a number of footmen, including one armed with a flintlock pistol and a blunderbuss. Crisp and elegant, this equestrian portrait looks back in style and technique to happier times in the Hills, and is ultimately indebted to Mughal portraiture for its format and image.

After the demise of the Rajput art centres and the complete domination of India by the British, miniature painting became a dead art. It is true that some petty rajas still maintained artists, but their productions were at best stiff, hollow copies of the past, and at worst were misunderstood interpretations of second-rate Western art. Some descendants of Mughal artists, in the late eighteenth and early nineteenth centuries, found employment producing paintings of flowers, animals, and exotic scenes for the British, and many of these 'Company Paintings' (so called after the East India Company) are excellent achievements within the limited scope of their genre.

The general deterioration of the Indian aesthetic was accelerated by the empire-builders' general misunderstanding and distaste for anything Indian, though some few among the 'Sahibs' had a genuine sympathy and understanding for Indian culture and were later instrumental in

aiding the Indians themselves to rediscover the excellence of their own art forms. But Major Handley's survey of the 'industrial arts of Rajputana' in *The Journal of Indian Art* in 1886 revealed a picture of confusion and decay: 'The most *advanced* artists have taken to clothing the gods in European costume with similar surroundings; thus Shiva is shown sitting in a hall lighted by candles in glass shades, and Krishna drives a Phaeton which is filled by his friends and attendants.'

One intriguing influence on Indian folk-art of the European presence appears in the paintings created at the Kali Temple in Calcutta in the second quarter of the nineteenth century. These simple 'Kalighat Paintings' were rapidly executed on thin sheets of paper and sold to pilgrims for pennies. The Kalighat artists not only adapted the technique of transparent English watercolour to create the illusion of rounded volumes, but occasionally depicted European subjects and events. But even these modest art works ultimately fell victim to the imported industrial revolution, first by being supplanted by woodcuts and finally, in the twentieth century, by cheap lithographic prints.

199 (left) A Sikh minister. Pahari, Guler, c. 1830. Paint on paper, 8 × 6⅛ in.

200 (right) An Englishman shooting Tiger from an Elephant. Calcutta, Kalighat, c. 1830. Watercolour with silver on paper, 17 × 11 in. (43.2 × 28 cm). Victoria and Albert Museum, London (Crown Copyright)

Epilogue

Throughout Indian history the great masses who lived in the villages have (in the words of Coomaraswamy) 'worshipped, not the abstract deities of priestly theology, but local genii (*Yaksas* and *Nāgas*), and the feminine divinities of increase, and mother goddesses'. Down through time the forces of the soil have robustly spawned and fertilized the arts. In fact, the sophisticated and complex icons of Hinduism could never have been conceived and brought to fruition without the support of this rich and vital substructure.

In the light of an unbroken continuity of more than four thousand years, it is not surprising that a lively folk tradition is still producing art as India moves into the twentieth century. In the villages near modern Delhi handmade fanciful pottery and ingenuous toys can still be purchased for pennies. Villagers still worship images of the 'Great Mother', composed of cow dung, straw, and terracotta, whose ancient form has the direct simplicity of much contemporary art. In Bombay, practically in the shadow of India's first nuclear reactor, the bazaars offer fantastic kites and fiercely coloured fabrics embroidered with multi-armed deities. Today across India folk arts display the current creativity of an aged but living tradition.

That tradition is the ultimate source for all that we have reviewed here. One might at first believe that a knowledge of India's complex history and religions would be a prerequisite for an appreciation of the creations of Indian culture. We have certainly attempted here to broaden the reader's base for understanding. It is this writer's ultimate belief, however, that the vitality and directness of Indian art make it accessible to all and no knowledge other than that basic to all humanity is needed.

Bibliography

History and culture

A. L. Basham, *The Wonder That Was India*, rev. ed. 1963. J. Nehru, *The Discovery of India*, 1946. V. A. Smith, *The Oxford History of India*, 3rd ed. 1958. P. Spear, *A History of India*, II, 1968. R. Thapar, *A History of India*, I, 1966.

Surveys and catalogues

L. Ashton (ed.), *The Art of India and Pakistan*, 1950. M. Beach *et al.*, *The Arts of India and Nepal: the Nasli and Alice Heeramaneck Collection*, 1966. A. K. Coomaraswamy, *Catalogue of the Indian Collections in the Museum of Fine Arts* (Boston), pt. V, 1926; and *History of Indian and Indonesian Art*, 1927. R. C. Craven, *Miniatures and Small Sculptures from India* (catalogue, University Gallery, Gainesville, Fla.), 1966. R. Y. L. D'Argencé, *Indian and Southeast Asian Stone Sculptures from the Avery Brundage Collection* (San Francisco), 1969. L. Frédéric, *The Art of India, Temples and Sculpture*, 1959. H. Goetz, *Art and Architecture of Bikaner State*, 1950; and *Studies in the History and Art of Kashmir and the Indian Himalaya*, 1969. L. P. Gupta, *Patna Museum Catalogue of Antiquities*, 1965. E. B. Havell, *Indian Sculpture and Painting*, 1908. S. Kramrisch, *The Art of India*, 1954. S. Lee (intro.), *Ancient Sculptures from India* (exhibition catalogue, Cleveland Museum of Art), 1964; and *A History of Far Eastern Art*, 1964. J. E. van Lohuizen-de Leeuw, *Indian Sculptures* (in the Von der Heydt Collection, Zürich), 1961. B. Rowland, *Religious Art East and West* (Frank L. Weil Institute for Studies in Religion and the Humanities, Cincinnati), 1961; and *The Art and Architecture of India. Buddhist, Hindu, Jain*, 3rd ed. 1967, paperback 1970. U. P. Shah, *Studies in Jaina Art*, 1955. V. Smith, *History of Fine Art in India and Ceylon*, 3rd ed., n.d. J. P. Vogel, *Catalogue of the Museum of Archaeology at Sarnath*, 1914. H. Zimmer, *The Art of Indian Asia*, 1955.

Religion and iconography

J. N. Banerjea, *The Development of Hindu Iconography*, 2nd ed., 1956. B. Bhattacharyya, *The Indian Buddhist Iconography*, 1958. A. K. Coomaraswamy, 'The Origin of the Buddha Image', *Art Bulletin*, IX, 1927, pp. 287–329; *The Transformation of Nature in Art*, 1934; *The Dance of Siva*, 2nd ed. 1957; and *Buddha and the Gospel of Buddhism*, rev. ed. 1964. A. T. Embree (ed.), *The Hindu Tradition*, 1966. J. Finegan, *The Archaeology of World Religions*, I, II, 1952. T. A. G. Rao, *Elements of Hindu Iconography*, 1965. P. Thomas, *Epics, Myths and Legends of India*, n.d. J. P. Vogel, *Indian Serpent Lore or Nagas in Hindu Legend and Art*, 1926; and *The Goose in Indian Literature and Art*, 1962. H. Zimmer, *Philosophies of India*, 1951; and *Myths and Symbols in Indian Art and Civilization*, 1946.

Architecture

P. K. Acharya, *Indian Architecture According to Manasara*, 1946. P. Brown, *Indian Architecture. Buddhist and Hindu*, 4th ed. 1959; and *Indian Architecture. Islamic Period*, 1942. J. Fergusson, *History of Indian and Eastern Architecture*, 1899. S. Kramrisch, *The Hindu Temple*, 1946. A. Volwahsen, *Living Architecture, Indian*, 1969; and *Living Architecture: Islamic Indian*, 1970.

Chapters 1 and 2

B. and R. Allchin, *The Birth of Indian Civilization*, 1968. N. R. Banerjee and K. V. Soundara Rajan, 'Sanur 1950 and 1952: A Megalithic Site in District Chingleput', *Ancient India*, no. 15, 1959, pp. 4–42. R. R. Brooks, 'The Caves of Men', *Art Gallery Magazine*, May 1973, pp. 24–6; and 'Rock-Shelter Paintings in India', *Asia*, no. 31, 1973, pp. 44–54. J. M. Casal, *Fouilles de Mundigak*, 1961. A. K. Coomaraswamy, *Buddha and the Gospel of Buddhism*, rev. ed. 1964. Sir A. Cunningham, *Archaeological Survey of India, Report V*, 1872–3. G. F. Dales, *A Suggested Chronology for Afghanistan, Baluchistan and the Indus Valley*, reprint from *Chronologies in Old World Archeology*, 1966. B. B. Lal, *Rock Paintings of Central India. Archaeology in India*, 1950. Sir J. Marshall, *Mohenjo-Daro and the Indus Civilization*, 1931. A. Parpola *et al.*, *Decipherment of the Proto-Dravidian Inscriptions of the Indus Civilization: A First Announcement*, Scandinavian Institute of Asian Studies, no. 1, 1969. S. Piggott, *Prehistoric India*, 1950. R. L. Raikes, 'New Prehistoric Bichrome Ware from the Plains of Baluchistan (West Pakistan)', *East and West*, XIV (1–2), 1963, pp. 56–8; 'The End of the Ancient Cities of the Indus', *American Anthropologist*, LXVI, no. 2, 1964; and 'Physical Environment and Human Settlement in Prehistoric Times in the Near and Middle East: A Hydrological Approach', *East and West*, XV (3–4), 1965, pp. 179–93. S. R. Rao, 'Further Excavations at Lothal', *Lalit-Kalā*, no. 11, 1962, pp. 14–30. M. S. Vats, *Excavations at Harappā*, 1940. R. G. Wasson, *Soma, Divine Mushroom of Immortality*, 1968. Sir M. S. Wheeler, 'Harappa 1946: The Defences and Cemetery R 37', *Ancient India*, no. 3, 1947, pp. 58–130; *Early India and Pakistan*, 1959; *Civilizations of the Indus Valley and Beyond*, 1966; and *The Indus Civilization*, supplement to *The Cambridge History of India*, 3rd ed. 1968. H. Zimmer, *Philosophies of India*, 1951.

Chapter 3

J. N. Banerjea, *The Development of Hindu Iconography*, 2nd ed. 1956. P. Brown, *Indian Architecture, Buddhist and Hindu*, I, 4th ed. 1959. L. P. Gupta, *Patna Museum Catalogue of Antiquities*, 1965. J. Irwin, *The Foundations of Indian Art* (Lecture), Asia House, New York, Winter 1974. S. Kramrisch, *The Art of India*, 1954. N. A. Nikam and R. McKeon, *The Edicts of Asoka*, 1959. N. R. Ray, *Maurya and Sunga Art*, 1945. B. Rowland, *The Art and Architecture of India. Buddhist, Hindu, Jain*, 3rd ed. 1967, paperback 1970. V. Smith, *History of Fine Art in India and Ceylon*, 3rd ed., n.d.

Sir M.S. Wheeler, *Early Indian and Pakistan*, 1959. H. Zimmer, *The Art of Indian Asia*, 1955.

Chapter 4

P. Brown, *Indian Architecture. Buddhist and Hindu*, I, 4th ed. 1959. A.K. Coomaraswamy, *La Sculpture de Barhut*, 1908; and *History of Indian and Indonesian Art*, 1927. Sir A. Cunningham, *The Stupa of Bharhut*, 1879. M.N. Deshpande, 'Important Epigraphical Record from the Chaitya Cave, Bhājā', *Lalit-Kalā*, no. 6, October 1959, pp. 30–32. A. Foucher, *Les Representations de 'Jatakas' sur les Bas-Reliefs de Barhut*, 1908. K. Khandalavala, 'The Date of Karle Chaitya' (editorial notes), *Lalit-Kalā*, nos. 3–4, April 1956–March 1957. A. Lippe, *The Freer Indian Sculptures* (Smithsonian Institution, Freer Gallery of Art, Washington, D.C.; Oriental Studies, no. 8), 1970. N.R. Ray, *Maurya and Sunga Art*, 1945. R. Thapar, *A History of India*, I, 1966. H. Zimmer, *The Art of Indian Asia*, 1955.

Chapter 5

D, E. Barrett, *Sculptures from Amaravati in the British Museum*, 1954. P. Brown, *Indian Architecture. Buddhist and Hindu*, I, 4th ed. 1959. M. Chandra, 'Ancient Indian Ivories', *Prince of Wales Museum Bulletin* (Bombay), no. 6, 1959; and 'An Ivory Figure from Ter', *Lalit-Kalā*, no. 8, October 1960, pp. 7–14. J. and Mme Hackin, *Recherches Archéologiques à Begram*, IX, 1939. J.E. van Lohuizen, 'The Date of Kaniska and Some Recently Published Images', *Papers on the Date of Kaniska*, ed. A.L. Basham, 1968. J. Marshall, *Guide to Sanchi*, 1918. T.N. Ramachandran, *The Nagapattinam and other Buddhist Bronzes in the Madras Museum*, 1965. C. Sivaramamurti, 'Amaravati Sculptures in the Madras Gov. Museum', *Bulletin of the Madras Gov. Museum*, n.s., IV, 1956. V. Smith, *History of Fine Art in India and Ceylon*, 3rd ed., n.d. R. Thapar, *A History of India*, I, 1966. A. Volwahsen, *Living Architecture, Indian*, 1969. Sir M.S. Wheeler, *Rome Beyond the Imperial Frontiers*, 1955.

Chapter 6

A.L. Basham (ed.), *Papers on the Date of Kaniska*, 1968. S. Beal (trans.), *Buddhist Records of the Western World*, 1883. A.K. Coomaraswamy, 'The Origin of the Buddha Image', *Art Bulletin*, IX, 1927, pp. 287–329. C. Fabri, 'Akhnur Terracottas', *Marg*, VIII, no. 2, 1955, pp. 53–64. C.A. Foucher, *L'Art gréco-bouddhique du Gandhāra*, 1905–18. J. and C. Hackin, *Nouvelles recherches archéologiques à Bamiyan*, III, 1933. M. Hallade, *Gandharan Art of North India*, 1968. H. Ingholt and I. Lyons, *Gandharan Art in Pakistan*, 1957. J. Legge, *A Record of Buddhist Kingdoms*, 1886. J.E. van Lohuizen, 'The Date of Kaniska and some Recently Published Images', *Papers on the Date of Kaniska*, ed. A.L. Basham, 1968. Sir J. Marshall, *The Buddhist Art of Gandhara*, 1960; and *A Guide to Taxila*, 1960. P.R. Myer, 'Again the Kaniska Casket', *Art Bulletin*, XLVIII, nos. 3 and 4, 1966. B.N. Puri, *India Under the Kushans*, 1965. J.

Rosenfield, *The Dynastic Art of the Kushans*, 1967. B. Rowland, 'The Colossal Buddhas at Bamiyan', *Journal of the Indian Society of Oriental Art*, XV, 1947, pp. 64–73; *Gandhara Sculptures from Pakistan Museums*, 1960; *Religious Art East and West* (Frank L. Weil Institute for Studies in Religion and the Humanities, Cincinnati), 1961; *The Arts of Afghanistan*, 1966; and *The Art and Architecture of India. Buddhist, Hindu, Jain*, 3rd ed. 1967, paperback 1970. D. Schlumberger, 'Surkh Kotal, a Late Hellenistic Temple in Bactria', *Archaeology*, Winter 1953, pp. 232 ff. R. Thapar, *A History of India*, I, 1966. J.P. Vogel, *The Goose in Indian Literature and Art*, 1962. Sir M.S. Wheeler, *Rome Beyond the Imperial Frontiers*, 1955. H. Zimmer, *Philosophies of India*, 1951.

Chapter 7

A.L. Basham, *The Wonder That Was India*, rev. ed. 1963. P. Brown, *Indian Architecture. Buddhist and Hindu*, I, 4th ed. 1959. M. Chandra, 'Ancient Indian Ivories', *Prince of Wales Museum Bulletin* (Bombay), no. 6, 1959. P. Chandra, *A Guide to the Elephanta Caves* (Gharapuri), 1962. R.Y.L. D'Argencé, *Indian and Southeast Asian Stone Sculptures from the Avery Brundage Collection* (San Francisco), 1969. D. Devahuti, *Harsha, A Political Study*, 1970. O.C. Gangoly, *The Art of the Rashtrakutas*, 1958. S.R. Rao, 'A Note on the Chronology of Early Chalukyan Temples', *Lalit-Kalā*, no. 15, 1972. A. Rea, *Chalukyan Architecture*, Archaeological Survey of India, XXI, 1897, reprint 1970. B. Rowland and A.K. Coomaraswamy, *The Wall Paintings of India, Central Asia and Ceylon*, 1938. M. Singh, *India, Paintings from the Ajanta Caves*, 1954; and *The Cave Paintings of Ajanta*, 1965. R. Thapar, *A History of India*, I, 1966. A. Volwahsen, *Living Architecture, Indian*, 1969. G. Yazdani *et al.*, *Ajanta*, 1930–55.

Chapter 8

D.E. Barrett, *Early Cola Bronzes*, 1965. R. Chanda, 'Exploration of Orissa', *Memoirs of the Archaeological Survey of India*, no. 44, 1944. A.K. Coomaraswamy, *The Dance of Siva*, 2nd ed. 1957. O.C. Gangoly, *The Art of the Pallavas*, 1957. Jainicke-Goetz, *Mamallapuram*, 1965. R. Nagaswamy, 'Rare Bronzes from Kongu Country', *Lalit-Kalā*, no. 9, April 1961, pp. 7–10. A. Rea, *Pallava Architecture*, Archaeological Survey of India, New Imperial Series, XXXIV, Southern India, XI, 1903, reprint 1970. C. Sivaramamurti, *Royal Conquests and Cultural Migrations in South India and the Deccan*, 1955; and *South Indian Bronzes*, 1963. K.R. Srinivasan, 'The Pallava Architecture of South India', *Ancient India*, no. 14, 1958, pp. 114–38. D.R. Thapar, *Icons in Bronze, An Introduction of Indian Metal Images*. n.d. R. Thapar, *A History of India*, I, 1966. A. Volwahsen, *Living Architecture, Indian*, 1969. H. Zimmer, *Myths and Symbols in Indian Art and Civilization*, 1946; and *The Art of Indian Asia*, 1955.

Chapter 9

S. Beal, *The Life of Hiuen-Tsiang*, 2nd ed. 1911. P.

Brown, *Indian Architecture. Buddhist and Hindu*, I, 4th ed. 1959. Sir A. Cunningham, *Mahābodhi or the Great Buddhist Temple at Bodh Gayā*, 1892. R. Ebersole, *Black Pagoda*, 1957. J. Fergusson, *History of Indian and Eastern Architecture*, 1899. M. Flory, *Les Temples de Khajuraho*, 1965. H. Goetz, *Art and Architecture of Bikaner State*, 1950; and *Studies in the History and Art of Kashmir and the Indian Himalaya*, 1969. S. Gorakshkar IV, 'A Bronze Shrine of Vishnu in the Freer Gallery of Art, Washington (D.C.)', *Lalit-Kalā*, no. 15, 1972, pp. 29–33. D. Hasedawa, *Konarak* (in Japanese), 1963. S. Kramrisch, *Pala and Sena Sculpture*, n.d.; and *The Hindu Temple*, 1946. J.E. van Lohuizen-de Leeuw, *Indian Sculptures* (in the Von der Heydt Collection, Zürich), 1961. P. Pal, 'A Note on the Mandala of the Eight Bodhisattvas', *Archives of Asian Art*, XXVI, 1972–3, pp. 71–3. B. Rowland, *The Art and Architecture of India. Buddhist, Hindu, Jain*, 3rd ed. 1967, paperback 1970. H. Shastri, 'The Nalanda Copper Plate of Devapāladeva', *Epigraphia Indica*, VIII, 1924, pp. 310–27. R. Thapar, *A History of India*, I, 1966. P. Thomas, *Epics, Myths and Legends of India*. E. Zanas, *Khajuraho*, 1960. H. Zimmer, *The Art of Indian Asia*, 1955.

Chapters 10 and 11

M. Archer, *Natural History Drawings in the India Office Library*, 1962. W.G. Archer, *Indian Painting in the Punjab Hills*, 1952; *Kangra Painting*, 1952; *Bazaar Paintings of Calcutta*, 1953; *Garhwal Painting*, 1954; *Central Indian Painting*, 1958; *Indian Painting in Bundi and Kotah*, 1959; *Paintings of the Sikhs*, 1966; *Indian Paintings from the Punjab Hills*, 1973; with E. Binney,3rd, *Rajput Miniatures* (catalogue), 1968. D.E. Barrett, *Paintings of the Deccan XVI–XVII Century*, 1958; with B. Gray, *Indian Painting*, 1963. E. Binney,3rd, *Indian Miniature Painting, The Mughal and Deccani Schools*, 1973. H. Blochmann (trans.), *Ā-īn-ī Akbarī by Abū'l-fazl Allāmī*, 2nd ed., 1927. P. Brown, *Indian Architecture. Islamic Period*, 1942. W.N. Brown, *The Story of Kalaka*, 1933; and *Miniature Paintings of the Jaina Kalpasūtra*, 1934. P. Chandra, *Bundi Painting*, 1959. A.K. Coomaraswamy, *Rajput Painting*, 1916; *Catalogue of the Indian Collections in the Museum of Fine Arts* (Boston), pt. V, 1926; and *History of Indian and Indonesian Art*,

1927. K.A.C. Creswell, *A Short Account of Early Muslim Architecture*, 1958. A.C. Eastman, *The Nala-Damayanti Drawings*, 1959. R. Ettinghausen, *Paintings of the Sultans and Emperors of India in American Collections*, 1961. O.C. Gangoly, *Ragas and Raginis*, 2nd ed. 1948; and *Critical Catalogue of Miniature Paintings in the Baroda Museum*, 1961. H. Goetz, *Art and Architecture of Bikaner State*, 1950. B. Gray, *Treasures of Indian Miniatures in the Bikaner Palace Collection*, 1955. Maj. T.H. Handley, 'Enamelling and other Industrial Arts of Rajputana', *The Journal of Indian Art*, II, 1886. Sir G. Hearn, *The Seven Cities of Delhi*, 2nd ed. 1928. W. Kaufmann, *Ragas of North India*, 1968. K. Khandalavala, *Pahari Miniature Painting*, 1958; with M. Chandra, *New Documents of Indian Painting – A Reappraisal*, 1969; with M. and P. Chandra, *Miniature Paintings from the Sri Motichand Khajanchi Collection* (New Delhi), 1960; with E. Dickinson, *Kishangarh Painting*, 1959. R. Krishnadasa, *Mughal Miniatures*, 1955. R. Krishnadasa, 'An Illustrated Avdhi Ms. of Laur-Chandā in the Bhārat Kalā Bhavan, Banaras', *Lalit-Kalā*, nos. 1–2, April 1955–March 1956. E. Kühnel, *Indische Miniaturen*, n.d. S. Lee, *Rajput Painting*, 1960. N.C. Mehta, *Studies in Indian Painting*, 1926; with M. Chandra, *The Golden Flute*, 1962. B.S. Miller, *Phantasies of a Love-Thief* (Bilhana), 1971. P. Pal, *Ragamala Paintings in the Museum of Fine Arts, Boston*, 1967. M.S. Randhawa, *Kangra Valley Painting*, 1954; *Basohli Painting*, 1959; *Kangra Paintings on Love*, 1962; with J.K. Galbraith, *Indian Painting: Scenes, Themes and Legends*, 1968. R. Skelton, 'The Ni'mat-Nama: a Landmark in Malwa Painting', *Marg*, XIII, no. 3, June 1959, pp. 44–8; and *Miniature Indiane dal XV al XIX Secolo*, 1960. P. Spear, *A History of India*, II, 1968. W. Spink, *Krishnamandala*, 1971. R. Thapar, *A History of India*, I, 1966. A. Volwahsen, *Living Architecture: Islamic Indian*, 1970. S.C. Welch, *The Art of Mughal India*, 1963; *God, Thrones and Peacocks*, 1963; and *A Flower from Every Meadow*, 1973. J.V.S. Wilkinson, *Mughal Painting*, 1949.

Epilogue

A.K. Coomaraswamy, *History of Indian and Indonesian Art*, 1927. S.K. Ray, *The Ritual Art of the Bratas of Bengal*, 1961.

Acknowledgments

Robert R.R. Brooks 15, Dominique Darbois 56; by courtesy of Dr Vidya Dehejia 41a; Department of Archaeology, Government of India, 19, 20, 37, 57, 110, 144, 145; Robert Ebersole 43–5, 102, 126, 138–40; W. Forman 115; Hans Hinz 62, 68, 141; George F. Hull 162; Martin Hürlimann 16, 31, 61, 108, 136, 142, 170; India Office Library, London (Archaeological Survey of India) 18, 24, 27–30, 34, 35, 39, 48, 76, 79, 85, 86, 93, 95, 96, 98, 100, 101, 111, 132b, 135, 158; Victor Kennett 38, 84, 87, 118, 119, 153, 159; Josephine Powell 3–5, 7, 123; Royal Academy of Arts, London 8, 21, 22, 33, 70; Barbara Wace 150; Robert C. Williamson 132a.

Illustrations 80 and 87 are from Madanjeet Singh, *The Cave Paintings of Ajanta*, Lausanne (Edita) and London (Thames and Hudson) 1965. The following illustrations, from *The Art and Architecture of India. Buddhist, Hindu, Jain*, by Professor Benjamin Rowland, Jr (Pelican History of Art, Harmondsworth 1953, 1956, 1967, 1970), are reproduced by kind permission of Mrs Benjamin Rowland, Jr and Penguin Books: 26, 41b, 42, 47, 58, 69, 73, 90, 92, 99, 134. The following illustrations are from photographs by the author: 77, 103–7, 147–9, 151, 152, 155–7, 160, 172.

Maps drawn by Hanni Bailey

Index

Page numbers in *italic* indicate illustrations